CAMERA
TRAPPING
GUIDE

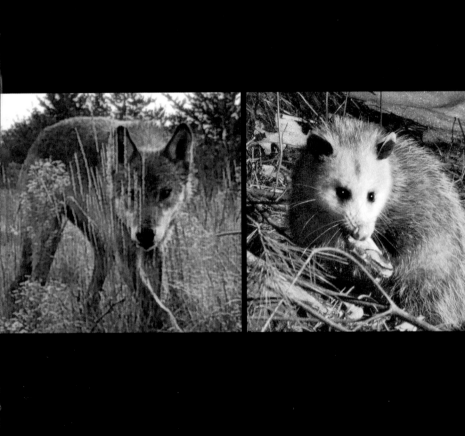

CAMERA TRAPPING GUIDE

GUIDE

TRACKS, SIGN, AND BEHAVIOR
OF EASTERN WILDLIFE

JANET PESATURO

STACKPOLE
BOOKS

Guilford, Connecticut

Published by Stackpole Books
An imprint of The Rowman & Littlefield Publishing Group, Inc.
4501 Forbes Blvd., Ste. 200
Lanham, MD 20706
www.rowman.com

Distributed by NATIONAL BOOK NETWORK
800-462-6420

Copyright © 2018 by Janet Pesaturo

Photographs by the author unless otherwise credited.

British Library Cataloguing in Publication Information available

Library of Congress Cataloging-in-Publication Data available

ISBN 978-0-8117-1906-3 (paperback)
ISBN 978-0-8117-6804-7 (e-book)

♾™ The paper used in this publication meets the minimum requirements of American National Standard for Information Sciences—Permanence of Paper for Printed Library Materials, ANSI/NISO Z39.48-1992.

Printed in the United States of America

To the animals of the eastern United States:
I hope this book inspires others to let you teach them.

CONTENTS

ACKNOWLEDGMENTS

MOST OF ALL, I WOULD LIKE TO THANK my husband of thirty-one years, Bob Zak Jr. I could never have done this if not for his patience, support, and adventurous spirit, not to mention his technical genius. We had a wonderful time exploring the eastern United States, from cypress swamps to sand plains to northern forests. I'm hoping for another thirty-one years together. I also thank our children, Alison Zak and Steven Zak, who put up with my odd obsessions with such good humor.

Thanks to Susan Fly and Anne Marie Meegan, for photo contributions, as well as many hours of wilderness exploration and conversation, as we followed tracks, sniffed pee, and puzzled over poop. I also wish to thank the many others who got cold, wet, sweaty, dirty, and lost with me over the years as we learned to track. These fellow adventurers include Alison Zak, Bob Moore, Dan Foster, Wendy Sisson, Rona Balco, and Donna Mackie.

I deeply appreciate several others who generously contributed photos: Tamara Anderson, Bob Etzweiler, Pat Jao, Charlie Perakis, Jessica Schindler, Rob Speiden, and John Van Niel. Most of you helped in other ways, as well, whether in the dirt, online, or both.

Special thanks to author Filip Tkaczyk, who provided very helpful advice and support in writing a nature guide and generously shared his knowledge of wildlife in online tracking groups. I also owe much to many authors I don't know personally, but whose work profoundly influenced me, especially Mark Elbroch, Paul Rezendes, and James Lowery.

Many thanks to the teachers who educated and inspired me, especially Sue Morse, Tom Wessels, Nick Wisniewski, Valerie Wisniewski, David Brown, George Leoniak, and Michelle van Naerssen. Most important among educators was my seventh-grade science teacher, Mr. Blaney, who ignited my interest in life sciences when he taught us about the interconnections of species through food webs. Thanks also to the many wonderful Mass Audubon educators, whose programs I attended decades ago for weekend fun while I was caught up in the rat race; you helped me find direction.

I also wish to thank Shane Rucker and Wayne Hall, who provided excellent advice on finding badgers; Susan Kirks, for sharing her knowledge of badger behavior; Sue Mansfield, for sharing her knowledge of black bear behavior; Ryan Penessi, who pointed the way to martens; and Mark Lotz and Matt Kruse, who advised me on tracking Florida panthers.

There are many other people who have been important in helping me learn about wildlife tracking or camera trapping through online groups. I have not yet had the pleasure of meeting most of them, but their willingness to share their knowledge and wisdom has been, and continues to be, immensely valuable. First and foremost among these generous souls is Kim Cabrera, who monitors several online tracking groups and shares her knowledge of wildlife through videos and blogs. Notable among the many others are Dan Gardoqui, Jonathan Poppele, Phil Johnston, Bob Ollerton, Kersey Lawrence, Christine Hass, Linda Jo Hunter, Dan Potter, Denis Callet, Tom Wilson, Cyn Cross, Ron Dean, Mike Bottini, Peter Apps, Eric Downes, Dave Barry, Connor O'Malley, and John Wolf.

Thanks to Ruth Sasala, Ann Zak, and Bob Zak, who generously hosted some of my cameras on their properties.

I am grateful for the folks at Stackpole Books for making this book a reality, especially Judith Schnell, for her enthusiasm for this project and her easygoing, affable style. I also wish to thank Judith's right hand, Stephanie Otto.

And last, but not least, I would like to thank the animals of the eastern United States, whose runs, dens, latrines, caches, and other important places hosted my trail cameras. I am sorry for the intrusion, but I hope that camera trapping ultimately benefits you by inspiring people to better appreciate you and plan for your needs as human "progress" marches on. That is, after all, the point of this book.

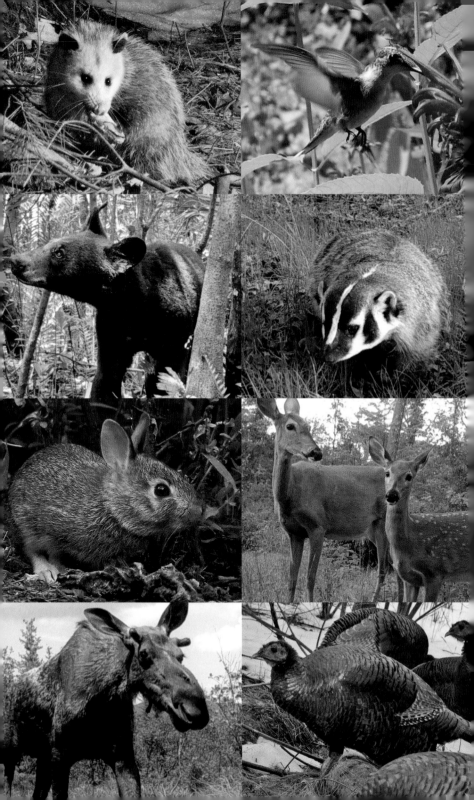

INTRODUCTION

About this Book

This is the book I wanted to read, but it didn't exist when I first picked up a trail camera years ago. While researching a species so I could decide on camera placement, I found that I needed three types of sources: a mammals field guide, a tracking guide, and a summary of the animal's behavior. And still, these sources did not directly answer my question. So, I thought, wouldn't it be wonderful to write a single book that covers the essentials needed for camera trapping; one that explains how, where, and when to find each species and offers suggestions for camera placement? Well, here it is, for the eastern United States.

Because this book encompasses a broad range of topics, I had to be concise and do not intend this to be a comprehensive guide to either tracking or behavior. For more detailed information, please consult the sources at the end of the book.

Forty-one species are covered, including thirty-five mammals, five birds, and one reptile, ranging from game animals, to charismatic predators, to common backyard visitors. There is something for everyone, from those who explore wilderness, to those who enjoy suburban and urban wildlife. I have striven to make it accessible to the casual naturalist, while also describing current research topics on the habits of animals.

Each species account provides a general description and range map and describes habitat, diet, dens, latrines, runs, caches, travel habits, and seasonal behavior, as well as basic track identification, commonly encountered trail patterns, and scat identification. I emphasize where and when the animal is likely to appear *repeatedly* on the landscape, because these areas are where camera capture is most likely. I also discuss interesting and rarely observed behaviors to target with video. For some species, I describe behaviors that remain poorly understood so that even the amateur naturalist with an inexpensive trail camera can study cutting-edge topics.

Why Camera Trapping?

Observing animal behavior is perhaps the most rewarding part of camera trapping. As a tracker, I have found it enlightening to see things I could only imagine through tracking. Sometimes trail-camera captures debunk my previously held assumptions, even assumptions perpetuated in books. They also reveal how animals are interconnected through the things they create. They visit each other's dens, steal each other's food, mark each other's scent stations, and so on.

I've also found that camera trapping heightens my awareness of wildlife. I now recognize the sound of a squirrel gnawing a hickory nut shell in the woods. This is a sound I most certainly "heard," without actually noticing, countless times before I learned what was making the sound from camera-trap footage. I also have found river otters by sound—because I learned their subtle vocalizations from camera-trap videos. I see wildlife more often now because I have developed more vivid search images through reviewing my trail-camera photos and videos. I am better at visualizing how animals move and predicting what they might do next, so I am more likely to catch those fleeting glimpses and recognize what I saw. So it's a lot more than getting pretty photos . . . but it's nice to get those, too!

Camera-Trapping Basics
WHAT IS A CAMERA TRAP?

A camera trap is a camera that can be left in the field and will take photos or videos when it detects an animal. Most use a passive infrared sensor that detects change in temperature. When a warm body passes through the detection zone, the camera is triggered to take a photo or video. Camera traps were first used by hunters to localize their quarry. But they are excellent noninvasive tools for learning about wildlife, and now hobbyists, naturalists, and scientists are using them as well.

SELECTING A CAMERA

Camera models come and go, so rather than suggest specific models, I will explain what to look for.

Cost

There is a trail camera for almost any budget. In general, though not always, more expensive trail cameras give better quality photos and videos, but you can learn a lot about animal behavior regardless of image quality. You do not need to spend a fortune. Many of the photos in this book were taken with trail cameras in the $60 to $270 range, as purchased from 2010 to 2017. Some were taken with a $600 trail camera, and others with "homebrew" camera traps made with digital cameras. For most of the trail-camera photos in this book, I have indicated in the captions which camera I used so you can get a sense of the image quality possible for a given model. However, be aware that camera traps may get hundreds, if not thousands, of poor images for every nice one. What you see in this book are some of my best shots. Photo editing was kept to a minimum, however. Most were cropped, and exposure was adjusted for some of them.

Your Goals

People often ask me to recommend the "best" model. But there isn't one. They all have different strengths and weaknesses, and what is best for you depends on what you want out of the camera. So, before you purchase a camera, think about your goals and priorities. If you intend to study animal behavior, you probably

want one that takes videos. Not all of them do, and not all cameras that take videos record audio.

If your priority is nice, crisp photos, then be sure to evaluate image quality before buying. If you want to study a fast-moving species, like the fisher, then trigger speed and recovery speed are important. If you want good quality images of small animals, then you need one that can focus on small bodies at close range. If you want color nighttime photos, you need a camera with a white flash. But if you want a camera that's less likely to startle animals or to attract the attention of nocturnal humans, you might prefer an infrared flash.

A good resource for comparing the features and specifications of many different trail-camera models is Trailcampro.com. Focus on the specifications and don't be distracted by the scores, because cameras are scored based on what they are designed to do. A very high-scoring camera that does not take videos is useless if you want videos.

Image Quality

Ads for trail cameras often boast a high megapixel count, implying superior image quality, but this is misleading because image quality is limited by lens quality. A higher megapixel count is achieved by interpolation, which is basically an editing process that does not always improve image quality. Interpolation does, however, create larger files that prolong recovery time.

So, don't make assumptions about image quality based on megapixels. Instead, look at images actually captured by that camera. It's often possible to find examples online, but be aware that many people post their best captures, not an average image for that camera. Also note that a given camera model may take better quality still photos than videos, or vice versa. The quality of daytime and nighttime images may differ dramatically as well.

Trigger Speed

Trigger speed (or, more accurately, trigger delay) is very important. This is the time that elapses between detection and triggering. So, a two-second trigger speed means that the image is taken two seconds after the camera detects the animal. The shorter the trigger speed, the better. The longer the trigger speed, the more likely that the animal will leave the detection zone before its image is captured. When that happens, you get a photo (or video) with no animal. These days many trail cameras, even inexpensive ones, have a trigger speed of less than one second, and some less than half a second.

Be aware that if a camera takes both photos and videos, the trigger speed for each might differ. Sometimes they differ substantially. For example, one camera I've used has a one-second trigger speed for photos and a five-second trigger speed for videos.

Camera placement and target species determine the importance of trigger speed. On an animal trail, a fast trigger speed is needed for a good capture rate,

because animals are merely passing through. But at a latrine, den, or concentrated food source, where the target animal spends more time, a slower camera might be fine. A fast trigger speed is more important for capturing an animal such as the red fox, which usually trots, than it is for a bobcat, which usually walks at a relaxed pace.

Recovery Speed
This is the time it takes to ready the camera for the next trigger. It can be several seconds long, and it can differ for photos and videos in a given model.

Flash
If you want color nighttime images, you will need a camera with a white flash, and there are two options. A white xenon flash gives excellent nighttime illumination for color photos, but the flash cannot be on continuously, so it cannot take color videos at night. A white LED flash is not as bright, but it can be on continuously, so nighttime color videos are possible.

Some species seem spooked by white flashes and might avoid the area in the future. Others appear curious, but ignore it after they learn that it does not pose a threat. Still others seem oblivious. In the Northeast, where I've done a lot of camera trapping, coyotes are wary of them and may avoid the area. Raccoons look up as if to study the flash, giving a nice face shot, but quickly adapt and ignore it. Porcupines seem oblivious. This may vary by location. A given species may be more suspicious of the sights and sounds of "human things" where they are persecuted, and less wary where they are tolerated.

Infrared (IR) flashes are less disruptive, but they produce only black-and-white images in darkness. "Red-glow" IR flashes produce both red and infrared light, and "no-glow" IR flashes produce only infrared light. No-glow IR flashes are said to be the least disruptive, but many mammals actually can see IR light. In my personal experience some animals do notice no-glow flashes, but they are less startling than white flashes. Anecdotally, I haven't noticed much difference in disruption caused by no-glow and red-glow IR flashes, and since a red-glow flash gives brighter, clearer nighttime images, I usually prefer it over no-glow. But in a populated area where I do not want humans to notice the camera, I go with a no-glow.

Batteries and Battery Life
A discussion of factors that influence power consumption, and therefore battery life, is beyond the scope of this book. Suffice it to say that battery life estimates vary widely from camera to camera. A longer battery life can save you a lot of money, and information on battery life for many different models is available online at trailcampro.com.

Lithium batteries are a favorite of many camera trappers. They are expensive, but they provide more power than other batteries, producing a stronger flash and

therefore better nighttime images. They are not affected by cold weather and can keep the camera going for many months.

Rechargeable nickel-metal hydride (NiMH) batteries produce less power and drain more quickly than lithium batteries. They decline even more quickly when the temperature exceeds 90 degrees. For these reasons, some people have had poor results with these batteries. If you would like to use them, make sure the camera is compatible with them—many older models are not. Many newer camera models are compatible with NiMH batteries, but some people still report inconsistent results.

Alkaline batteries are the least expensive, but they, too, produce less power and drain quickly. They drain even more quickly in below-freezing conditions, and most people report very poor results with them.

Sensitivity

Most trail cameras are sensitive enough to trigger for small changes in temperature, such as that produced by waving vegetation in the sunlight. This can be problematic if the vegetation is lush. The camera may take many thousands of unwanted images of waving leaves and grasses. For this reason it is nice if the camera has a setting that allows you to turn down the sensitivity.

Many standard trail cameras (i.e., those designed to capture medium- to large-size animals) are sensitive enough to capture animals as small as mice, and possibly hummingbirds. But if you want detailed images of these tiny creatures, you will need a camera that is both highly sensitive and capable of close focus. See the chapters on these specific species for suggestions.

User Interface

An intuitive user interface allows you to quickly change settings in the field without flipping through the manual, and that can be important in an extremely cold or mosquito-infested setting. A poor user interface also increases the chance that you'll make a mistake with the settings, possibly wasting months. While this is somewhat subjective, user interface is sometimes mentioned in online reviews.

GETTING STARTED
Getting Permission

Be sure to ask the landowner for permission before deploying a trail camera on private land that does not belong to you. Before placing one on public land, check the website under permits, licenses, or regulations. Sometimes camera traps are explicitly prohibited, sometimes a special permit or hunting license is required, and sometimes there is no specific policy. In the latter case it's a good idea to ask the land manager. In my experience many say it's fine to place the cameras as long as it is understood that they are not responsible for theft or damage. On the other hand, one land manager told me that trail cameras are not permitted under their "take it in, take it out" policy, and if found by staff, they could be removed as "trash."

In general I have found that the rules regarding camera traps on town- and state-owned properties are more permissive than those on federal lands. At least some National Wildlife Refuges and National Parks prohibit camera traps unless they are part of an approved research project.

Where to Put the Camera: General Considerations

Determining good camera placement for capturing specific behaviors of a target species requires knowledge of the animal's habits and an ability to find and interpret its tracks and sign. Most of this book is dedicated to detailing that information, but the basic idea is that animals are, like people, creatures of habit. Most species have favored areas for foraging, drinking, eliminating, resting, and breeding, and use regular routes for travel. Food caches and middens, puddles and ponds, latrines and scent stations, beds and lays, burrows and dens, and trails and crossing structures are all good camera-trap targets. Also be aware that *when* the camera is deployed can be very important. Many animals use different food sources, habitats, or travel routes in different seasons. And breeding and scent marking are often seasonal, as well.

If you are a beginner, it's a good idea to start with the common species in your backyard. That way the camera will be conveniently located for you to make frequent adjustments as you get to know the camera, and the animals will be used to human activity and won't be deterred by your frequent visits to the set.

How to Set Up the Camera

Think carefully about what the camera will "see" before you station it. Make sure it will be at the proper height and distance from the target spot to capture the animal. For medium- to large-size animals, I place my standard trail cameras anywhere from five to twenty-five feet from that spot depending on the size of the animal. Obviously the camera will need to be farther away to capture the entire body of a moose than a mink. If you are using a close focus camera for small animals, check the instruction booklet to determine the optimal distance from the target spot.

Also consider the lighting. This, of course, varies over the course of the day, but if possible, it's a good idea to face the camera to the north. Sunlight shining directly into the camera—which can happen if the camera faces east, west, or south—results in poor images and sometimes causes the camera to trigger repeatedly, wasting storage space and battery charge.

If the camera is to be stationed along a trail or run, it's usually best to mount it at an angle toward the direction of travel. The sensor used in most trail cameras does not detect bodies moving directly toward it very well, but does a better job detecting animals moving directly away from it. Therefore, few face shots and many butt shots are typically captured by a camera looking straight down the trail.

To optimize lighting, face the camera to the north. To improve the chances of capturing the animal's face, direct the camera at an angle to the anticipated direction of travel.

Animal Trail

Be aware that waving vegetation can cause the camera to trigger, especially on sunny, windy days, resulting in thousands of useless photos or videos, within weeks, or even days, of operation. You might trim some vegetation to give the camera a clear view, but grasses and herbaceous plants often grow back quickly in spring and summer. Also keep in mind that trimming the vegetation might make the site less desirable to your target species, and it may be prohibited by the landowner.

Once you've determined an appropriate spot for your target species, it's time to deploy the camera. Usually a strap, bungee cord, or cable lock is used to secure a camera to a tree or post, but sometimes more creativity is required for just the right shot. I've secured them to flower pots and to "tripods" made from sticks and logs found on-site, and I've perched them on the ground,

Because there were no suitable trees for mounting this camera, sticks found on-site were used to make a tripod.

hidden under little shelters of rocks or logs. There are also trail-camera mounts for purchase that can be screwed into a tree or log and tilted and rotated to achieve the perfect angle.

Preventing Theft and Damage

Humans sometimes steal trail cameras, and bears can dislodge or damage them, as they twist, pull, and bite on them. A properly fitted security box and cable lock prevent these problems most of the time. A determined thief can return to the site with a bolt cutter, but it rarely happens, and I've never had a bear successfully damage a camera housed in a security box. That said, I sometimes don't use a security box or lock. If the camera is inexpensive, bears are uncommon, and people are unlikely to see it, I don't worry much about security.

If you decide to use a security box, be sure to purchase one that is designed for the specific model of your camera, such as those that can be purchased at camlockbox.com. Be wary of any trail-camera security box advertised as "universal" or "universal for all our models." In my experience that just means any trail camera can fit inside. It does not necessarily mean that the camera will be held firmly in place or securely contained. I once purchased a security box "universally fitted" for all of that brand's trail-camera models and found that the particular model that I had could be wiggled right out of the front window of the box.

When to Retrieve Your Trail Camera

Camera trapping is an exercise in patience and persistence. Do not expect to get amazing photos of shy or uncommon species with your first camera after a few days in the field. It can take a long time to get your target animal, depending on the species' habits and type of location you chose. For example, if the camera is set on a travel corridor of a wide-ranging, sparsely distributed species, like a cougar, it could be weeks or months before the animal returns to the site.

I check backyard cameras as often as daily, but I usually check "wilderness" cameras no more than every few weeks. I often leave them for months. Cameras at presumed nests or dens should be left alone until the animals have probably moved on.

BAITS AND LURES

Bait is any kind of food used to attract wildlife. Sardines, pet food, meat scraps, roadkill, apples, carrots, and so on can be effective, depending on the target species. A *lure* is an inedible attractant, usually something with a strong scent, such as beaver castoreum and catnip. If you are thinking of using bait or a lure, be sure to find out if it's allowed on the land you are using. If you are thinking of using roadkill, check the law in your state, for collecting it may be illegal or require a permit.

Baits and lures are especially useful when the camera can focus only within a very narrow range (such certain DSLR setups) and you want the animal to come to a specific spot. However, it's not a good way to learn about an animal's natural behavior.

So, for example, a baited camera trap in your backyard shows what animals visit when bait is available, not necessarily which species normally use your backyard.

If you decide to use bait or a lure, be mindful of possible unintended consequences. It's not a good idea to use them close to trails, backyards, or farms, where you might unwittingly draw wildlife into conflict with people, pets, livestock, or crops. Also consider the potential impact on wildlife. For example, if you use beaver castoreum to attract a fisher, might it attract a beaver far from the water, making it vulnerable to wolves?

MINIMIZING IMPACT

Avoid spending too much time near resources of special importance to the animal, for your own safety and for the welfare of the animal. No animal wants you close to its den, for example, and it might let you know that aggressively. Some animals abandon den sites after human disturbance, causing unnecessary disruption. This is not trivial. It takes time and energy for a mother to find and prepare a new den site and to relocate her young—time and energy that could have been used for feeding them. The impact on a struggling family could be deadly.

BUILDING YOUR OWN CAMERA TRAP

If you want better quality images and have the time, you might be interested in building your own camera trap by connecting a digital camera to a passive infrared sensor. The quality of the camera you use will determine the quality of the images, but they are almost always better than those taken with ready-made trail cameras. Different types of digital cameras are used, from inexpensive point-and-shoot to professional quality.

Basically, the digital camera is wired to an electronic control board that has a passive infrared sensor and can trigger the camera. The camera's own flash can be used, or one or more external flashes may be used. Batteries are needed to power the board and to provide reserve power to the digital camera's own batteries, and some kind of weatherproof housing is needed to protect the camera. If external flashes are used, batteries and protective housing will be needed for them as well.

Instructions for building a variety of "homebrew" camera traps can be found online. At some of these sites, you may be able to purchase one already made. These cameras get beautiful photos (or videos, in some cases), but they tend to be high-maintenance, mostly because the batteries do not last as long and the SD card fills up quickly with the higher quality images.

Track-and-Trail Pattern Basics

For most species, I give an overview of tracks, trails, and sign, emphasizing what is most useful for finding good spots for camera trapping. Many of the track-and-trail measurements I provide are based on my own fieldwork, but where I did not have the opportunity to take measurements from at least several different individual animals, I relied on previous publications.

I do not discuss the nuances of track morphology or trail patterns, for that level of detail isn't necessary for reasonable success in camera trapping. Of course excellent tracking skills can only improve camera-trapping results, and the interested reader should check out the tracking books listed in the Bibliography.

TRACK MORPHOLOGY AND MEASUREMENT

Given the small number of birds and reptiles in this book, a discussion of their tracks and trails beyond what is presented in the species accounts is unnecessary.

Mammal tracks are usually composed of prints of the toe pads, heel pads, and claws. Unfortunately, nomenclature is not consistent among sources. In this book, *heel pad* is synonymous with *metacarpal pad*.

Most mammals have heel pads just behind the toes, and some have additional heel pads behind those. Those additional, or posterior, heel pads often do not

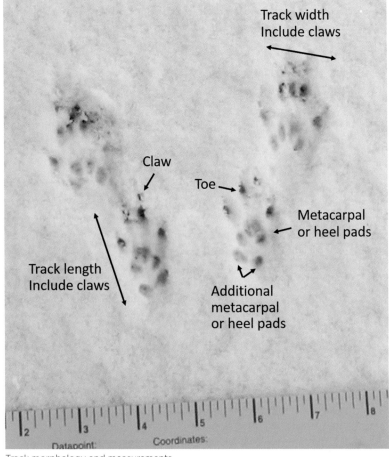

Track morphology and measurements.

register in the track, and for some species, claw marks do not register reliably. However, I include both posterior pads and claws in track measurements, if they register, to be consistent with most of the sources I've used.

Both posterior heel pads and claw marks can affect track length quite significantly, so for most species I rely much more on track *width*, and for all species I provide a range for, or an average of, track width. Track width also varies somewhat, depending on whether the toes are splayed. Where it varies dramatically, as it does for the hind tracks of rabbits and hares, I provide measurements for both splayed and unsplayed toes.

TRAIL PATTERNS

Because tracks are often unclear, it's important to learn the basic trail patterns, for they also aid in species identification. For each species I explain which trail pattern is most common and other trail patterns it may produce.

Trail parameters are given for the most common trail pattern for each species. Important measurements for most trail patterns are stride (step length)

Direction of Travel ➡											
Direct Register Walk	D	D	D	D	D	D	D	D	D		
Overstep Walk	F H	F H	F H	F H	F H	F H	F H	F H	F H		
Direct Register Trot	D	D	D	D	D	D					
Side Trot	F H	F H	F H	F H	F H	F H					
Straddle Trot	F H	F H	F H	F H	F H	F H					
Raccoon 2x2 Walk	F H	H F	F H	H F	F H	H F					
Lope	F F H	H	F F H	H	F F H	H					
2x2 Lope	D D	D D	D D	D D	D D	D D					
Gallop	F F H	H	F F H	H	F F H	H					
Hop	H F H F	H F H F	H F H F	H F H F	H F H F						
Bound	F F H H	F F H H	F F H H								

Basic trail patterns show hind tracks (H), front tracks (F), and double, or direct, registered tracks (D), where the hind foot stepped on top of the front track. All of these patterns have variations in spacing, and some have variations in track positions.

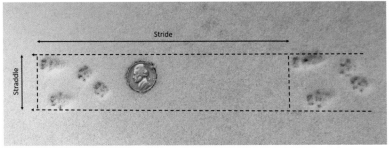

How to measure stride and straddle for a bounding trail pattern.

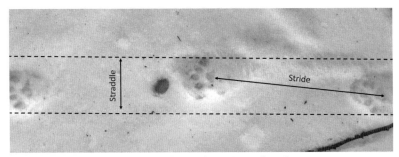

How to measure stride and straddle for an alternating-walk trail pattern.

and straddle (trail width), and they are measured as depicted in the examples shown above.

Trail parameters can be helpful, but it's also important to open your eyes to associated sign, behavior, and habitat, rather than get hung up on numbers. Do not miss the forest for the trees. Often these other facts help you distinguish among species that create similar tracks and trail patterns, and familiarity with them is more important because they are helpful in determining camera placement.

1

VIRGINIA OPOSSUM

Order Didelphimorphia / Family Didelphidae

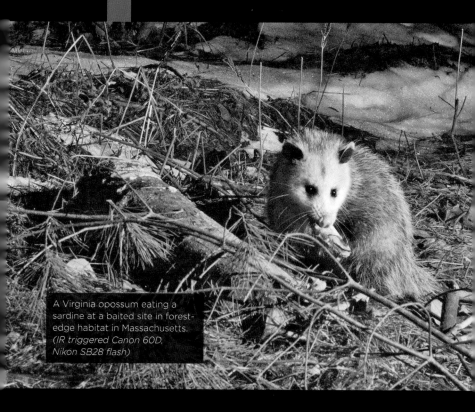

A Virginia opossum eating a sardine at a baited site in forest-edge habitat in Massachusetts. *(IR triggered Canon 60D, Nikon SB28 flash)*

THE VIRGINIA OPOSSUM (*Didelphis virginiana*) is the only marsupial in the United States. It evolved in South America and continues to expand its range northward into Canada. In the southeastern United States, its meat was once favorite fare, but in recent years its reputation has declined to that of a pest. This is undeserved, for its impact on small livestock is minimal, and it limits the spread of Lyme disease by killing most of the ticks that attach to it.

Physical Characteristics

An adult usually weighs 6 to 10 pounds. The body is white to pale gray with darker guard hairs and has a long, naked, prehensile tail. The animal's conical head has a pointed snout and is white to pale gray, with a darker gray "widow's peak" of guard hairs on the forehead. Its roundish, naked ears are black with white at tips.

Tracks and Trails

The front feet have 5 toes, all with short claws, and 6 heel pads. Claws often register. All 6 heel pads usually register, but the posterior 2 are sometimes obscured by overstepping hind track. Toes splay widely, giving track a star-like appearance. An adult's front track is about 2 inches wide.

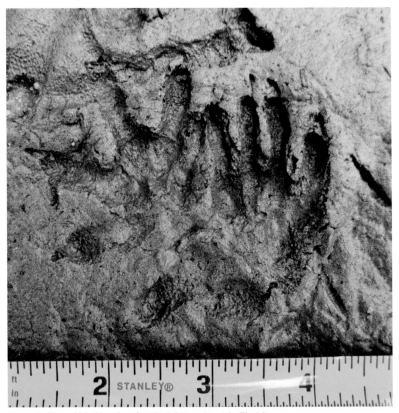

Front (left) and hind tracks of a Virginia opossum in Florida.

Hind feet look like tiny human hands, with 4 clawed "fingers," an un-clawed opposable "thumb," and 6 heel pads. Claws and heel pads usually register. An adult's hind tracks are about 2 inches wide.

Opossums often trot, with a step length of about 12 inches and trail width of up to 4 inches. They sometimes walk, and they climb frequently, though somewhat clumsily.

Diet

This true omnivore eats earthworms, insects, other invertebrates, grasses, forbs, tubers, nuts, fruits, berries, bird eggs and nestlings, amphibians, reptiles (including some poisonous snakes), small mammals, carrions, and maggots infesting carrion. In wilderness areas, it forages along streams and in swamps; in suburban and urban areas, it forages in human sources of food.

Scat and Urine

I have not encountered opossum scat or urine in the field, but scat appearance is said to be highly variable, given the animal's variable diet.

Habitat

The opossum is a habitat generalist, but historically it had a preference for mixed forest near a water source, especially where exposed roots along streams provide natural den sites. This is still true in some wilderness areas. However, it has adapted well to suburban and urban areas, where it thrives, sometimes to the exclusion of more "natural" areas. Opossums like cover and avoid wide-open grasslands and agricultural fields, but frequent forest-field edges.

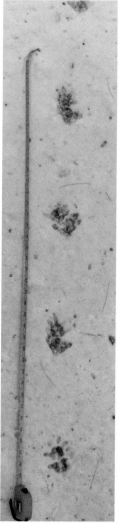

A Virginia opossum's trotting pattern found in Massachusetts.

Breeding

The breeding season is from late winter through summer, with a peak in February and another in June. Most females in the north bear one litter, and most in the south bear two. After a 2-week gestation, 1 to 13 tiny young are born. They crawl to the nipples in her pouch, where they spend most of the next 2 months. At 6 weeks, the nipples elongate, allowing the young to venture out of the pouch. At 8 to 10 weeks, young can detach from the nipples, and the mother begins to forage on her own. The young wean at about 14 weeks and begin foraging for themselves,

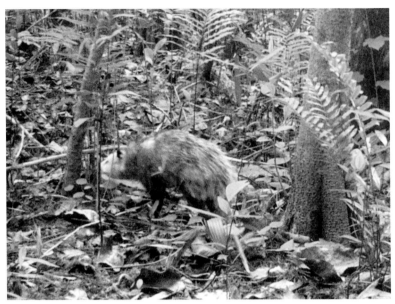

A Virginia opossum in a cypress swamp of South Florida. *(Exodus Lift)*

but they remain in the weaning area, gradually expanding their range until they disperse in winter.

Camera-Trapping Tips

This is one species that can usually be camera trapped even in urban areas. If compost, garbage, pet food, birdseed, or suet is accessible, an opossum will probably pay you a visit. It might use your yard intensively for a few days or weeks before wandering on to the next neighborhood, for opossums are nomadic and do not maintain territories.

In cities and suburbs most opossum denning and resting sites are in or under human-made structures, such as culverts, attics, decks, sheds, and scrap piles. In undeveloped areas opossums use ground burrows excavated by other animals, such as woodchucks, skunks, and muskrats, for opossums do not dig their own dens. They also use tree cavities, hollow logs, rock crevices, and vine tangles.

In fall and winter opossums sometimes line their dens with leaf litter and other debris, gathering it in an interesting way. With the snout and feet, the animal pushes it under the body, toward the prehensile tail, which wraps around the material. It then carries the material wrapped in the tail to the den.

In most studies opossums weigh more and have smaller home ranges in cities and suburbs, suggesting that they do better there than in the wilderness. In the Northeast I find their tracks and catch them on camera more often in backyards than in remote areas. In fact, the opossum is the only mammal that I've captured in the suburbs of Massachusetts but not in the Quabbin Reservoir area, which

features extensive wetlands and many miles of streams in mixed forest, a type of landscape that has historically appealed to opossums.

In other areas opossums still thrive in the wilderness. In the swampy, mixed forests of the Fakahatchee Strand Preserve of Florida, their tracks are abundant and they regularly show up on camera, despite the patrolling panthers and alligators and lack of human sources of food and shelter. Most photos are captured at night, for opossums are largely nocturnal, whether living in developed or more "natural" areas.

As nomadic creatures, opossums move erratically and do not create runs, but wherever they are they prefer to move near or under cover. In fact, fur trappers of the early 1950s reported success in trapping opossums along stone walls and fence rows, and in the modern landscape they frequently travel through culverts. Any of these areas could be good camera targets.

Regardless of whether you are camera trapping in a developed or more natural environment, many interesting opossum behaviors relate to breeding. Scent marking reaches its height during the breeding season. Opossums rub their heads on trees, saplings, and other objects, leaving scent from facial glands. These sites may be used repeatedly by multiple animals, which makes them good trail-camera targets. Both sexes mark, but males do so more vigorously.

As a marsupial, the female opossum's denning needs differ from those of most other mammals, which use a natal den for birthing and tending to infants. For the first two months after giving birth, the mother's pouch essentially *is* the den. Her young are attached to her nipples, and they travel with her everywhere as she

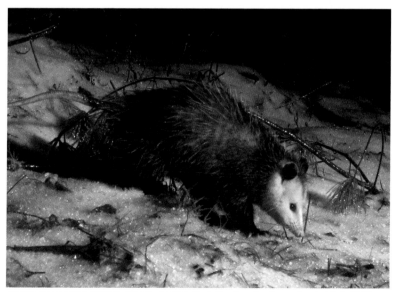

An opossum checking the site of an old bait station in suburban edge habitat. *(PIR triggered Canon 60D with Nikon SB28 external flash)*

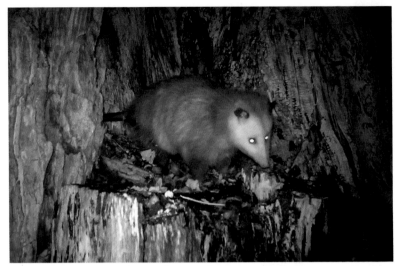

The nomadic opossum rarely uses the same den for more than a few consecutive days. This animal, in Massachusetts, napped in this tree crotch three nights in a row before moving on. *(Reconyx Ultrafire)*

continues her nomadic lifestyle, wandering and varying her resting sites, just as males and barren females do.

When her young detach from her nipples and begin to explore beyond the pouch, she chooses a "weaning den" with good cover in good foraging habitat. In natural areas the weaning den is usually a ground burrow with shrubby, brushy cover. In cities and suburbs she chooses a private spot, often under a structure, and usually near some kind of vegetative cover. Though she does not excavate her weaning den, she does add nesting material. During the weaning period young begin to forage on their own, but still sometimes travel with mother, riding on her back. A weaning den would be an outstanding trail-camera target.

Opossums have some interesting behaviors that are not associated with breeding. "Playing possum" is a well-known defense reaction in which the opossum passes out due to extreme fear. It falls on its side, eyes and mouth open, and often defecates and discharges a smelly green substance from its anal glands. Another is the "fighting dance," a display that ends in either a retreat of the submissive individual or a fight to injury or death of one of them. The animals stand face-to-face, swaying head and shoulders from side to side, with mouth open and ears flattened. Catching these behaviors on a trail camera would be like winning the lottery, but perhaps the odds are best at a large food source, such as a carcass, which could attract more than one opossum.

Opossums readily scavenge carcasses and come to many types of human food sources. This means that one may come to a camera trap baited with almost anything. Fish oil, sardines, chicken heads, crayfish, honey, corn, canned dog food, and apples have been used to attract them.

2 EASTERN COTTONTAIL

Order Lagomorpha / Family Leporidae

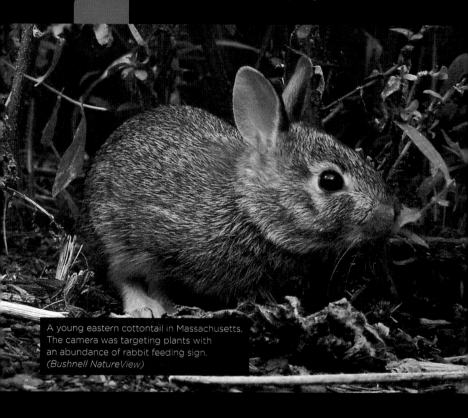

A young eastern cottontail in Massachusetts. The camera was targeting plants with an abundance of rabbit feeding sign. *(Bushnell NatureView)*

AS THE MOST WIDELY DISTRIBUTED RABBIT in North America, the eastern cottontail, *Sylvilagus floridanus*, owes its success to its superior vision, allowing for early predator detection. For this reason it can safely venture away from cover to access choice forage, and perhaps to colonize new areas.

Physical Characteristics

An adult reaches about 2½ pounds. It is rusty grizzled with black, and its sides are paler than the back. The nape is orange, the belly is white, the legs are orange, the feet are whitish to pale orange, and the tail is gray brown above and white below. The approximately 3-inch-long ears (longer in the South, shorter in the North) are edged white and tipped black. The eastern cottontail has a cream eye-ring, and it may

have a black or a white spot on the forehead, or no spot at all.

Tracks and Trails

The pointy appearance of both front and hind tracks, blurring of the heel pads (due to heavily furred feet), and a characteristic bounding pattern are the key diagnostic features of cottontail tracks. They are very similar to snowshoe hare tracks, but they are usually smaller.

The front tracks, measuring ¾ to 1¼ inches wide, typically have 4 toes prints, and sometimes claw marks. An additional, vestigial toe usually does not register. Hind tracks have 4 toes and sometimes claw marks and do not exceed 3¾ inches in length. Unsplayed hind tracks rarely exceed 1¼ inches in width. However, when toes splay in deep, soft substrate, hind tracks may reach 2½ inches in width, and the leading edge is rounded.

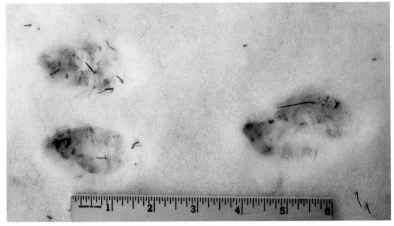

These unsplayed tracks of eastern cottontail in Massachusetts show the characteristic pointy leading edge. In this single group within a bounding pattern, the hind tracks are at left, and the animal is moving from right to left.

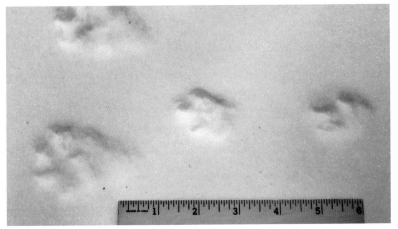

A single group of splayed eastern cottontail tracks within a bounding pattern in Massachusetts. Note the rounded leading edge. Hind tracks are on the left, and the animal is moving right to left.

Cottontails usually move in a bounding pattern with the front feet typically landing one in front of the other. The stride can vary from 5 to 32 inches, and the straddle from 2¼ to 6¼ inches.

Diet

During the warmer months, these herbivores consume a wide variety of grasses, sedges, and forbs, including clover, bluegrass, wild rye, crabgrass, alfalfa, timothy, ragweed, goldenrods, asters, plantains, chickweed, dandelion, and more. They also enjoy garden crops. When grasses and herbs are covered with snow, cottontails eat buds, small twigs, and the cambium (inner, living bark) of deciduous shrubs and young trees, especially raspberry, blackberry, apple, oak, hawthorn, blueberry, dogwood, birch, maple, and sumac. They sometimes browse lightly on white pine and hemlock. Cottontails reingest their pellets after the first pass through the intestinal tract to digest them more completely.

Scat and Urine

Cottontail pellets are usually ¼- to ½-inch diameter dry, discrete spheres or slightly flattened spheres. The animal also excretes moist, clumped cecal pellets that are usually reingested directly from the anus for further digestion.

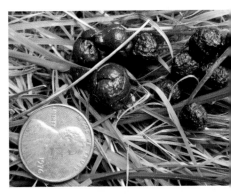

Moist, clumped cecal pellets and dry fecal pellets of eastern cottontail in Massachusetts.

When lush greenery is abundant, however, they may leave many of their cecal pellets behind. Cottontails do not use latrines; one to several pellets are dropped at a time. However, runs may be heavily littered with scat and urine. The urine is orange-brown to orange-red.

Habitat
Eastern cottontails are most common where there is a mosaic of grassy fields and dense shrubby cover with an abundance and diversity of grasses, sedges, forbs, and deciduous shrubs and young trees. They also inhabit marshes and swamps, but avoid dense forests. They don't do well in grass monocultures of manicured suburbs, but can thrive in less formal neighborhoods with weedy patches and brushy edges, where they may habituate to people and loaf openly on lawns. Home range is usually several acres in size, but varies with habitat quality. Eastern cottontails are not territorial and may congregate in excellent habitat.

Breeding
Breeding is nearly year-round in the South, and runs from March through September in the North, where females have fewer but larger litters. After a 28-day gestation, 3 to 6 naked, blind, and helpless young are born in a small depression or cavity in the ground. The female alone raises them. The mother may mate immediately after giving birth, resulting in monthly litters. Young are weaned at 3 weeks, at which point they are independent.

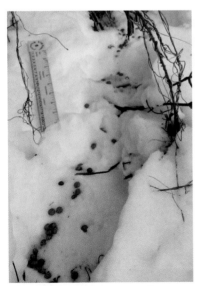

A heavily used eastern cottontail run littered with scat in Massachusetts. Note the orange urine stain above center.

Camera-Trapping Tips
A tendency to cluster in areas of excellent habitat and year-round activity make eastern cottontails a fairly easy subject. In snow their regular use of runs makes them even easier to find and photograph. Look for runs littered with scat and urine spots, leading from dense cover to favored feeding areas.

Winter cover may be dense shrubbery, a brush pile, the base of a hollow tree, or a cavity under a rock. Eastern cottontails sometimes use abandoned burrows of other animals, such as woodchucks, but they do not dig extensive burrows. They do, however, create short tunnels through snow to reach a shelter, such as a brush pile. Winter feeding sign is found on trees and shrubs. Cottontails nip twigs with

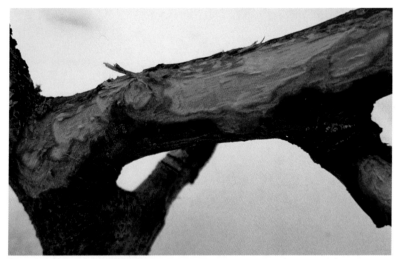

Eastern cottontail debarking sign on a pruned apple tree branch in Massachusetts. Note that the animal has gnawed more deeply than necessary to reach the cambium.

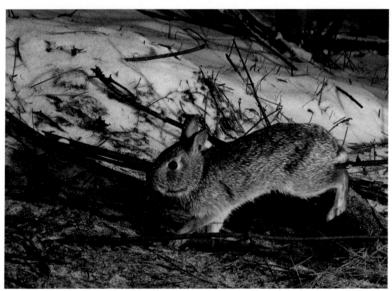

An eastern cottontail in Massachusetts. Notice the feeding sign on the twig behind it. *(IR triggered Canon 60D, 2 Nikon SB 28 flashes)*

their incisors, leaving a clean, angled cut, and it's no higher than the animal can reach by standing on its hind legs. Deer, on the other hand, leave ragged edges and can reach much higher. Cottontails debark young woody stems to feed on the cambium, but often gnaw much more deeply than the cambium. Deeper gnawing into the wood distinguishes cottontail from vole sign.

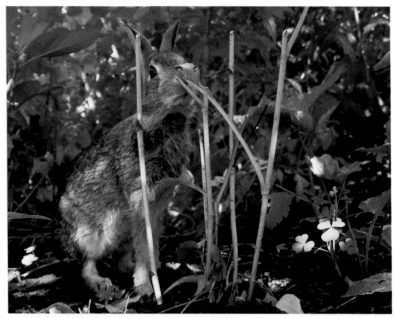

An eastern cottontail and the feeding sign it left on *Echinacea* in Massachusetts. Note the clean, angled cuts on the stems. *(Bushnell NatureView)*

Look for predator tracks around rabbit haunts in winter, for cottontails are favorite fare for bobcats, coyotes, foxes, weasels, and fishers. In Massachusetts, for example, eastern cottontails thrive at the edges of apple orchards and throughout the orchards at piles of pruned apple tree branches, which provide excellent food and cover. In turn, bobcats and coyotes relentlessly patrol the brush piles and orchard edges for cottontails. Weasels live and hunt in the piles, and fishers hunt forest edges that border orchards. Trail cameras in these locations may capture both prey and predator.

In warm weather abundant greenery gives cottontails many more options for food and cover. Their movements are more varied, and they don't create well-defined runs. Feeding sign on grasses and leaves is subtle, but it's obvious on stems of herbaceous plants, which bear the characteristic clean, angled cut. Shallow depressions, called "forms," where an animal rests can be found in clumps of green vegetation or under shrubs. In greenery, a form appears as a trampled oval about 8 inches long. On bare soil it may be used for dust bathing as well as resting, in which case it can measure more than 12 inches long. Forms may be used for days or weeks and make good camera-trap targets.

During the warmer months the courtship behaviors of eastern cottontails are interesting to observe, but difficult to capture with a trail camera, because they involve a lot of running and jumping over a wide area. Try aiming the camera into a field, along the field edge, or at a bottleneck connecting habitat elements.

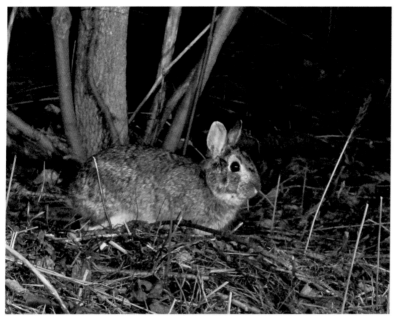

An eastern cottontail in its form under a shrub in Massachusetts.

An eastern cottontail form under a hazelnut bush in Massachusetts. This one was probably also used for dust bathing.

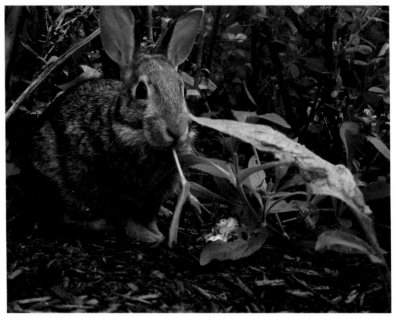
Cottontails sometimes eat soft stems like spaghetti. *(Bushnell NatureView)*

During the few days before a female's single hour of estrus, males begin chasing her, and a dominant male claims and guards her. She is aggressive at first, but as estrus approaches, she becomes increasingly submissive and the males become increasingly excited. If a male fails to back off when she is not ready to mate, she may crouch and look up at him, attempting to stare him down. If he persists, she may charge him, kick him, or even pin him down and bite him. Sometimes when the male chases or the female charges, the other rabbit leaps straight up as the aggressor runs beneath.

Prior to giving birth, the mother finds an existing cavity or abandoned burrow—or digs a small, slanted depression—several inches wide and deep. She lines it with vegetation and then with her own fur. Natal dens are often well hidden under the cover of shrubs or tall grasses or herbs, but occasionally they are in the open and rather obvious. I once found one in my lawn. The approximately 4-inch-wide hole was covered by a loose flap of grass, and I watched the mother come to unearth and nurse her young around dusk. She spent only several minutes with them before hopping away, young still attached. While she was in the air, they detached and tumbled to the ground.

3 SNOWSHOE HARE

Order Lagomorpha / Family Leporidae

A snowshoe hare in its white winter coat in northern Maine. *(Moultrie)*

WHITE WINTER PELAGE and low foot loading make the snowshoe hare, *Lepus americanus*, well adapted to northern latitudes. In Canada and Alaska an 8- to 11-year population cycle is well recognized, but in the contiguous United States, the snowshoe hare exists at low density and fluctuates irregularly. It is a critically important prey species for the Canada lynx.

Physical Characteristics

Adults average about 3 pounds, and females are 10 to 25 percent larger than males. In summer the upper parts are brown, the belly and chin are cream, the short tail is brown above and grayish white below, and the ears are brown with black tips. The eye-rings, cheeks, and sides are orange brown. The winter coat is entirely white except for black ear tips. The hind feet are very long and heavily furred underneath. Rare individuals in the Adirondacks of New York are black year-round.

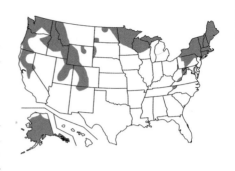

Tracks and Trails

Compared to cottontail tracks, snowshoe hare tracks are larger, and the leading edge of the hind track is less pointy, even when toes are not splayed.

Front tracks are 1⅛ to 2¼ inches wide. Usually 4 toes register, but often appear indistinct, and occasionally vestigial toe #1 registers. Hind tracks have 4 toes and

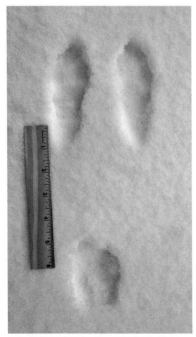

These snowshoe hare tracks in shallow snow in New York are not splayed.

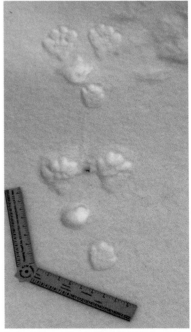

Splayed snowshoe hare tracks in typical bounding pattern in Maine.

measure 3 ¼ to 6 inches in length. Unsplayed hind tracks are 1 ½ to 2 inches wide, but when toes are splayed, track width may reach 5 inches.

Snowshoe hares usually move in a bounding pattern, with the front feet usually landing one in front of the other. The stride can vary from 8 to 72 inches and the straddle from 3 ¾ to 10 inches.

Diet

In summer, snowshoe hares eat grasses, sedges, forbs, ferns, and birch and willow leaves. Clover, lupine, dandelion, and jewelweed are some summer favorites. In winter they subsist on buds, twigs, evergreen needles, and cambium. Favored trees and shrubs include blueberry, raspberry, huckleberry, cranberry, hazel, willow, aspen, birch, alder, maple, fir, spruce, larch, pine, and hemlock. Twigs up to about ½ inch in diameter may be browsed. While snowshoe hares are more likely than eastern cottontails to feed on conifers, both species prefer deciduous browse when available. Snowshoe hares reingest their pellets after the first pass through the intestinal tract to digest them more completely. Occasionally they eat carrion.

Scat and Urine

Snowshoe hares excrete pellets, usually ⅜- to ⁹⁄₁₆-inch diameter spheres or some-what flattened spheres. On average, these are slightly larger than eastern cotton-tail pellets, but the overlap makes size an unreliable way to distinguish between the two species. Hares drop pellets wherever they happen to be, and they may accumulate where an animal has spent time. Urine is orange to reddish orange.

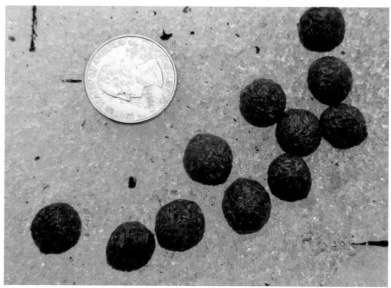

Snowshoe hare scat in Maine.

Habitat

Ideal habitat in most areas consists of dense thicket and 20- to 25-year-old forest. Cover is thought to be the dominant factor in habitat choice, with a preference for conifers in winter and deciduous cover in summer. Alder fens, upland-alder edges, and conifer bogs are preferred habitats. Open fields are avoided, though small forest openings are used. Home range size averages about 13 to 17 acres, but there may be extensive overlap among individuals, with density reaching one animal per acre in the southern portion of the range.

Breeding

Breeds two to four times a year, March through September. Females in the North have fewer but larger litters. The female alone raises young. After a 37- to 38-day gestation, she gives birth in a small depression in the ground, to 2 to 13 precocial young, fully furred and with eyes open. Young hares depend on their own speed and camouflage, for the mother does not defend them. They are weaned at 1 month, at which time some may disperse, while others linger in their mother's habitat for several months.

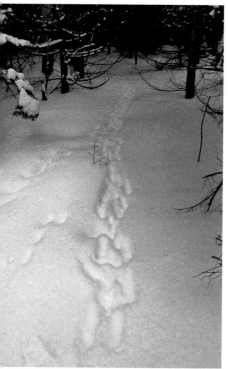

A snowshoe hare run after a snowfall within the past twenty-four hours in New York.

Camera-Trapping Tips

Snow tracking is the easiest way to find this secretive, well-camouflaged creature of northern and high-elevation forests. Like cottontails, snowshoe hares create runs, but it's rare to find deeply worn hare runs abundantly littered with scat and urine. This is because the heavier and more frequent snowfall in the hare's range covers the runs before they accumulate a lot of sign. But hares use runs regularly enough so that you can often see some evidence of use between storms. Look for feeding sign along the animal's trail to confirm that it is a well-used run. Hares leave the same kind of feeding sign as cottontails: clean angled cuts on twigs and debarking with deep gnawing.

Though snowshoe hares spend a lot of time in dense cover, they do sometimes venture into small forest openings for choice forage. In northern Maine, I found that such openings

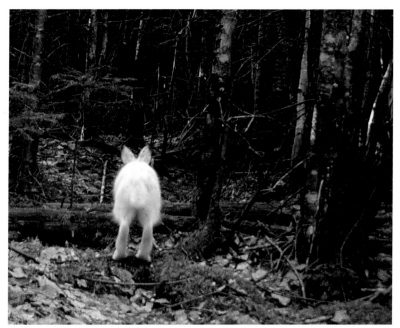

In mid-April in Maine, this snowshoe hare has not even begun to molt, and it is vulnerable to predation in the snow-free landscape. However, late molters have a survival advantage during spring snowstorms. *(Moultrie)*

within young spruce-fir forest are excellent for camera trapping the hare, not to mention one of its principle predators, the lynx.

Snowshoe hares are most active around dawn and dusk and spend much of the remainder of the day resting in forms, small depressions in the ground, located at the base of a shrub, or under a conifer branch, brush pile, or log. A hare may have several forms and use them repeatedly, but forms are not shared among hares. Scat may accumulate in the form.

An abundance of hare sign is often associated with predator sign, for the hare is a favorite prey species. In northern Maine, finding sign of hare is a good first step toward finding sign of lynx, a specialized predator largely dependent on hares. In the Adirondacks of New York, marten tracks are often associated with snowshoe hare tracks, but the marten is far less particular than the lynx about its prey, and there are other places better than hare haunts for capturing marten.

When winter gives way to spring, hares in Maine seem to make greater use of alder thickets and forest-alder edges. A brown summer coat replaces the white coat, and courtship commences. Snowshoe hare breeding behavior, like cottontail courtship, involves chasing and jumping.

It may be possible to capture family activity with a camera stationed at a snowshoe hare form in spring, for females sometimes give birth in one of their forms. No nest is prepared, and young may be born in some other sheltered location, if

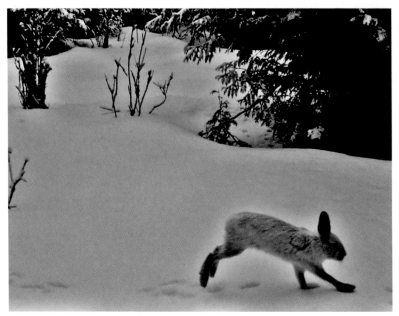

The snowshoe hare's large feet allow it to run over deep, soft snow while sinking minimally. *(Exodus Lift)*

not in the mother's form. Littermates may huddle for warmth, quickly scattering to separate hiding places if disturbed and reassembling within a few hours. Sometimes, perhaps during warmer weather, littermates move on to their own hiding places within a few days after birth. They come together with the mother only once a day after sunset to nurse for several minutes.

Like cottontails, snowshoe hares dust bathe. It is thought that dusting spots are used indiscriminately by multiple hares and perhaps other mammals and birds.

4 EASTERN GRAY SQUIRREL

Order Rodentia / Family Sciuridae

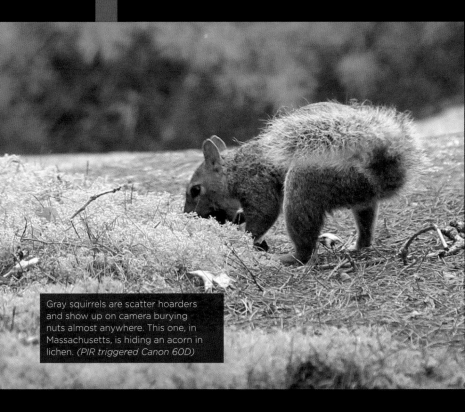

Gray squirrels are scatter hoarders and show up on camera burying nuts almost anywhere. This one, in Massachusetts, is hiding an acorn in lichen. *(PIR triggered Canon 60D)*

ACTIVE BY DAY THROUGHOUT THE YEAR, and common in suburbs and urban parks, the eastern gray squirrel, *Sciurus carolinensis*, is one of the most recognized mammals in the United States.

Physical Characteristics

Eastern gray squirrels usually weigh ¾ to 1½ pounds. They are usually gray with a light-brown wash on the upper back and head, a white eye-ring, and gray to rusty brown ears. The belly is usually white, and occasionally rusty. The fluffy tail is yellow orange at the center, mixed with black and edged with white. Southeastern animals are smaller and browner. These creatures are occasionally melanistic, especially in the North.

Tracks and Trails

Front tracks, measuring ¾ to 1⅛ inches wide, show 4 toes in a classic rodent "1-2-1" pattern, with the 2 central toes pointing forward and the 2 lateral toes pointing out to the sides. There is a 5th vestigial toe, which usually does not register. Hind tracks, measuring 1 to 1½ inches wide, have 5 toes, which register well, in the classic "1-3-1" pattern, with 3 central toes pointing forward and the lateral toes pointing out to the sides. Nails of both front and hind usually register in good substrate. Tracks of southeastern animals may be slightly smaller.

Gray squirrels bound over longer distances, but they are slow to a walk upon reaching a destination, such as a cache. Their bounding stride is 6 to 30 inches, and their straddle is 3¾ to 6 inches.

Diet

Gray squirrels are omnivorous, but nuts are essential for their survival. They eat acorns, hazelnuts, hickory nuts, pecans, beechnuts, walnuts, seeds, fruit, berries, buds, flowers, fungi, insects, larvae, bird eggs, young birds, and occasionally small mammals and carrion. Gray squirrels also raid bird feeders for sunflower seed, corn, peanuts, and suet. In winter they may strip

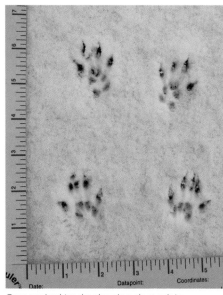

Gray squirrel tracks showing clear prints of toes, claws, and metacarpal pads. The front tracks (above) are ahead of the hind tracks, indicating that the animal is either standing still or hopping. Squirrels usually bound, with hind feet landing ahead of the front feet.

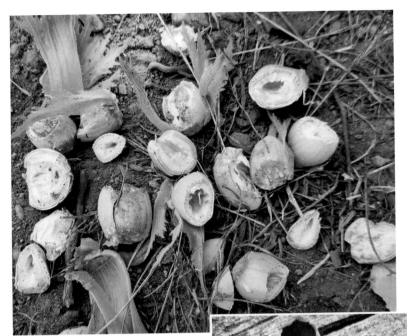

I watched a gray squirrel in Massachusetts eat these green hazelnuts. It opened most of them from the pointed end after peeling off the husk and let many fragments drop uneaten. This "wasteful" behavior is typical of gray squirrels when food is abundant.

young bark from trees to feed on the cambium. They store acorns and other nuts for winter consumption, burying each one in a different spot, just below the soil surface.

Scat and Urine

Scats are about ⅛- to ⅜-inch-long pellets, left wherever the animal has been feeding. They are easiest to find on snow, beneath a squirrel feeding in a tree above. The warm pellets may melt the snow and absorb water and may appear as swollen pellets or splats.

Hickory nut shell fragments left by a gray squirrel in Massachusetts. Gray squirrels often leave a mix of small and large irregularly shaped shell fragments. Red squirrels leave larger fragments. Flying squirrels, on the other hand, create a large, neat, roundish hole and leave the rest of the shell intact. Mice make small, sometimes multiple, holes in the shell.

Habitat

Gray squirrels prefer hardwood and mixed forests with an abundance and diversity of nut-producing trees, as well as cavity trees and snags for nesting. They also thrive in suburbs and urban parks, as long as mast producing hardwoods are present. Population density is usually about 1 animal per acre, but can be much higher, especially where squirrels have access to birdseed or other foods supplied by humans.

Breeding

There are usually one or two litters per year. Breeding has been observed in all months of the year, with a nadir in fall, a small peak in winter, and a larger peak in late spring through mid-summer. Most females breed sometime in May through July, depending on latitude, and up to a third of them also breed in winter, if the mast crop the previous fall was good. After a 45-day gestation, 2 to 4 young are born. The female alone cares for young. They are weaned around 10 weeks, at which point they are capable of independence, but some stay with the mother until her next litter arrives.

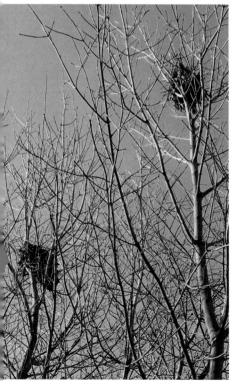

A pair of gray squirrel dreys in Rhode Island. *Photo by Anne Marie Meegan*

Camera-Trapping Tips

If you place a trail camera in an eastern forest, suburban neighborhood, or urban park with nut-producing trees, you are likely to get many images of this abundant species, whether you want them or not. That's a good reason to learn about their interesting behaviors. Better to appreciate their place in the intricate web of life, rather than bemoan them as battery-draining pests. At least they are diurnal, so you can get nice color photos.

Nest-building behavior is commonly seen. Gray squirrels construct leaf nests, or dreys, usually in large trees. Dreys need maintenance in all seasons, so squirrels often are seen harvesting or carrying leaves or shredded bark.

While leaf nests are often used for both sleeping and raising young in warm weather, cavities are preferred in cold weather. The entry hole must be at least 2 inches in diameter, and it's usually in a tree trunk or large branch

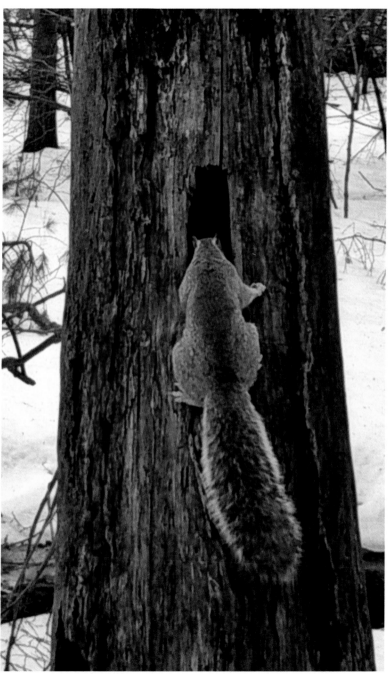

A camera trap targeting a tree cavity is likely to capture a nosey gray squirrel like this one in Massachusetts. *(Exodus Lift)*

A gray squirrel captured on camera-trap video in Massachusetts appeared to be gnawing, licking, and cheek rubbing this sugar maple branch, which may be used for both marking and tapping.

Gray squirrels chew vertical stripes on the trunks of large trees with rough, furrowed bark, like this hemlock in Massachusetts. It is presumably for communication purposes.

25 to 40 feet off the ground. I've found that gray squirrels often investigate cavities, even those just a few feet off the ground. Perhaps they are looking to raid the caches of other rodents or the nests of birds or rodents.

Like many other mammals, gray squirrels engage in marking behavior, presumably to communicate with other individuals about sexual status, diet, health, and such. It does not, however, communicate territorial ownership, for gray squirrels tolerate extensive home-range overlap with other gray squirrels, and several individuals may share a cavity or drey for warmth in winter. They chew and rub their cheek glands on branches and other protrusions along their travel routes, create vertical stripes by

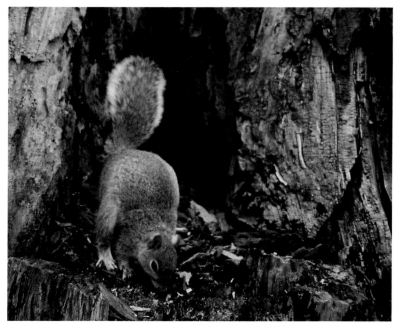

A red squirrel defends a cache of hickory nuts in this large cavity in Massachusetts, but when he is otherwise occupied, this gray squirrel raids the cache. *(Bushnell NatureView)*

chewing and rubbing on the trunks of large trees, and roll on moss patches, leaving scent behind.

However, scent marking isn't the only reason gray squirrels chew on trees. They also bite trees to feed on the cambium and to harvest sap. Feeding on the cambium is usually done in winter, and tapping is usually done in late winter and early spring. Trail-camera videos can help distinguish between feeding and marking behavior, but sometimes the squirrel appears to be doing both. Gray squirrels may also peel off loose strips of bark to use as nest material.

Squirrels also communicate with visual displays and vocalizations. Visual displays are largely accomplished with the tail: Flicking indicates alarm, shivering conveys anxiety, piloerection warns of aggression, and side-to-side waving offers friendship. Vocalizations may be appreciated if the audio recording capability of the camera is excellent. Squirrels *kuk*, *buzz*, *quaa*, moan, and shriek to convey various levels of distress or fear, and these are often accompanied by tail movements indicating the same emotion.

Gray squirrels must communicate not just with each other, but also with other species. The larger fox squirrel, which competes for the same foods, is dominant. Even the smaller red squirrel is dominant over the gray squirrel. As a larder hoarder, the red squirrel must aggressively protect its large food caches, and the gray squirrel does try to raid them.

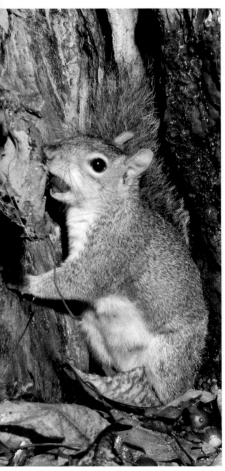
A gray squirrel making off with an acorn. *(PIR triggered Canon 60D, Nikon SB28 flash)*

The gray squirrel does not need to be so aggressive, for it is a scatter hoarder, storing one nut at a time in many different locations throughout its home range. However, I've gotten several video clips of a gray squirrel driving away an eastern chipmunk. The smaller animal seems to follow the larger one, hoping to steal its cache. In one clip, a gray squirrel buried a nut, and moments later a chipmunk dug it up and ate it.

Sometimes gray squirrels "pretend" to cache a nut before carrying it to a new location for actual caching. Whether they do this specifically when they think a potential thief is watching is unclear, but it's something to think about when reviewing videos of gray squirrel caching behavior.

Breeding behavior is also often seen and captured by trail cameras. There are four phases. First, up to several males follow a female for 20-minute periods, during the several days before she enters estrus. She usually stays several feet ahead of them, but when she is ready, she allows the dominant male to mount her. It might seem like an unlikely moment to capture on a trail camera, but with an animal as common as the gray squirrel, it's not that unusual.

5

RED SQUIRREL

Order Rodentia / Family Sciuridae

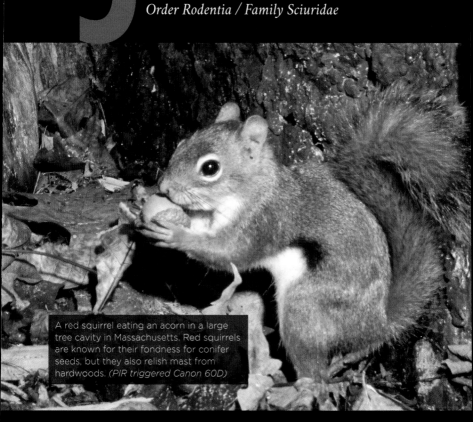

A red squirrel eating an acorn in a large tree cavity in Massachusetts. Red squirrels are known for their fondness for conifer seeds, but they also relish mast from hardwoods. *(PIR triggered Canon 60D)*

THE RED SQUIRREL, *Tamiasciurus hudsonicus*, is a small, noisy tree squirrel that inhabits forests and backyards where conifers are present.

Physical Characteristics

The red squirrel weighs about 6 ounces. It has a deep-orange upper back, belly, and feet; brownish sides; a white eye-ring; and, in summer, a black lateral line on its lower sides. The tail is orange above and grizzled black and yellow on the sides and undersides.

Tracks and Trails

Front tracks are about ½ to 1 inch wide and show 4 toes in the classic rodent 1-2-1 pattern, with 2 central toes pointing forward and 2 lateral toes pointing out to the sides. A 5th vestigial toe does not register. Hind tracks measure about ⅝ to 1⅛ inches wide and show 5 toes in the classic rodent 1-3-1 pattern, with 3 central toes pointing forward and 2 lateral toes pointing out to the sides. Nails usually register in good substrate.

Red squirrels bound over longer distances, but they slow to a walk for careful exploration and tunnel through deep, soft snow. Their bounding stride is 4 to 25 inches, and their straddle is 2⅞ to 4⅜ inches.

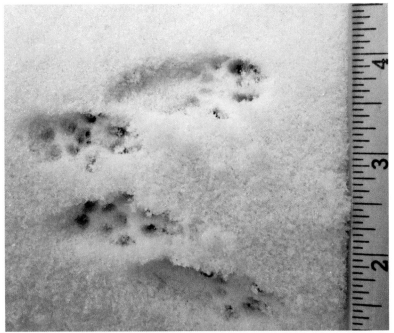

A single group of red squirrel tracks from a bounding trail in Maine. The hind tracks are the larger ones at right, and the animal is traveling to the right.

Red squirrel tracks in a bounding pattern in Maine. The animal is traveling from bottom to top in the photo. Usually the hind tracks are ahead of the front tracks, as in the first group.

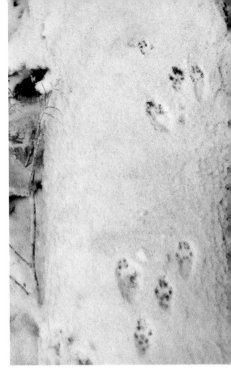

Diet

Red squirrels are omnivorous, but conifer seeds are an important part of their diet. The eat seeds of spruce, fir, pine, and hemlock, as well as acorns, hickory nuts, hazelnuts, black walnuts, maple seeds, beechnuts, fungi, buds, fruit, berries, tree sap, bird eggs, young birds, and occasionally small mammals and carrion. Red squirrels also take sunflower seeds, peanuts, and suet at bird feeders.

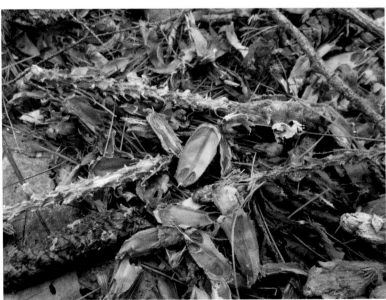

This debris left by a feeding red squirrel was part of a large accumulation under a white pine in Massachusetts. Note that the seeds have been harvested from the base of the scales, and the spines have been neatly stripped. Chipmunks feed on pine cones in similar fashion, but do not cut the scales as close to the spine, leaving a rougher, messier appearance.

Scat and Urine

Scats are ³⁄₁₆- to ⁷⁄₁₆-inch-long pellets. They are easiest to find on snow, beneath a feeding perch in a tree. The warm pellets may melt the snow and absorb water and appear as swollen pellets or splats.

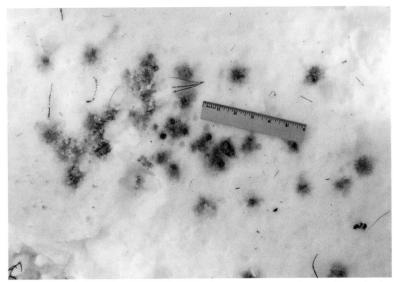

Scat splats under a branch where a red squirrel perches in Massachusetts. The animal probably excreted pellets, but their warmth melted the snow around them.

Habitat

Red squirrels prefer mature coniferous and mixed forests with plenty of cavity trees and snags for nesting and caching. They do well in suburbs and urban parks, as long as conifers are present. Population density in good habitat is about 1 animal per acre, when seed and nut crops are good.

Breeding

There is usually 1 litter in the North and 2 in the South. After a 33-day gestation, an average of 3 to 5 young are born in spring or summer. The female alone cares for the young. They are weaned around 8 weeks and independent at 10 to 11 weeks. Sometimes the young disperse, and sometimes the mother disperses, leaving her home range to her young to divvy up among themselves.

Camera-Trapping Tips

Active year-round and diurnal by nature, this colorful tree squirrel is photogenic and charming. But its interesting behaviors and interactions with other species are what make it an interesting camera-trapping subject.

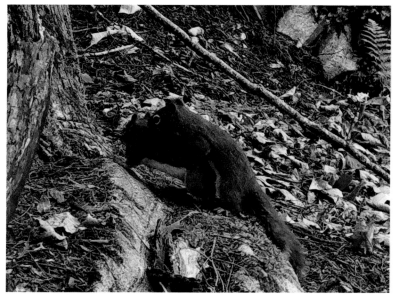

This was incidentally captured by a camera set on a bobcat run in Massachusetts. The date of the capture, September 23, was surprising, for red squirrel mating in the Northeast should have been long over. It's possible that this was a show of dominance, rather than actual copulation, but most red squirrels screech and chase intruders long before they get anywhere near that close. *(Exodus Lift)*

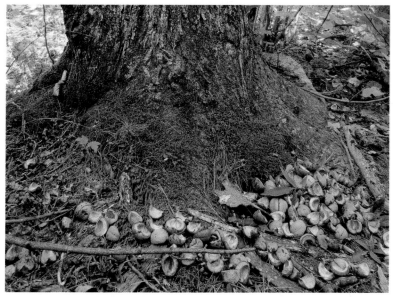

A midden of hickory husks left by a red squirrel, as it consumed some and prepared most for caching.

A piece of mushroom placed on a branch by a red squirrel. The animal may store the mushroom in a cavity once it's dry.

The red squirrel is considered a larder hoarder, which means that it usually stores most of its food in one or several large caches. However, in the Northeast, red squirrels tend to make a larger number of smaller caches, and may even scatter hoard more than half of their food. Individual acorns, apples, and other foods are often stored singly in branch crotches for later consumption. Mushrooms are sometimes left singly to dry on branches, but many others may be placed on other branches in the same tree. Mushrooms keep better once dried, at which time the squirrel may store it in a larder in a cavity or crevice.

Typical locations for larders are in tree cavities and crotches, under logs, in hollow logs, and under tree roots.

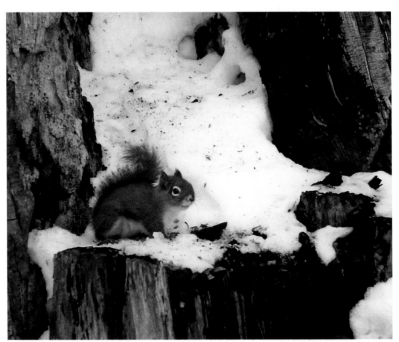

A red squirrel guarding its cache of acorns and hickory nuts in a snag in Massachusetts. (*Reconyx UltraFire*)

Food also may be stored under middens, piles of the animal's feeding debris that accumulates beneath branches and beside stumps, logs, or stones near the animal's feeding perches. In that case, the cache and midden are in one pile, giving way to confusion over the two terms. Occasionally, generations of red squirrels use the same pile as cache and feeding station, in which case they can be quite large and obvious.

In any case, the use of a midden pile for caching cones is thought to reduce theft of conifer seeds, since the cool, moist environment within the midden keeps the cones closed and the seeds inaccessible to birds and mice that cannot open the cone scales.

A large red squirrel cache is an excellent camera-trap target, for it is a site of much activity. The owner, of necessity, protects it aggressively. Gray squirrels, flying squirrels, chipmunks, and mice pilfer these caches, and many other species may appear at the cache, especially if it consists of nuts. Fisher, martens, and bears are all possible thieves and potential predators of the owner and pilfering small animals. Food stolen from red squirrel caches may even be essential for the survival of some northern flying squirrels, which seem to locate their own nests near red squirrel caches.

These chew marks on a mountain laurel branch in Massachusetts are the work of a red squirrel, presumably for marking purposes.

The red squirrel itself may locate its nest within, under, or near its food cache. It prefers to nest in tree cavities, but also uses other types of holes, such as those under tree roots—the same sort of spaces it chooses for food storage. During the warmer months red squirrels may construct nests of leaves, sticks, and other debris in tree branches, usually close to the trunk of a conifer.

This fiercely territorial species uses a variety of vocalizations. It rattles and screeches at trespassers, buzzes to appease other red squirrels, growls to intimidate other red squirrels, and screams when injured. Though not a vocalization, the sound it makes when gnawing the shell of a hickory nut is quite loud. To

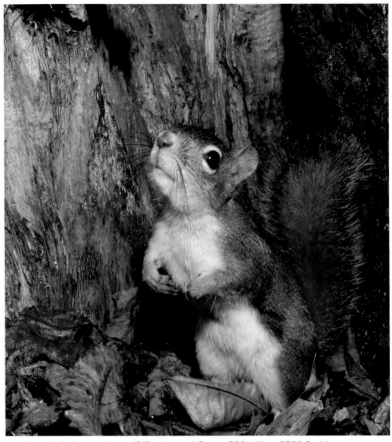

A red squirrel about to leap. *(PIR triggered Canon 60D, Nikon SB28 flash)*

appreciate all of these sounds, use the video function of a trail camera with good audio input.

Red squirrels also communicate with scent and visual cues. For example, they sometimes gnaw and cheek-rub repeatedly along horizontal branches. A conifer is usually chosen, but they sometimes mark deciduous trees and shrubs, too.

6 WOODCHUCK

Order Rodentia / Family Sciuridae

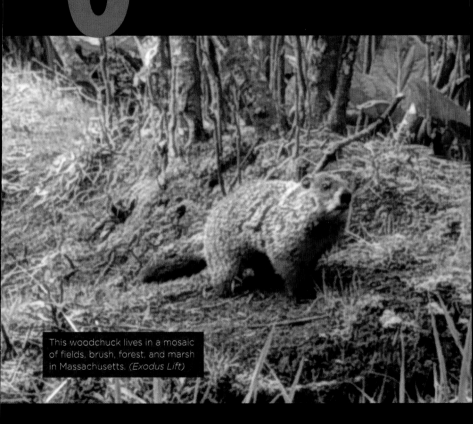

This woodchuck lives in a mosaic of fields, brush, forest, and marsh in Massachusetts. *(Exodus Lift)*

A COMMON AND WIDESPREAD SPECIES of the eastern United States, the woodchuck, *Marmota monax*, is also known as a groundhog or whistle pig. It is a creature of low elevation and open landscape, in contrast to its alpine cousins in the West.

Physical Characteristics

This large, stocky rodent weighing 5 to 13 pounds is grizzled dark brown and cream above with a rust belly. Its head is blackish brown on top with buff cheeks and cream near the nose. Its legs are blackish, and its tail is black with cream stippling.

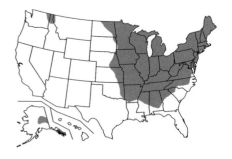

Left: Right front foot of a woodchuck. *Right:* Right hind foot of a woodchuck. Note the similarity of these feet to gray squirrel tracks (see p. 22).

Tracks and Trails

Front tracks, measuring 1 to 2⅛ inches wide, show 4 toes in classic rodent 1-2-1 pattern, with 2 central toes pointing forward and 2 lateral toes pointing slightly out to the sides. A 5th vestigial toe does not register. Hind tracks, measuring 1⅜ to 2 inches wide, have 5 toes that register well, in the classic 1-3-1 pattern, with 3 central toes pointing forward and the lateral toes pointing out to the sides. Claws of both front and hind tracks usually register.

Woodchucks usually walk, but they can speed up to a trot or lope, and bound when frightened.

Diet

Woodchucks eat a wide range of green vegetation, including the leaves, flowers, and seeds of forbs, which they prefer over grasses. Clover, alfalfa, wild lettuce, and plantain are favorites, as are a variety of vegetable crops. Woodchucks eat some tree leaves, including those of hackberry, peach, and red mulberry. In the fall they also eat acorns and other mast. They are primarily herbivores, but sometimes

consume invertebrates, such as June bugs, grasshoppers, and snails, and, occasionally, small mammals.

Scat and Urine
Woodchucks usually leave scat in underground latrines, chambers within their burrow systems specifically for defecating. Sometimes scat can be found on or within the throw mound outside the entry hole. I do not know whether this is because the animal defecates there, or if it inadvertently throws scat out from the burrow while remodeling. Scats are about ½ inch in diameter and 2 inches long.

Habitat
Woodchucks use open fields, meadows, suburban backyards, farms, gardens, golf courses, fencerows, highway median strips, brushy areas, field-forest edges, and open woodlands. They may use different burrows for breeding and hibernation. Dry slopes and other well-drained sites are preferred for both, but natal dens are often located in fields, while hibernacula are more likely to be in sheltered locations, such as under trees or shrubs, under a porch, in an abandoned barn, and similar spots. Population density can reach 1 animal per acre in good habitat.

Breeding
Woodchucks mate late February through April, depending on latitude, and produce 1 litter per year. About 1 month after mating, 2 to 9 young are born. They are weaned at 3 to 4 weeks, at which time they venture out of the burrow and soon begin to eat

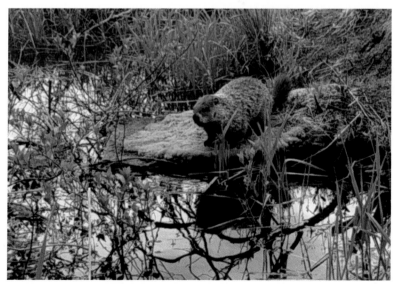

Woodchucks prefer well-drained soil for burrowing, but sometimes feed around wetlands, like this one in Massachusetts. *(Exodus Lift)*

plants. Young explore individually and in groups. Many, especially males, disperse at 2 to 3 months of age, but some females and an occasional male do not disperse until the following spring, just prior to the birth of their mother's next litter.

Camera-Trapping Tips

While the diurnal woodchuck is familiar and widespread, there is an opportunity for the camera trapper to contribute to science, for the social behavior of this species remains poorly understood. The work must be done during the warmer months, for these diurnal creatures hibernate in burrows for 3½ to 6 months in winter.

A groundhog burrow on a slope in an open woodland in Massachusetts. Note the large throw mound.

Often the first observed sign of a woodchuck is neither track nor scat, but feeding sign in a vegetable garden or a burrow with its conspicuous throw mound. Entry holes are usually 5 to 8 inches in diameter, with a 3-foot-wide throw mound. However, the mere presence of a den is not necessarily indicative of current woodchuck activity, for many are inactive at any given time. Look for a throw mound of loose, fresh soil and woodchuck tracks on the mound.

Fresh evidence of marking near a burrow is also a good sign of occupancy, especially during the breeding season, when marking is most common. Woodchucks bite, chew, and rub their cheek glands on trees, shrubs, roots, and stones, usually within 20 feet of the burrow. Look for teeth marks no higher than about 18 inches above ground, as high as a woodchuck can reach. These scent stations make good camera-trap targets. It's interesting to see how they chew and hold a sapling. I believe some of the marks are actually made by the claws, as the animal clutches the sapling while chewing.

The burrow also makes a good camera-trapping target. Courtship and mating may be seen near it, as well as digging and nest building. Both parents excavate and bring mouths full of leaves and other debris for the nest chamber. Other animals may visit, whether searching for real estate or food. At one woodchuck den in Massachusetts, a weasel, an opossum, and a skunk nosed around occasionally. Cottontail rabbits, opossums, and raccoons all use woodchuck dens, sometimes while the makers are still in residence. Foxes remodel abandoned dens, and they

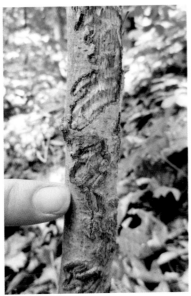

Left: Fresh sign of woodchuck chewing, confirmed by trail-camera video, on a small sapling several feet from a burrow entry. *Right:* The other side of the same sapling shown in the previous photo. Trail-camera video showed the animal gripping the sapling with front paws as he chewed, most likely creating most of these marks with claws.

may remodel active dens, too, after consuming the occupants.

Young may eventually emerge from an active burrow in spring. However, woodchucks often have several burrows, and up to 3 entry holes per burrow, so the failure of young to appear at one hole does not necessarily indicate nest failure.

If you are lucky enough to capture a young family at the den, pay careful attention to social interactions. Many sources describe the woodchuck as solitary except during breeding, with the female providing all of the care and most young dispersing by the end of their first summer. But social structure may be variable. In an Ohio study, for example, social groups consisted of an adult male and female, their young of the year, and sometimes yearling

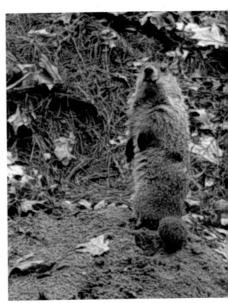

Woodchucks often stand tall on the throw mounds to monitor for danger. This photo was captured in Massachusetts. *(Exodus Lift)*

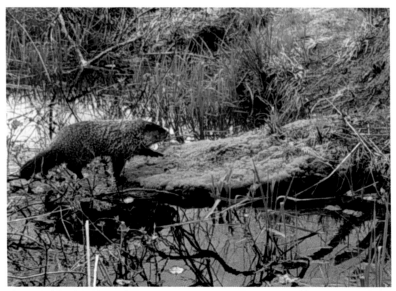

This woodchuck in Massachusetts regularly waded through shallow water to reach feeding areas. *(Exodus Lift)*

daughters, implying maintenance of a bond between a mated pair from year to year. There are also anecdotal reports of playful and affectionate behavior between adult males and juveniles.

Some researchers have suggested that social organization may depend on resource distribution. When suitable habitat exists in small areas of abundance separated by inhospitable areas, the situation resembles that of the colonial marmots of the West, and woodchucks exist as distinct social groups that share burrows, like their alpine relatives. At the other extreme, when suitable habitat is continuous and extensive, woodchucks may spread themselves out, with the bond between parents fading after mating, and young dispersing by the end of their first summer.

After the breeding season, woodchucks at the den spend a lot of time remodeling: throwing soil out of the hole, pushing soil away from the hole, and bringing nesting material to the den, as they prepare their hibernacula. They also groom and rest on the throw mound, often lying spread-eagle on their bellies. Periodically they stand on hind legs to scan for danger. At this time of year they also spend a lot of time away from the den, feeding heavily in preparation for hibernation.

Woodchucks sometimes climb trees to feed on leaves, observe for danger, and escape predators, though they prefer to retreat to a burrow for safety. They can also swim and will wade through shallow water. An individual in Massachusetts regularly waded when traveling between resources.

7

EASTERN CHIPMUNK

Order Rodentia / Family Sciuridae

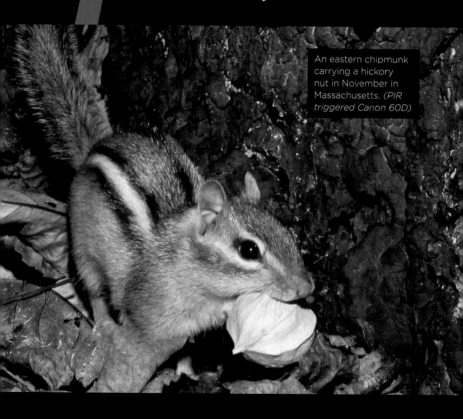

An eastern chipmunk carrying a hickory nut in November in Massachusetts. *(PIR triggered Canon 60D)*

OF THE 24 SPECIES OF CHIPMUNK in the United States, the eastern chipmunk, *Tamias striatus*, is the only one that ranges throughout most of the East. It is intermediate between ground squirrels and tree squirrels, for it lives in burrows and climbs frequently. It is also intermediate between true hibernators and active winter foragers, for it goes dormant for days at a time, surviving winter on hoarded food, rather than on accumulated fat or fresh forage.

Physical Characteristics

Adults usually weigh 2 to 4 ounces. On its back, it has 5 narrow black stripes, two narrow cream stripes, and two wide grayish stripes. The lower sides are light orange, shoulders and top of head are grayish, and the belly is cream. The forehead and cheeks are orange, and the eye-rings are cream. The tail is grizzled orange and cream.

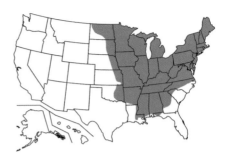

Tracks and Trails

Front tracks are about ½ to ⅝ inch wide and show 4 toe prints in the classic rodent 1-2-1 pattern, with 2 central toes pointing forward and 2 lateral toes pointing out to the sides. A 5th vestigial toe (thumb) does not register. Three metacarpal pads often register, and 2 posterior metacarpal pads sometimes register.

Hind tracks are about ¾ inch wide and show 5 toe prints in the classic rodent 1-3-1 pattern, with 3 central toes pointing forward and 2 lateral toes pointing out to the sides. Four metacarpal pads and 2 posterior metacarpal pads often register but may be indistinct.

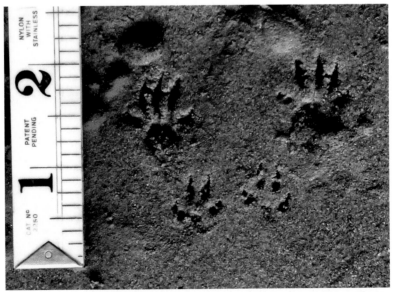

Front and hind eastern chipmunk tracks in a bounding pattern. The two larger prints are the hind tracks, and the direction of travel is bottom to top. *Photo by Charlie Perakis*

Eastern chipmunks usually bound, with a trail width of about 2 to 3 inches and a stride between 8 and 20 inches. They may walk or hop when foraging or when near the den.

Chipmunks climb trees, but somewhat clumsily, compared to tree squirrels. They generally do not jump from branch to branch, and occasionally they fall from trees. They avoid climbing smooth barked trees, such as beech.

Diet

This omnivorous rodent eats nuts, seeds, trout lily bulbs, fruits, berries, mushrooms, invertebrates, bird eggs, and occasionally small mammals, amphibians, and reptiles. Favorite nuts and seeds include acorns, hickory nuts, pecans, beechnuts, hazelnuts, buckeye seeds, maple samaras, conifer seeds, wild cherry stones, and sunflower seeds. Many nuts and seeds are hoarded, but nuts are especially important for winter consumption. Pregnant and lactating females and growing young consume more animal protein than other individuals. Chipmunks also eat picnic scraps, cultivated grains, and garden vegetables.

Scat and Urine

Eastern chipmunks probably defecate at random. I have never definitively identified chipmunk scat, but Elbroch (2003) says they excrete $\frac{1}{8}$- to $\frac{9}{32}$-inch pellets, often on feeding perches. Where they eliminate underground remains a mystery. Scat has not been confirmed in either sleeping or food-storage chambers in the burrow. Other than males detecting females in estrus by scent, chipmunks do not use scent for communication.

Habitat

Chipmunks require plenty of mast from deciduous trees, well-drained soil for burrowing, and good cover at ground level. These requirements may be met in hardwood or mixed-forest and forest-edge habitat with mature oak, hickory, or beech for food, and rock crevices, coarse woody debris, or low vegetation for cover. Forest edge is preferred over forest interior, because chipmunks take advantage of cover and mast provided by shrubs at the edges. Suburban backyards and urban parks with mature nut trees and cover in the form of stone walls, hedgerows, brush piles, log piles, or foundation plantings are also suitable. In excellent habitat the population density may reach 25 animals per acre.

Breeding

Chipmunks usually mate January to April, depending on latitude (late February in Virginia, late March in Massachusetts), and the female gives birth to 3 to 5 young a month later. In the South they may breed a second time in summer. It is thought that the female alone raises the young, though there are reports of males entering burrows housing litters they have sired. At 5 to 6 weeks of age, young emerge from the den and disperse 1 to 3 weeks later. Young of summer litters in the South

emerge in late summer or fall and often remain active all winter, perhaps because they do not yet have a burrow system with sufficient capacity for a winter cache.

Camera-Trapping Tips

This noisy, diurnal rodent, which thrives in edge habitat alongside humans, hardly needs to be tracked to be found. Despite its familiarity, much can be learned about it from camera trapping that the casual observer never notices. Chipmunk burrows, feeding perches, travel routes, and concentrated sources of preferred foods, all make good targets. A standard trail camera can be used to capture coarse scale behaviors, such as chases, but for fine detail a camera with good close focus is needed. At the time of this writing, the only ready-made trail camera I know of that can do this is the Bushnell NatureView Cam HD Live View, which comes with 2 close-focus lenses.

Chipmunks usually live in ground burrows with 1½- to 2-inch entry holes that descend vertically at least 4 inches before extending more gradually. You can check this by sticking a straight twig down the hole. There is no throw mound near the hole because chipmunks remove the soil through a different hole, the "work hole," which they plug upon completion of the burrow. Burrows can be almost anywhere in good habitat, but most are under some kind of cover, and many are near dead trees, where rotting roots provide natural tunnels. The burrow may have a single

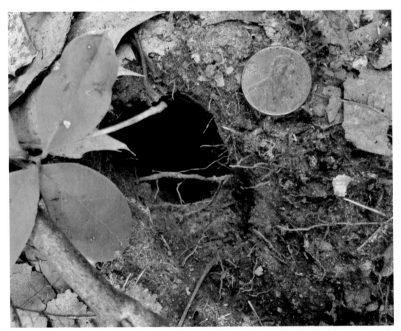

The clean 1½-inch entry hole of an eastern chipmunk burrow. There is no throw mound because chipmunks excavate through a "work hole," which is plugged upon completion of the project. This one was near the edge of an oak forest in Massachusetts.

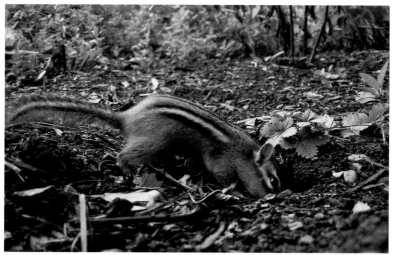

A chipmunk entering its burrow located between the foundation of a house and a perennial garden in Massachusetts. *(Bushnell NatureView)*

chamber for both sleeping and food storage, or it may have several additional chambers and numerous side pockets used just for food storage.

Chipmunks frequently remodel their burrows, and sometimes the entry hole is plugged and a new hole leading to the same burrow system is created. The new hole is often no more than several feet away from the old one. A camera targeting an entry hole should be checked every few days or so, and repositioned as necessary. A day or two after I stationed my NatureView to capture a chipmunk carrying leaves to line its nest in preparation for winter, the animal created a new entry hole a foot away, just out of view.

Begin looking for burrows when chipmunks emerge from their winter slumber, in late January to mid-March, depending on latitude. The familiar chipping sounds, often made from a perch near the burrow, will clue you in. A few weeks after emergence, breeding behavior begins. A chase ensues, as a few males pursue a female, who tries to lose them by doubling back or disappearing into a hole as her suitors tumble past her. Mating chases are noisy affairs, with plenty of squealing and chattering. After several hours of this, the female chooses the male who was strong and clever enough to keep up with her. Segments of the mating chase are easily captured by trail-camera video. Be sure to use one with good audio capability, to appreciate the animals' rich vocal repertoire. Copulation is rarely observed, because it usually takes place under cover, often under a log or in a hole at the base of a stump.

The mating season is a good time to station a camera at a burrow. If you are lucky enough to choose a female's burrow, you may see her bringing leaves to line the nest. Later you may see the young when they first emerge and their interactions with the mother at the entry hole. A standard trail camera may suffice for

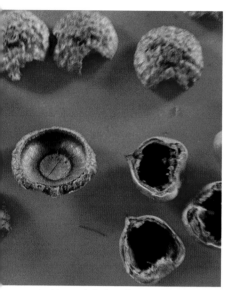

A chipmunk fed on these red oak acorns in a backyard in Maine, leaving much of the shell intact. This is not uncommon, but they may also break them into small pieces. *Photo by Charlie Perakis*

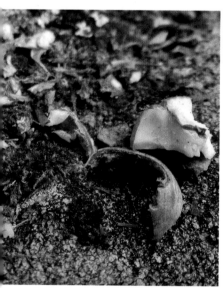

Red oak acorn debris left by an eastern chipmunk on this rock, one of its feeding perches at the shrubby edge between mixed forest and wetland in Massachusetts.

a wide view of playing, wrestling, and maternal discipline, but use a camera with close focus for good resolution.

If you cannot locate a burrow during the mating season, try again 2 to 3 months later when young are dispersing. This is when chipmunks are noisiest, for adults announce territorial ownership by sounding off with chipping songs from a perch near the burrow intermittently throughout the day. Chipmunks have a relatively poor sense of smell, and, unlike most rodents, use sound rather than scent to claim ownership.

Feeding perches are also excellent camera targets. Chipmunks use well-learned travel routes punctuated by elevated surfaces such as stumps, logs, and rocks, where they can feed while watching for danger. A perch can be identified by an accumulation of feeding debris left behind by the animal. A trail camera targeting a perch can reveal exactly how the animal creates the sign discovered by the tracker. Chipmunks, however, do not re-use their feeding perches as often as red squirrels do. Chipmunk middens are much smaller accumulations, and the frequency of camera capture will probably be much lower.

As primarily larder hoarders, chipmunks stuff their cheek pouches with food and dash away to the burrow to hide it. They may hoard food in their burrows at any time of year. Spring through early summer is the time for gathering trout lily bulbs, a favorite food. I have never observed a chipmunk harvesting bulbs, and should like to place a camera at a patch of this plant to see exactly how it is done. Despite

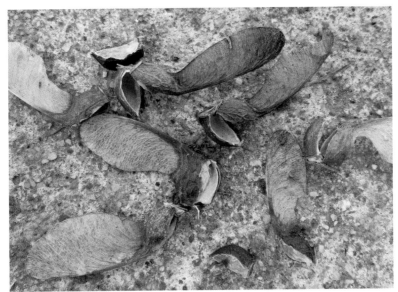

An eastern chipmunk, using a porch step as a feeding perch, left these remains of sugar maple samaras as it harvested the seeds. The hole to its burrow was about ten feet away from the perch, near the foundation of a house in Massachusetts.

their poor sense of smell, chipmunks must be able to find those underground delicacies by scent.

Chipmunks are harder to find in mid-summer, because they spend more time underground, perhaps to avoid the heat. Activity picks up again in late summer and fall. In the South there may be a second period of territorial singing as the summer litters disperse, and in the North chipmunks begin gathering and hoarding nuts at this time.

A large cache of mast is necessary for winter survival, because chipmunks do not accumulate excess fat prior to dormancy, which lasts several weeks to several months, depending on latitude. They retire to their burrows in early October in the far North, and early December in the far South. They wake from torpor every few

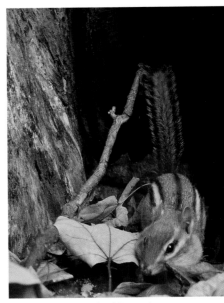

An eastern chipmunk with pouches stuffed with food, probably sugar maple seeds, which it appeared to be processing in the previous photos. *(Bushnell NatureView)*

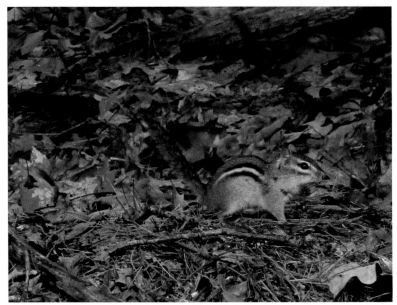

This chipmunk in Massachusetts is visiting an otter latrine. Note the remains of dried-up otter scat in the foreground. Rodents are known to eat the bones of animal remains for calcium, and I suspect they eat the fish scales in otter scat for the same reason, for I have footage of mice (*Peromyscus* spp.) appearing to do just that. Watch for unusual behaviors captured by your own camera—you never know what you're going to discover! *(PIR triggered Canon 60D)*

days to consume stored food, and some occasionally come out to forage during mild weather.

Chipmunks pilfer nuts from the burrows of other chipmunks, and from the caches of other rodents. They have difficulty finding nuts by scent, however, and may monitor the behavior of their neighbors by watching and detecting sound and vibrations. I have several videos of a chipmunk climbing a snag that houses a southern flying squirrel, but the resolution is too low to see if the chipmunk is stealing nuts. I have another video of a chipmunk stealing and eating an acorn moments after it was buried by a gray squirrel. A chipmunk typically appears in a tree cavity, which I occasionally bait with nuts, soon after a gray squirrel finds the food, as if the smaller rodent follows the larger one around. Gray squirrels may be well aware of this pesky thieving behavior, for I have some clips of a gray squirrel aggressively driving a chipmunk away.

Chipmunks can be easily baited with sunflower seeds, acorns, and other nuts, especially if they are still in the shell. Some people report success with peanut butter and roasted nuts, but others say chipmunks ignore them. I have never tried peanut butter, but the chipmunks in my yard refuse pecans and hazelnuts, roasted or raw, that have been removed from the shell.

8 FLYING SQUIRRELS

Order Rodentia / Family Sciuridae

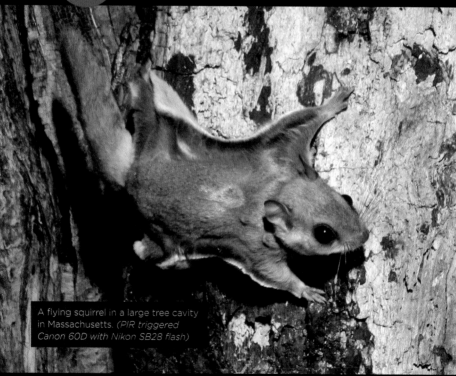

A flying squirrel in a large tree cavity in Massachusetts. *(PIR triggered Canon 60D with Nikon SB28 flash)*

THE EASTERN UNITED STATES is home to 2 species of flying squirrel: the southern flying squirrel (*Glaucomys volans*) and the northern flying squirrel (*Glaucomys sabrinus*). Both species are nocturnal, cavity-nesting rodents that can glide through the air with the aid of a fold of skin that connects forelimb to hind limb. The northern flying squirrel (NFS) is retreating in the southern limits of its range in the eastern United States, perhaps as a result of climate change, habitat conversion, and an intestinal nematode, *Strongyloides robustus*, carried by the southern flying squirrel (SFS). The nematode is harmless to the SFS but

Physical Characteristics

Both species are gray brown above and whitish below, with a flattened tail. The NFS weighs about 4 ounces and tends to have gray cheeks, while the SFS averages 2½ ounces and has whitish cheeks, but there is overlap with respect to these characteristics. However, the belly fur is distinctive. That of SFS is white to the base, while that of the NFS is white at the tips and dark gray at the base.

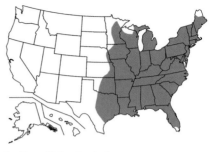

Southern Flying Squirrel

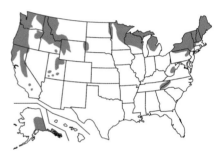

Northern Flying Squirrel

Southern flying squirrel tracks in Massachusetts. This is a single group within a hopping pattern; the front tracks are above.

Tracks and Trails

The feet of both species are of classic rodent structure. SFS front and hind tracks measure about ⅜ to ¾ inch wide. NFS tracks run about ⅛ inch wider. On the ground, the SFS usually hops with a stride of 6 to 21 inches and a straddle of 1⅝ to 3 inches. The NFS usually bounds, and when it does, its front tracks are almost as far apart as its hind tracks, giving each group a boxy appearance. The stride is 6 to 34 inches, and the straddle is 2¾ to 4¼ inches.

Diet

Both species consume a wide variety of foods, including nuts, seeds, berries, buds, flowers, fungi, tree sap, insects, bird eggs and nestlings, and carrion.

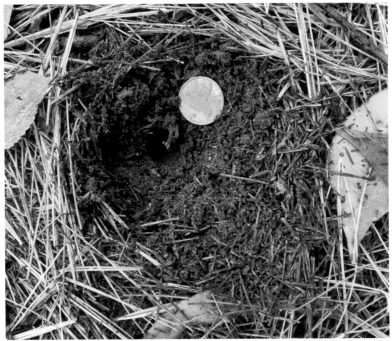

The small circular depression in this dig was left by either an underground mushroom or a cached acorn. Many animals, including deer and porcupines, will harvest either, but the small size of this dig suggests flying squirrel or tree squirrel activity.

A flying squirrel about to take off with a hickory nut, carrying it by one of the pointed ends. Sometimes you can see carry notches near the point, which come from the animal's incisors. *(PIR triggered Canon 60D with Nikon SB28 flash)*

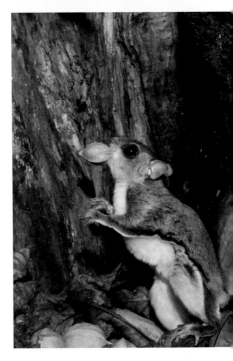

However, the SFS relies more on nuts, and the NFS consumes more lichens and fungi, particularly the underground fruiting bodies (truffles and false truffles) of mycorrhizal fungi. The NFS also consumes more catkins and staminate cones, which it eats in vast quantities in spring.

When flying squirrels carry away acorns or hickory nuts, they usually

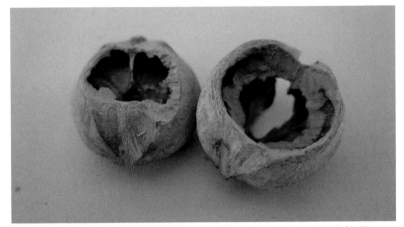

Compare flying squirrel sign on a hickory nut shell (right), to mouse sign (left). The flying squirrel left a broader incisor mark at the carry notch near the nipple, and created a smooth, round opening. The mouse, on the other hand, left very fine incisor markings at the carry notch and all around an irregular opening. Red squirrels and chipmunks also create irregular holes, and both red and gray squirrels may cut the shell into several pieces.

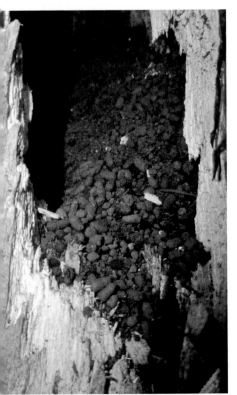

hold them by one of the pointed ends between the incisors, sometimes creating a "carry notch" visible on the shell. When they eat acorns or hickory nuts, they tend to open from one side of the nut, leaving a smooth, roundish opening, instead of breaking the shells into several pieces, as gray and red squirrels often do.

Scat and Urine

Scats are about ¹⁄₁₆- to ¼-inch-long pellets, and, according to Rob Speiden, slightly flattened. The animals often deposit them in holes used specifically as latrines. While scats may overlap in

This accumulation of small pellets is almost certainly flying squirrel scat, for no other rodent in this region leaves such a large collection. Flying squirrels create latrines in tree cavities, and as the tree decays, scat comes spilling out. As decay continues, scat piles may be found at the base of the tree.

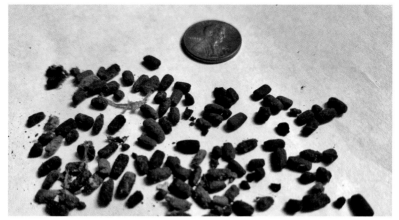

Note the slightly flattened shape of these flying squirrel pellets. *Photo by Rob Speiden*

size with those of other small rodents, a large accumulation spilling out at the base of a cavity tree or stump is almost certainly flying squirrel scat.

Habitat
Both species prefer mature forest with plenty of dead and dying trees and coarse woody debris. The SFS prefers hardwood and mixed forests with nut-producing trees such as hickory, oak, or beech and achieves a population density of 1 to 5 animals per acre. The NFS is a creature of mixed and coniferous woodlands with spruce, fir, or hemlock, especially cool, moist, mossy forests where lichens and fungi abound. In the southern portions of its range, the NFS is limited to high-elevation, north-facing slopes. It may well be capable of living in predominately hardwood forests in warmer areas, if not for the deadly parasite carried by the SFS which occupies those forests.

Breeding
SFS has 1 to 2 litters of 2 to 4 young, usually in an old woodpecker hole or natural cavity generously lined with finely shredded tree bark. The NFS has 1 litter of 2 to 4 young, usually in late spring. Gestation is about 5 weeks and young are weaned at about 2 months, though they may remain with females for a few more months.

Camera-Trapping Tips
In most of the eastern United States, the species you are likely to see is the SFS. The NFS is endangered in Pennsylvania, North Carolina, and Tennessee; is a species of special concern in Wisconsin; and was recently delisted in West Virginia. In southern New England it has not been documented for over 40 years, but may survive in northern and western Massachusetts and northwestern Connecticut. In any case, you cannot distinguish between the two species with a camera trap. The only reliable way to do that is to examine the belly hairs to the base.

Nonetheless, where flying squirrels are common, they are not difficult subjects during the warmer months, when they are quite active outside the den. You can get many photos with a typical ready-made trail camera, for flying squirrels often pause after landing. However, a short trigger delay (less than 1 second) for videos, is needed to capture the action of landing. A white flash is needed for color photos, because flying squirrels are almost entirely nocturnal. I've captured hundreds of photos of them; none were during daylight.

Like many larger mammals, flying squirrels use well-established "travel corridors." An individual uses regular routes for climbing, gliding, and landing between nests and foraging spots. When the animal wants to glide, it climbs to the top of the tree and glides down to the trunk of another, usually 50 to 100 feet away. In the forests of central Massachusetts, I often capture flying squirrel by cameras targeting large logs, cavity trees, snags, and boulders and sometimes on the ground, and they do appear repeatedly in the same spots.

Most flying squirrel nests are within a hundred yards of water, 5 to 40 feet above ground in old woodpecker holes or natural cavities in hardwood trees or snags. Entry holes are 1 ½ to 2 inches in diameter, often with sign of gnawing around the opening. SFS nests need not be in the forest interior. They are sometimes found in trees in backyards, as long as there are other trees within gliding distance. Both species readily accept nest boxes.

Outside leaf nests, or dreys, are sometimes used, particularly in warmer weather. The animal may construct an approximately 8-inch-diameter drey of shredded

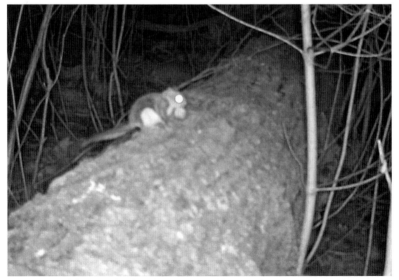

Flying squirrels have well-defined travel routes, like many larger mammals. This one appeared several times in this spot on a large log in Massachusetts. Notice the characteristic flattened tail. The quality of this photo is about the best you can get with a standard trail camera designed for medium to large animals. *(Exodus Lift)*

bark and leaves, or use an abandoned red or gray squirrel drey. Occasionally they use old crow or raven nests.

The NFS uses dreys more often than the SFS does. The larger, more densely furred NFS is better able to withstand the cold without the protection of a cavity, and hardwood cavities are harder to come by within its coniferous and mixed forest habitats. Most NFS dreys are well concealed in conifer branches relatively close to the trunk.

Females almost always raise their young in cavities. SFS litters are quite vocal, with chirps, clucks, and squeals, and it is possible to find a nest by ear on warm evenings in June, when young become active. Targeting a natal den tree should make for excellent camera-trapping opportunities.

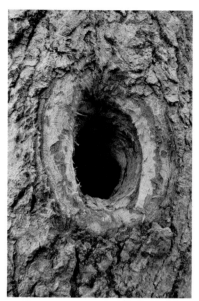

A cavity in a live tree in Massachusetts used by a rodent. Mice and squirrels all chew the rim of their tree cavities.

In addition to the main sleeping den, the SFS maintains other cavities as hiding places, latrines, feeding stations, and caching sites. They may store a collection of nuts in one cavity, but they also cache individual nuts under leaf litter, under bark flaps, in cracks, and in branch crotches. A camera targeting a cavity tree where SFS caching sign is abundant in the vicinity is likely to capture the culprit.

The NFS is not known to store food, but it is thought to raid the caches of red squirrels in winter, and its nests tend to be located close to red squirrel caches. One approach to camera trapping the NFS would be to target red squirrel caches or cavity trees and snags near them.

Both species are known to eat insects, and in captivity the SFS uses an interesting hunting strategy. It hangs from the cage top by its hind feet near

An acorn jammed under a flap of bark may have been cached by a southern flying squirrel. The hole above the acorn was probably used by a rodent, as evidenced by the chew marks on the rim.

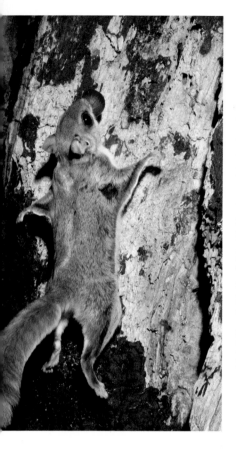

A flying squirrel sallies out with an acorn in a tree hollow in Massachusetts. *(PIR triggered Canon 60D with Nikon SB28 flash)*

the light, catching, with its front feet, moths attracted to the light. I don't believe this has been observed in the wild, but it would be interesting to try to capture it at an outdoor lamp in a leafy suburb.

In winter both species spend much time huddling in the nest with other individuals for warmth, emerging briefly only to feed, and entering torpor for short periods during extreme cold. Aggregates of 5 or 6 SFS per nest is typical, though as many as 50 have been observed in a single nest. Winter aggregates of NFS are usually smaller. Where the two species overlap, some nests may house members of both species.

9
NORTH AMERICAN BEAVER

Order Rodentia / Family Castoridae

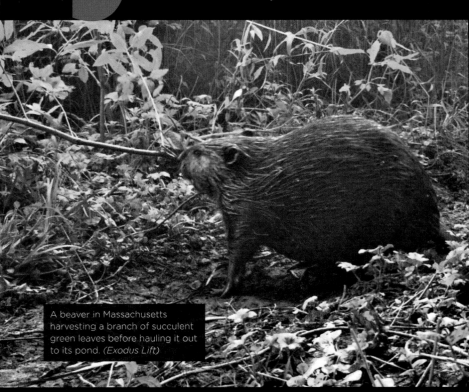

A beaver in Massachusetts harvesting a branch of succulent green leaves before hauling it out to its pond. *(Exodus Lift)*

BY THE EARLY TWENTIETH CENTURY, the beaver (*Castor canadensis*) had been extirpated from large expanses of its range, primarily as a result of demand for its fur. But reintroductions, regulations, and reforestation have allowed this semiaquatic rodent to thrive once again. It's a good thing, too, for the beaver is a keystone species. Its ponds provide habitat for many other animals, afford some protection from drought, and cleanse water of pollutants. Its lodges provide shelter for several other species.

Physical Characteristics

This largest of North American rodents usually weighs 35 to 70 pounds. It has a stalky physique; short limbs; brown fur; a large, scaly, horizontally flattened tail; large, webbed hind feet; and small front feet. When swimming, its nose, eyes, forehead, and back are usually visible above water.

Tracks and Trails

Beavers have 5 toes on both hind and front feet. The large, webbed, flipper-like hind feet measure about 5 to 7 inches in length. The heel and 4 or 5 toes usually register. The much smaller front tracks are hard to find, because beavers often use an alternating walk, in which the hind track registers on top of the front track, or they walk upright while using their front paws to carry materials to a scent mound or bank lodge. But even clear hind tracks can be hard to find, for beavers use runs regularly and soon trample over their old tracks, and the tail sometimes drags,

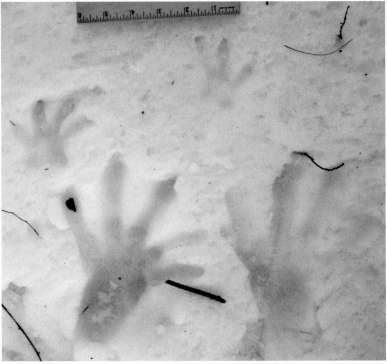

Front (above) and hind tracks of a beaver in Massachusetts. The webbing is most easily seen in the left rear track.

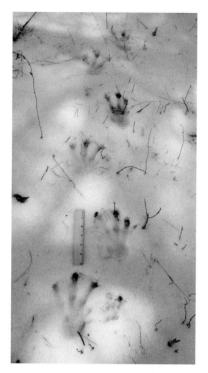

obliterating tracks. When frightened on land, a beaver uses a squirrel-like bound to return to the water.

Diet

In winter, beavers eat the inner, living bark (cambium) and twigs of trees and shrubs, as well as water lily roots, where available. Because they cannot climb, beavers access the choice portions of trees by felling them. They do this by gnawing the trunk with their large incisors. In summer, beavers prefer herbaceous plants, cattails, sedges, corn, and the leaves of woody plants, but if necessary they continue to consume cambium. Aspens and willows are favorites in all seasons, and in general they prefer hardwood over softwood trees.

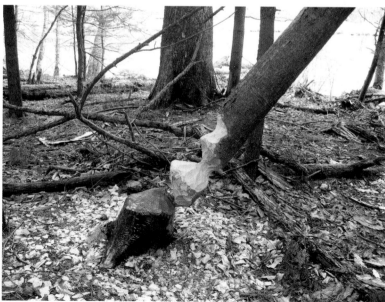

The familiar sign of debarking and logging by beaver. Beavers eat the leaves, twigs, and cambium and use branches and logs as building materials for their lodges and dams.

Scat and Urine

Beavers usually defecate in the water. The only beaver scats I have seen were on the bottom of a pond or in a meadow after the pond had drained. Scats look like compressed sawdust, measuring about 1 inch in diameter by 2 inches long.

Habitat

Beavers need a year-round source of fresh water, in the form of a pond, lake, river, or stream, large enough for them to swim and dive and to create either a bank lodge or a freestanding lodge. They prefer gentle terrain and a diversity of vegetation, including a variety of trees and shrubs, but they can eke out a living on steep terrain or with willow brush as the only woody vegetation.

Breeding

Mating occurs from late December through February. After a 4-month gestation, 3 or 4 kits are born. Young can walk and swim the day they are born, but are largely confined to the lodge for the first couple of weeks. They sample green vegetation at about 1 week of age, consume mostly plants by 3 weeks, and are fully weaned by 8 weeks. They spend their first winter with parents in the lodge, and they disperse the following spring if unoccupied habitat is available. When the population density is high and young cannot find their own territories, they may stay with parents for another year, helping to raise their parents' next litter.

Camera-Trapping Tips

Even though beavers spend much time in their lodges or in the water, they are generally easy subjects, because their sign is obvious, their behavior is predictable, and the animals move slowly except when threatened.

Beaver lodges and dams are obvious signs of beaver presence, but not all beavers create them. In rivers or lakes, where the water is too deep for a freestanding lodge, beavers may live in bank burrows. Usually this is a temporary situation, though, for most beavers eventually pile sticks around the burrow entry, creating a bank lodge.

Spring is the time to capture beaver activity at scent mounds, which are found at the edge of the pond or the bank of the river. A new mound may be just a few inches high, while one that has been faithfully maintained for weeks, months, or even years, may be a large, conical pile. The largest I have seen was about 18 inches tall.

Once the snow melts and young begin to disperse, resident beavers begin announcing territorial ownership by adding debris to mounds and anointing them with urine and probably anal gland secretions. The urine contains castoreum, the rather pleasant–smelling contents of the castor sacs located between the kidneys and bladder. Anal gland secretions appear oily and smell rancid. From a male it is sticky and brown, and from a female it is thin and whitish yellow. The female's thin secretion is probably absorbed by the debris too quickly to be observed, but I once saw a male's sticky brown secretion on a freshly scented mound.

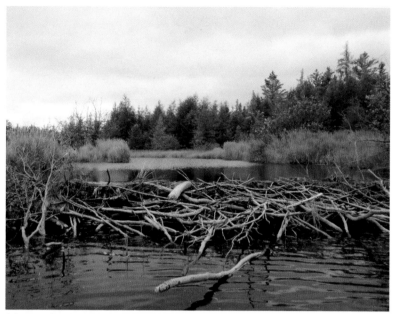

A beaver dam in Maine. Using sticks, mud, and debris, beavers dam streams to create ponds where they can build a lodge.

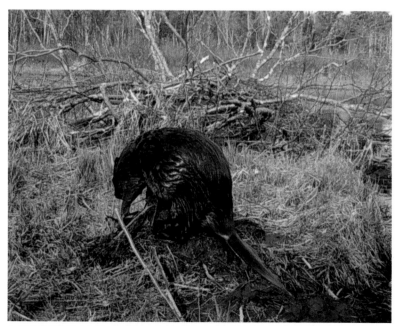

A beaver tending to its scent mound in Maine. A bank lodge is in the background. (Exodus Lift)

A beaver adding a stick to its lodge in late June in Maine. Beavers do most of their repair work in spring and fall. It's probably better to try to capture it in fall, when vegetation is dying back. This lodge was totally hidden by grasses a week after this photo was taken. *(Exodus Lift)*

Scent mounds are most numerous in areas of high beaver population density and in springtime. Where beavers are numerous, the odor is detectable on a casual walk by the pond. Take every opportunity to smell scent mounds, and you will quickly learn to recognize the odor and hone in on active mounds. Those with fresh debris and strong odor are excellent camera targets, and I have many video clips of a beaver assiduously tending his pile.

Spring is also the season for repairing infrastructure. A camera placed at the end of a dam or near a lodge may capture beavers replacing mud that early spring rains have washed away. In summer you can capture beavers harvesting succulent green plants, and if you're lucky, a kit following its parent.

To facilitate transport of food and building material to the pond, beavers dig canals. At the end of a well-used canal, where beavers exit and enter the water, is a muddy "haul out." A clear path extends from the haul out to feeding areas. An active run or haul out is an excellent camera target for capturing beavers, as well as other animals that share the run.

As fall approaches, beavers in cold climates must prepare for winter. They reinforce the dam with more logs, rocks, and/or debris and weather-proof the lodge with a fresh plastering of mud. They also begin preparing a winter food cache, a stockpile of branches in the water near the lodge. Generally it begins earlier in colder climates and later in warmer areas, but there is a lot of variation.

A beaver canal and haul out in Massachusetts. A run courses from the haul out to a feeding area.

One beaver family in a large wetland in Wisconsin had a large stockpile by the first week of November, while another in a small pond in Massachusetts did not begin to store branches until the last week of November. In warm climates, where the water does not freeze for extended periods, beavers may not create a cache at all.

While beavers may fell trees at any time of year, the peak is usually in the fall as the animals prepare their winter cache, and in winter, when a warm spell melts the ice, allowing beavers to forage on land. This is a great time to look for fresh sign on trees and for a canal where beavers are hauling the branches. Both the tree and the canal are great camera-trap targets.

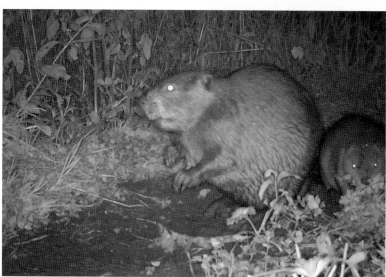

In summer an adult beaver and kit pause on the run, after hauling out of their pond in Massachusetts. They made many trips to and from the water, sometimes stopping for a snack on land, but more often hauling food to the water. *(Exodus Lift)*

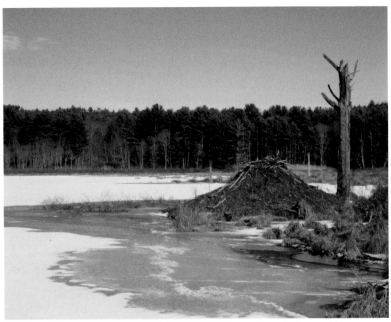

A cache of branches sticks out of the ice just to the left of a well-plastered beaver lodge in Massachusetts.

A beaver canal is a worn path, from land to lodge, filled with water. As the animals use the path, they deepen it by dredging up mud from the bottom and depositing it at the edges, causing it to flood. This eventually creates a channel of water deep enough to float logs to the lodge. Depending on how you position your camera, you can get beavers hauling out of the water at the end of the canal or carrying branches as they swim down the canal.

Beavers also create runs, 8- to 10-inch-wide worn paths, between haul outs and favorite feeding areas. In high-quality habitat, runs may be very short, but as trees and shrubs are depleted, beavers must travel further inland to find food.

Finally, beaver wetlands truly are biodiversity hot spots, and therefore superb places for camera trapping other animals. I've captured coyote, fox, and lynx marking lodges with urine, otters sliding over dams and making latrines at the pond edge, mink hunting at a haul out, deer and moose feeding on the lush vegetation around the pond, rodents caching nuts in the loose debris of scent mounds, and many animals—from bears to porcupines—using the dam as a crossing structure.

10

COMMON MUSKRAT

Order Rodentia / Family Cricetidae

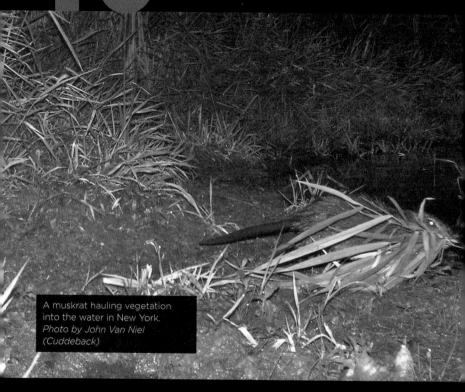

A muskrat hauling vegetation into the water in New York.
Photo by John Van Niel (Cuddeback)

MORE CLOSELY RELATED TO VOLES and lemmings than to rats, the muskrat (*Ondatra zibethicus*) is a medium-size semiaquatic rodent ranging over most of the United States and Canada. It is a keystone species: As muskrats feed on aquatic vegetation, they create open water that provides habitat for fish, songbirds, wading birds, ducks, and invertebrates. Their lodges are used as nesting platforms by certain species of ducks and geese, and mink den in old muskrat burrows.

Physical Characteristics

Muskrats weigh 2 to 4 pounds and wear a dense, short, glossy coat that is medium brown to blackish brown with pale gray cheeks and belly. They have small ears that can be closed off to exclude water. The naked, scaly tail is vertically flattened. The animal often swims with its head, back, and tail partially exposed.

Tracks and Trails

Both front and hind feet have 5 toes. Front tracks average about 1 ¼ inch in width and show typical rodent pattern. The innermost toe is vestigial and very small, but sometimes registers. The remaining 4 toes register in the typical 1-2-1 rodent pattern, with the center 2 toes pointing forward and the lateral 2 toes pointing outward. Rear tracks average about 2 inches in width. Toes are long and wide and more evenly spread than in classic rodent hind feet. The muskrat often walks, with a stride of 3 to 7 inches and a straddle of 3 to 5 inches. When in a hurry, it moves in a lope, hop, or bound. There is often an obvious tail drag.

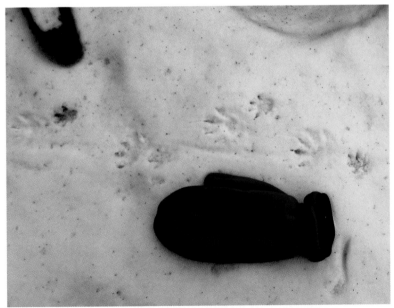

Muskrat tracks in an overstep walk in Massachusetts. Note that hind tracks are much larger than front tracks. The tiny vestigial toe of the front foot registered well in the track directly above the mitten. The tail drag is evident.

Diet

Favorite foods of the primarily herbivorous muskrat are cattails, bulrushes, arrowhead, and corn. They also eat water lilies, pondweeds, pickerel weed, and many other aquatic and terrestrial plants, including fallen fruits, vegetables, and other crops. A small amount of the muskrat's diet is meat, such as freshwater mussels, clams, crabs, crayfish, snails, frogs, turtles, insects, and fish. Muskrats living where favored plant foods are scarce eat more meat. Muskrats are said to store only small quantities of food, but there are a few reports of large caches of corn and arrowhead roots ("duck potato") in muskrat burrows.

Scat and Urine

Due to the muskrat's varied diet, the appearance of its scat is quite variable. When feeding on dry vegetation, scats are pellets of about ¼ by ¾ inch. Moister vegetation results in clumped pellets, and a seafood diet can result in scat splats. Muskrats sometimes defecate in the water and sometimes create latrines on elevated surfaces near the water. Scat may also accumulate at feeding stations with feeding remains.

Habitat

Muskrats prefer shallow, slow-moving water where the water level is stable. Cattail marshes are ideal and support high population densities, but muskrats can live at lower population densities along slow-moving streams or in shallow, wooded ponds. Wetlands near cornfields are also favored.

Muskrat scats on a log in the water, a typical place to find them. *Photo by John Van Niel*

Breeding

Muskrats are prolific breeders. In the South, litters are more frequent but smaller in size. Females in Louisiana may give birth year-round, almost monthly, to an average of 3 to 4 young. Muskrats in the far North have just 1 or 2 litters between June and August, but there may be as many as 9 per litter. Gestation is about 30 days. Mother is the sole caregiver while youngsters nurse, but after weaning, at 3 to 4 weeks, the father becomes the primary caregiver. If the mother is pregnant with another litter, she will create a new chamber in the lodge for the new litter. The young stay with the parents through their first winter, then disperse the following spring.

Camera-Trapping Tips

The main challenge in camera trapping muskrats is their habitat preferences. There are usually few, if any, easy options for mounting the camera in a cattail marsh, where muskrats abound and their lodges are obvious. Forested streams and ponds offer many options, but muskrats are less common there, and their habit of using bank burrows and old beaver lodges in these settings makes them harder to find.

During the breeding season scent marking at latrine sites intensifies. Look for scat accumulations on elevated surfaces near lodges, bank burrows, and on runs between these shelters and favorite feeding spots. Multiple individuals use these latrines, and mink sometimes mark them, so they make excellent camera targets.

In winter in northern climes, muskrats spend more time in lodges and burrows and foraging under the ice, but their aboveground activity is more predictable and more diurnal, creating good camera-trapping opportunities. They use haul-out areas to access fresh air and warming sunlight. They create "pushups" through the ice by pushing pond debris up through the hole and onto the ice, sometimes creating a roof over a small chamber for safe eating. The animals use the structure for as long as the ice around it stays frozen. Multiple animals huddle for warmth in burrows and lodges, and aboveground activity is usually within 50 feet of lodges and burrows.

In winter they may also use haul outs to access other above-water feeding platforms, such as logs, rocks, or debris piled by the muskrats themselves. Some

A muskrat lodge in a cattail marsh in Massachusetts.

This muskrat feeding platform, found in Massachusetts, is probably the remains of a collapsed lodge.

of these debris piles have roofs and are called "feeding shelters." Much has been written about feeding platforms and shelters constructed by the animals, but more often I've found them using an existing surface just above the water level, such as a log, rock, collapsed lodge, or private spot on shore. Plant debris and scat are found at the feeding site, and in still water debris may litter the water near the platform.

At any time of year, muskrat lodges, burrows, feeding platforms, and feeding shelters are good targets for a camera trap. At a lodge you might see occupants maintain it or raccoons or coyotes destroy it in search of occupants. During waterfowl breeding season, ducks and geese use muskrat lodges as nesting platforms.

11

MEADOW VOLE

Order Rodentia / Family Cricetidae

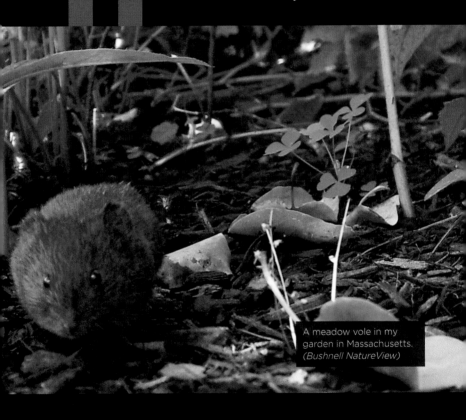

A meadow vole in my garden in Massachusetts. *(Bushnell NatureView)*

THE WIDESPREAD MEADOW VOLE (*Microtus pennsylvanicus*) is a keystone species. In addition to its critical role as prey for a wide variety of aerial and terrestrial predators, it can delay forest succession by feeding on saplings and seedlings of woody plants and influence plant composition of herbaceous communities by selective feeding.

Physical Characteristics

The vole is a sausage-shaped 1- to 2-ounce rodent with a dark-brown back, gray-brown sides, a gray-white belly, a short tail, and small ears. Mature adults reach 4¾ inches in length, excluding the 1¾-inch tail.

Tracks and Trails

Front tracks are about ¼ to ½ inch wide and long. Hind tracks are about ¼ to ½ inch wide, and ⅜ to ⅝ inches long. Vole feet are of typical rodent structure, but clear tracks are rarely seen, so the ability to recognize trail patterns and runways is essential.

Voles often move in an alternating trot, with a stride of 2 to 3¼ inches and a straddle of ⅞ to 1 ¹¹⁄₁₆ inches. They also commonly use a 2-2 lope. They sometimes walk and occasionally bound. They create runs, leaving familiar 1-inch-wide worn paths through grass and on snow. Networks of runways and tunnels may be extensive and punctuated by burrow openings. In deep snow they create tunnels that are revealed as the snow melts.

As snow melts, vole tunnels and nests are revealed. These nests are probably just for sleeping, not breeding.

Diet

In spring and summer, shoots of many different grasses, sedges, and forbs dominate the meadow vole diet. In summer, leaves, flowers, and fruits of forbs are also taken. Seeds, roots, and bulbs become more important in fall and winter, and the cambium of trees and shrubs is eaten in winter, especially if snow cover limits foraging for other foods. Voles occasionally consume fungi, insects, snails, and carrion. They may eat in situ or carry food away for consumption in a safer spot. They are known to sometimes cache foods, such as ground beans and Jerusalem artichokes, in underground

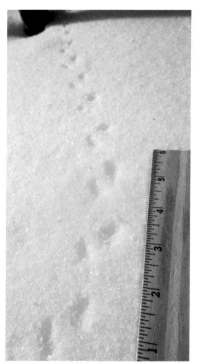

A vole's 2-2 loping pattern in New York.

burrows for winter feeding. They may also cache food in times of abundance, regardless of season. My camera traps have captured them dragging off carrot pieces (placed aboveground for baiting) and lettuce leaves in summer, but I do not know if this was for storage or for immediate consumption under denser cover.

Scat and Urine

Meadow vole scats are about ¼ inch long and the shape of rice grains. Color ranges from greenish to blackish brown. Scats are left along runs, especially at trail junctions, and at entry holes to nests and dead-end latrines. Urine and glandular secretions are rarely observed due to the tiny volume.

This meadow vole, baited with a potato attached to a fence, ate some of it in place and carried the rest away, in pieces. (Bushnell NatureView)

Habitat

Optimal habitat is open landscape with moist soil and thick perennial grasses, which provide excellent overhead cover. Grassy marshes are ideal, and meadows, crop fields, open woodlands, orchards, lawns, gardens, bogs, riparian zones, and pond edges are also used. Voles are subject to 2- to 5-year population cycles, with population density exceeding 600 per acre in peak years in ideal habitat. In less favorable habitat, the population density can average less than 50 per acre.

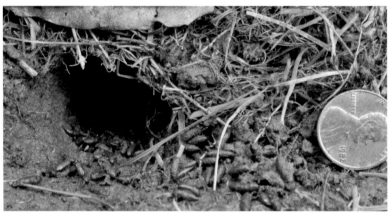

A vole latrine at the mouth of a burrow in Massachusetts. About a week after this photo was taken, the hole was plugged for reasons unknown to me, but voles continued to feed daily around the old hole.

Breeding

In the South, meadow voles can breed year-round, but stop for the winter months in cold climates. Voles are promiscuous, and offspring within one litter may be fathered by several different males. After a 21-day gestation, an average of 3 to 6 young are born in a 4- to 8-inch diameter grass nest with a central chamber. In warm weather, nests are usually placed under thick clumps of grass or other vegetation,

This 6- to 8-inch-diameter vole nest, found in Massachusetts, was revealed after a lawn was mowed. Several baby voles were turned up out of the nest, one of which is at top right. The mother soon retrieved her young and returned them to the nest.

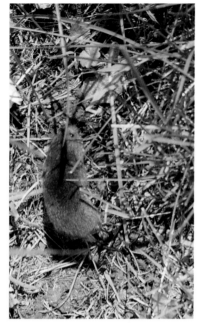

A meadow vole pauses in its run near a latrine in Massachusetts. *(Bushnell NatureView)*

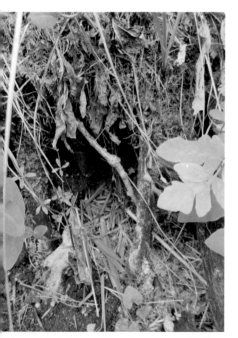

This pile of match-length grass blades at the mouth of a burrow was created by a vole in a wetland habitat in Massachusetts. Voles cut them to reach the seed heads, and they may eat the grass blades too.

hay bales, scrap wood, or logs and sometimes in underground burrows. Young are weaned in 14 days.

Camera-Trapping Tips

Because voles spend much time underground and rocket through their above-ground runs at impressive speed, a camera trap with a fast trigger speed is needed for reliable capture. And because voles are very small, they are best captured with a camera that can focus on small bodies at close range. At the time of this writing, the Bushnell NatureView Cam HD Live View fits the bill. It is an IR flash camera that comes with two additional lenses for close focus.

Voles are said to be active both day and night, but during the summer months in my backyard I have found them to be far more active during daylight, allowing me to get nice color photos with the NatureView.

It's worthwhile to try to capture a vole darting through its runway on video just to appreciate the speed. But because of that speed, you won't see much more than a furry sausage shooting across the screen, if you are lucky enough to capture the animal at all.

Set a camera on 1-inch diameter holes and runs in grasses. Tall grasses provide sufficient cover, but where vegetation is short, voles prefer to create their runs along some object for cover. Look for them along logs, low

fence rails, raised garden bed frames, and foundations, though they do sometimes course through open lawn.

Because voles have short life spans (only 2 to 3 months in some areas), and because they experience population surges and crashes every few years, some runs and tunnels are inactive at any given time. Look for fresh scat at a trail junction or hole, and fresh feeding sign, such as clipped grasses and piles of match-size lengths of grass, near holes. One-inch-diameter holes near disappearing vegetable crops, such as lettuces, Swiss chard, corn seedlings, and so on, often indicate vole feeding.

In winter, fresh debarking at ground level (or on snowpack) may indicate vole activity, which can be captured by trail camera. Voles gnaw no more deeply than is necessary to reach the cambium. Deeper gnawing is likely the work of a rabbit.

Debarking by a vole in Massachusetts.
Photo by Anne Marie Meegan

Voles are quite aggressive with each other, and many adults bear battle scars on the ears or flanks. Males fight when near females in estrous, probably for breeding rights. Breeding females are aggressively territorial, but in winter in cold climate, territorial behavior ceases and multiple animals huddle for warmth in burrows.

Scent marking may help both sexes avoid aggressive encounters. Both sexes defecate or urinate over or beside the scent of other voles. Males rub their flanks on objects along runs, and they may groom their own anogenital region when they encounter a female's scent.

Voles may be baited with lettuce, carrots, peanut butter, and other vegetable foods.

12

DEERMICE

Order Rodentia / Family Cricetidae

A juvenile deermouse in Massachusetts carries an acorn by the cap end. After studying many photos of mice carrying acorns, I believe they usually carry large acorns by making a hole in the cap end by inserting the lower incisors and grasping outside the shell with the upper incisors. *(PIR triggered Canon 60D)*

OF THE MORE THAN 120 SPECIES OF DEERMICE in North America, the most widespread and abundant, and the subjects of this account, are the North American deermouse (*Peromyscus maniculatus*) and the white-footed mouse (*Peromyscus leucopus*). They are closely related and use similar habits but do not interbreed and do not appear to compete with each other.

Physical Characteristics

Adults of both species weigh about ¾ ounce. The tail is usually slightly shorter than the body. Adults are brown to gray brown above and orange brown on the sides. Juveniles are gray above and on the sides. The belly fur is white at the tips and gray at the base. The tail is gray above and white below and covered with short fur. Compared to the North American deermouse, the white-footed mouse has a longer tuft of fur at the tip of the tail and a larger white chin patch, and the length of gray at the base of the belly fur is shorter.

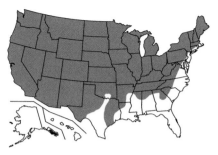

North American Deermouse

Tracks and Trails

Front tracks of adults are up to ½ inch and show a typical rodent 1-2-1 pattern, with 2 central toes pointing forward and 2 outer toes pointing to the sides. A 5th vestigial toe does not register. Three metacarpal pads often register and 2 posterior metacarpal pads sometimes register.

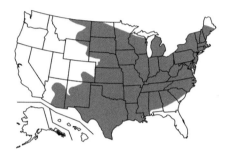

White-footed Mouse

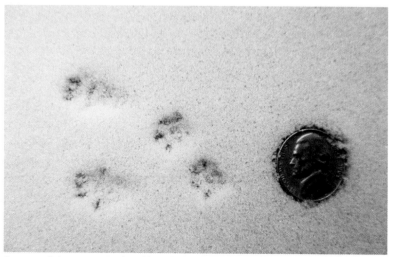

A group of deermouse tracks within a bounding pattern. The two hind tracks are at left, and the animal is moving to the left.

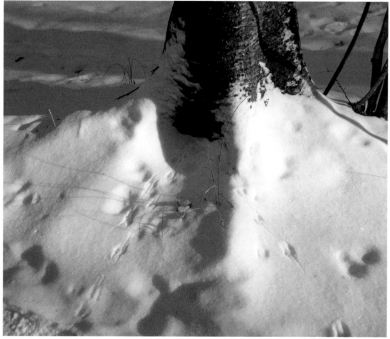

Deermouse bounding trails in soft snow. Each group is an H-shaped depression with a tail drag. Mice spend a lot of time under snow in winter, and when they do travel over snow, their trails often begin and end at the base of a tree or shrub, or some other type of cover.

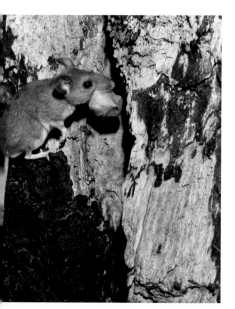

Hind tracks of adults are up to 9/16 inches wide and show typical rodent 1-3-1 pattern, with 3 central toes pointing forward and 2 outer toes pointing to the sides. Four metacarpal pads usually register, and 2 posterior metacarpal pads may register.

Deermice bound through open areas, leaving a trail width of 1¼ to 1⅔ inches, a group length of 1⅛ to 2⅛ inches, and a stride of 4 to 20 inches. The tiny tracks of mice are usually indistinct, but often the bounding

Mice are competent climbers. This one carries a hickory nut as it climbs the inside wall of a hollow tree in Massachusetts. *(PIR triggered Canon 60D)*

pattern is recognizable. In soft snow each group looks like an H-shaped depression with a tail drag.

Deermice climb well, often high into trees to forage or nest in cavities. They also swim well.

Diet

Both species rely primarily on seeds and nuts, but also eat insects, spiders, caterpillars, other invertebrates, fruit, mushrooms, and green vegetation. Insects and spiders tend to be staples in some areas. They are important predators of gypsy moth pupae and caterpillars.

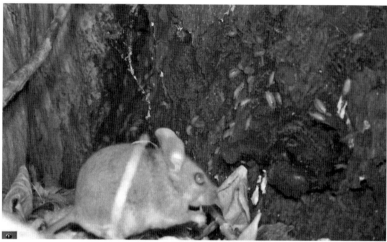

This mouse in Massachusetts is eating an insect that it grabbed from the wall of the tree cavity. It is probably a woodlouse—notice that many are crawling on the wall above and to the right of the mouse. (*Bushnell NatureView, snipped from a video*)

Scat and Urine

Droppings are ³⁄₃₂ to ¼ inch long irregular pellets with either pointed or blunt ends. Scats appear smooth when fresh but rough and wrinkled as they dry. Mice do not defecate in their nests. They form latrines near nests, and also drop scats along travel routes and at feeding areas. They urinate along travel routes and also at conspicuous locations, and drag the groin, scenting with glands near the genitals, after fighting and in novel environments.

These rough and wrinkled deermouse droppings are at least several days old. Note the variation in shape.

Habitat

The North American deermouse is the more widespread, making a living in almost any habitat, from forest to shrubland to grassland to desert. The white-footed mouse also lives in a wide variety of habitats but is most abundant in warm, dry forest and shrubland. Both species may occupy suburbs with a substantial amount of brush, forest, fields, or parks.

Breeding

Breeding peaks in spring and fall, but in warm climates, they may breed monthly, nearly year round. More typically, 2–4 litters are produced per year. The male may remain with the female after mating, and may even use the natal nest, but does not seem to provide any parental care. After a gestation of 23–28 days, 3–7 young are born. They are weaned at about 3 weeks. Spring litters disperse soon after weaning; fall litters may not disperse until 2 months of age.

Camera-Trapping Tips

Nearly ubiquitous and almost entirely nocturnal, deermice are responsible for many unwanted nighttime triggers of trail cameras intended for larger animals. But their lives are every bit as complex as those of larger animals. Most people who choose to study them come to appreciate them for the intelligent and curious creatures that they are.

While many standard trail cameras are sensitive enough to trigger for mice, they cannot focus on a tiny body at close range. Images of mice look like blurry little blobs with long tails and big eyes. They allow you to see gross behaviors—chasing or foraging, for example—but to see the details, you need a camera that can focus close-up.

The Bushnell NatureView Cam HD Live View is the only ready-made trail camera for small animals available at the time of this writing. It's excellent for small creatures that are active by day, and it's reasonably good for small nocturnal animals like mice, with a couple of limitations. Photos captured in darkness tend to be way overexposed. A flash diffuser made from the semiopaque material of a plastic milk jug might correct this problem. I have not tried this for the NatureView, but have found that it does correct overexposure in other trail cameras.

When the NatureView is used in video mode, exposure is appropriate and screen shots can be taken from video clips if still images are desired. Unfortunately, though, the NatureView has a slow video trigger speed (about 2 seconds), so fast-moving mice will often be missed. To capture a video with this camera, you must target a site such as a nest, food cache, or bait station where a mouse will stop for at least several seconds.

For sharp, color images of mice, a homemade camera trap with a white flash is needed. The color images of mice in this book were captured with a Canon 60D DSLR wired to a passive infrared sensor, with an external flash and an 18–55mm

lens set at 18mm and manually focused at F18. The photos are heavily cropped, but the resultant images are still quite crisp.

Good spots for camera trapping mice are often discovered incidentally with a standard trail camera deployed for other animals, but to search for them purposefully, knowledge of their habits and recognition of their spoor are necessary. Finding their haunts is not quite as easy as finding vole runs, for deermice do not create well-worn paths.

Winter in colder climates can make camera trapping deermice difficult, because they tend to move about under the snow, spend much time huddling in nests, and may even enter torpor during extreme cold. On the other hand, it's easier to track them in snow. When they do travel over snow, bounding trails begin and end at some form of cover. These spots of entry and emergence may be good targets.

Deermouse nests are good targets, if you can find them. Both the North American deermouse and the white-footed mouse may nest near ground level, high in trees, and anywhere in between, filling nooks and crannies with grass and leaves and a lining of fur, feathers, and shredded vegetation. At ground level they use holes under the roots of trees and shrubs and nest in and under stumps, logs, and brush piles. Deermice don't dig burrow systems, but they sometimes nest in abandoned ground burrows constructed by other animals. Above ground level, tree cavities and old bird nests are popular. Bird nests are refurbished with a protective roof of vegetation. Deermice also readily take up residence in buildings.

Deermice are quick to pilfer seeds or nuts from the caches of other animals. While the red squirrel sleeps, a nocturnal mouse may be busy transporting food from its larger cousin's larder to its own. In fact, the most continuous mouse activity I've seen happened one winter at a red squirrel's cache of hickory nuts.

It's very interesting to observe how mice create the sign on nuts and seeds that we find in the field. I have found that they most often carry large acorns in their mouths by the cap end. From what I can see in photos, I believe they cut a hole in the cap end of the shell and insert the lower incisors into the

Mice often use old pileated woodpecker foraging excavations for nesting or caching. Often scat, feeding sign, nesting material, or even the mice themselves may be seen upon careful inspection of a hole. This one has a single mouse dropping.

This large midden spilling out of the end of a hollow log was the work of deermice. Notice that many of the acorns were eaten from the cap end.

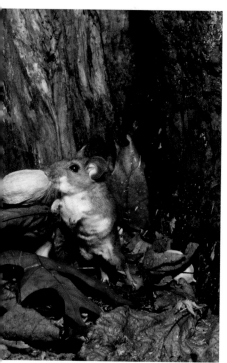

A deermouse in a large tree cavity in Massachusetts carries a hickory nut by grasping the point of one end in its mouth. *(PIR triggered Canon 60D)*

acorn, while the upper incisors grasp the outer shell. Perhaps this is why so many acorn shells in mouse middens appear to have been eaten from the cap end.

On the other hand, deermice usually carry hickory nuts by grasping either pointed end between the teeth. They may create a visible carry notch with their incisors to maintain a firm hold during travel. Smaller seeds, such as cherry pits and basswood seeds, are carried in their small cheek pouches.

Mice may carry seeds and nuts to eat in a safe spot, usually under the cover of a log or overhanging rock. Look for their middens in such locations and deploy a camera to see how they feed. In the fall they cache some of their seeds and nuts, engaging in both scatter hoarding and larder hoarding. They create scatter caches by digging shallow holes in the ground, depositing the food and covering it with soil and debris. They amass larders in the

This cache of multifora rose hips in an old robin's nest in a crabapple tree in Massachusetts was created by deermice. My camera trap showed that they returned to feed from the cache at night throughout winter, and robins occasionally stole berries during the day.

A deermouse fed on the cherry pits in the scat of another animal, possibly a fox, in Massachusetts.

Deermice engage in chases, fights, and mutual grooming. They also use a variety of body postures and sounds to communicate, and I long for an excellent quality video-camera trap to study them in a natural setting. *(PIR triggered Canon 60D)*

same kinds of nooks and crannies used for nesting. They often store food in old bird nests, but they don't create a roof like they do when they use a bird nest for sleeping. Such an open cache is an excellent camera target, for mice return to feed from it, and birds and other small mammals may pilfer from it.

Any collection of seeds or nuts can attract hungry deermice, even if it's in the scat of another animal. I have found what appears to be mouse feeding sign on cherry pits in a canid scat, and someday I should like to document this with a camera trap. And it's not only seeds and nuts that attract mice to scat. I've captured them visiting river otter scat, which does not contain mast. The images were poor resolution, but it appeared that the mouse was eating something in the scat. Perhaps the fish scales in otter scat are a source of calcium for rodents.

Deermice eat mushrooms, something I was able to confirm with a camera trap. Often the fruiting body rots before long, so the camera must be placed soon after it appears. Look for one that appears to have a bit of nibbling on it already, for the nibbler might return.

Finally, it's important to know that deermice carry and spread the hantavirus, which causes a potentially lethal flu-like illness. Enjoy them with your trail camera, but do not handle them or their droppings, and do not stir up dust in a mouse-infested closed space without goggles and a respirator with a filter, because the disease can be contracted by inhalation of contaminated dust.

13 NORTH AMERICAN PORCUPINE

Order Rodentia / Family Erethizontidae

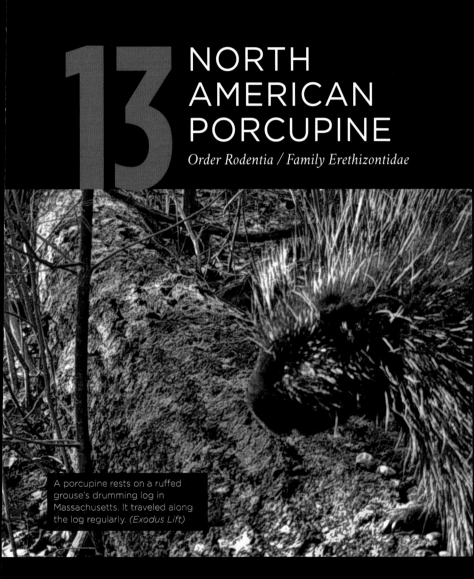

A porcupine rests on a ruffed grouse's drumming log in Massachusetts. It traveled along the log regularly. *(Exodus Lift)*

NATIVE AMERICANS REVERED THIS PRICKLY RODENT, the North American porcupine, *Erethizon dorsatum*. The meat was valued for food, its quills were dyed and used to embellish textiles, and bristles from the underside of the tail were used to make combs. However, modern Americans often see the porcupine as a pest because of the damage it does to vehicles, outbuildings, and implements in its quest for salt, and to trees in its quest for food. In fact, these concerns prompted some of the reintroductions of the fisher, one of the few effective porcupine predators.

Physical Characteristics

The upper portion of the porcupine's 7- to 40-pound, stout, short-tailed, short-legged body is covered with creamy white quills from head to tail. Long, black to yellowish-brown guard hairs conceal quills over much of the body, but quills of the head, lower back, and sides of the tail are exposed, creating a strong black-and-white contrast.

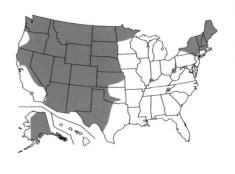

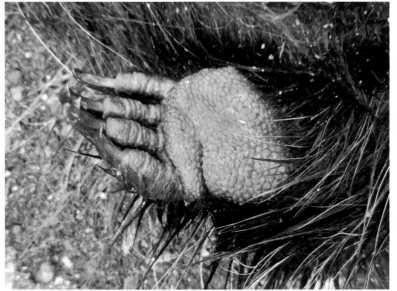

A porcupine's right front foot. Note the long claws and the pebbled surface of the heel pad.

Tracks and Trails

The heel pads of a porcupine's feet form one large pad with a textured surface to provide friction when the animal climbs. The toes do not register in shallow substrate, but the long claws do. The hind feet have 5 toes and average about 1½ inches wide by 3¼ inches long. The front feet have 4 toes and average 1½ inches wide by 2¾ inches long.

Well defended with sharp quills, porcupines move at a relaxed pace in an alternating walk. Their stride is 6 to 10 inches and their straddle is 5 to 9 inches. Tail quills often create drag marks. Clear tracks can be hard to find, because the animal creates well-used runs. In deep snow, runs may appear as troughs.

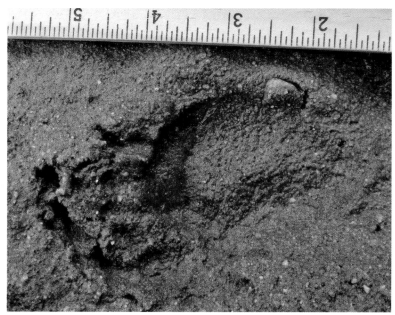

A left hind porcupine track in Massachusetts. The toes register here in deep mud, but usually do not register in shallow substrate.

A porcupine trail in Massachusetts. The quills sometimes drag in snow, but in this case, the drag marks appear to be from claws.

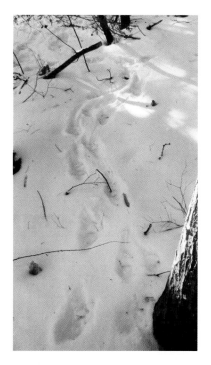

Diet

As an herbivore, the porcupine varies its diet with the seasons. Buds and young leaves of trees and shrubs are taken in spring. In summer, leaves of aspens, American linden, and raspberry are preferred, as well as leaves of herbaceous plants. In late summer through fall, many fruits and nuts are taken. Its winter diet consists of hard mast such as acorns if available, the inner bark of a variety of trees, and the twigs, buds, and needles of conifers.

Scat and Urine

Porcupines excrete pellets measuring about 1 inch long and ⅜ inch wide.

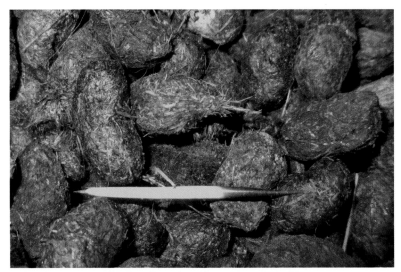
A pile of porcupine pellets and a single quill found in a den in Massachusetts.

Many are curved, giving them the appearance of a cashew nut. Sometimes several pellets are linked together at the ends, like a chain of little sausages. When porcupines have been feeding on conifers, their urine has a pleasant, piney odor. Both scat and urine are left indiscriminately.

Habitat
Habitat use varies by season. Forest is essential for fall mast, winter woody forage, spring buds, summer leaves, and resting and denning sites. In summer porcupines also frequent meadows and other open areas to feed on herbaceous plants.

Breeding
Mating occurs in fall, usually September through November. If the female does not become pregnant, she may ovulate again a month later. A single *porcupette* is born about 7 months after mating. The mother does not defend her baby, and while it is fully quilled, it cannot yet deliver a powerful tail slap, so hiding is its best defense. Once it can climb, the baby begins to eat solid food. At first it forages in a tree with the mother, but eventually it finds its own feeding trees, venturing farther and farther away from her. By 3 months babies weigh 4½ to 5 pounds. Young are fully weaned after 4 months and independent by around 6 months. Females disperse during their first year, while males may remain in their mother's territory for several years.

Camera-Trapping Tips
Because the porcupine's main defense is its sharp quills, it can afford to move very slowly, and that means it's an easy and gratifying trail-camera subject. Winter

is by far the easiest time of year to track and camera trap porcupines, because it's much easier to find them, and it's not just because snow is a great substrate for tracks. Winter dens are easily identified, and the occupant travels just a few hundred yards on well-used runs between its den and its feeding trees, which bear obvious sign.

Rock crevices are preferred winter dens, but porcupines are amazingly adaptable. I've seen them use a wide variety of shelters, including an old beaver bank lodge, a hollow log, a cavity at the base of a tree, a hollow beneath the roots of a tree, a hole in a stream bank, and an old cellar hole. All dens are ready-made shelters; porcupines do not dig their own. Preferred dens are high and dry, but I have seen several in low-lying areas with floors of ice! Occasionally 2 porcupines share a den, often a pair that mated the previous fall.

If the den was only recently occupied, there may be only a few droppings littering the floor. As scat accumulates, though, the animal pushes it out of the way, and it begins to spill out of the den. The most coveted dens may be used year after year, as evidenced by vast quantities of scat spilling out of the mouth. There might also be shed quills on the floor of the den.

Where caves and crevices are abundant in close proximity to favorite tree species for winter feeding, porcupine densities are highest. In central Massachusetts, where rock outcrops and jumbles of boulders provide many denning options within hemlock-dominated, mixed forest, density estimates range from 32 to over 100 animals per square mile.

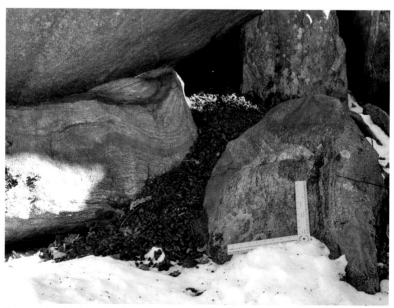

A porcupine den in Massachusetts in a crevice among a pile of boulders has scat spilling from its mouth.

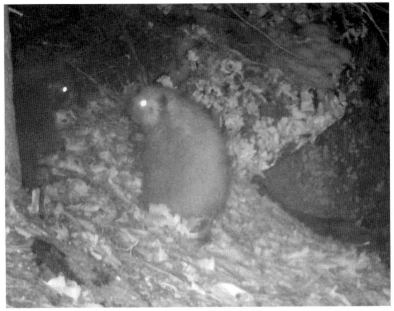

Where winter resources, such as rock caves and hemlock trees, are concentrated, porcupines are close neighbors in separate dens, or may even share large dens. This pair were in Massachusetts. *(Exodus Lift)*

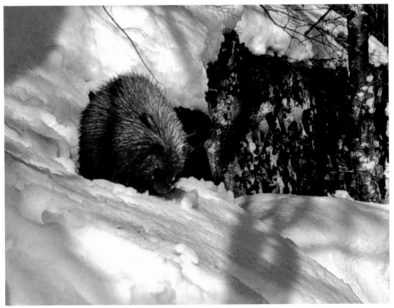

Steep cliffs provide excellent denning and sunbathing opportunities, both of which are important for thermoregulation in winter. This porcupine in Massachusetts sat in the sun for about two hours. *(Exodus Lift)*

Porcupines leave an angled cut when they nip twigs.

Where available, eastern hemlock usually tops the winter menu, but sometimes it is ignored, and preferred tree species really vary by region. In the Great Lakes states, eastern white pine, sugar maple, and American elm are most desirable. In the Adirondacks of New York, eastern hemlock and red spruce are preferred. In Maine, white cedar, eastern hemlock, and beech are favored. In central Massachusetts, eastern hemlock is heavily browsed, but sugar maple, eastern white pine, and northern red oak are frequently used, as well.

Porcupines tend to return to the same few feeding trees day after day, in winter, so that feeding sign accumulates. Look for twigs and small branches littering the ground beneath. The porcupine climbs the tree, cuts a twig or small branch, consumes the choicest leaves or buds, and drops the rest to the ground. A porcupine-nipped twig or branch shows an angled cut that is relatively smooth on small twigs, but has a stepwise appearance on larger ones. Many of the buds, or needles in the case of a conifer, will have been eaten from the distal end.

Though less common, feeding on the living, inner bark in winter is also easily spotted. It appears as patchy debarking anywhere on the tree, from exposed roots up to narrow branches. On tree trunks and roots, it can be confused with beaver activity, but there are some differences. Porcupines feeding is superficial, no deeper than necessary to eat the cambium, while beaver gnawing may be either superficial or deep. Favored tree species also differ. Beavers usually shun conifers, while porcupines often prefer them. If you're not sure which rodent is the culprit, set up a trail camera!

A porcupine run under a rock overhang, heading to a hemlock tree in Massachusetts. Notice the nipped twigs littering the ground beneath the tree.

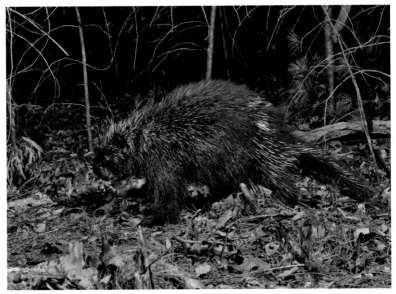

This porcupine in Massachusetts passes through an otter latrine along an otter run, to reach a lakeshore where it can feed on succulent vegetation in early spring. *(PIR triggered Canon 60D with two Nikon SB28 flashes)*

Runs between winter dens and feeding trees may appear as troughs in deep snow and as trampled paths without snow. They often course under rock overhangs, where snow accumulation is lighter. Due to heavy use, clear tracks may be hard to find, but occasional scats and quills betray porcupine usage.

Keep in mind that animal trails can be multiuse. I once found an otter run coincident with a porcupine run for a few hundred feet. My trail camera showed regular usage by both species and revealed that porcupines sometimes plopped down to relax on the run. One autumn it captured a porcupine pausing to groom and nap.

Try following a run in each direction to find the den and a feeding tree. Both the tree and den are outstanding spots for a camera. I had a camera set on a den and captured not only the

Porcupine feeding sign on exposed root found in New Hampshire shows scrape marks by the animal's incisors. At left a piece of the root cut by the animal shows the characteristic stepwise pattern.

porcupine's many arrivals and departures, but also a bobcat spraying and a coyote urinating on the rock just outside the den.

When winter gives way to spring, most porcupines leave their winter dens and rest in the open, usually in trees but sometimes on the ground. It isn't clear whether females typically give birth in a den, but at least some are born more or less in the open on the forest floor. Dark-brown coloration makes them hard to see in the shadows. Mother rests and feeds in a nearby tree, returning to her baby at night to nurse. If you can capture this interaction on a trail camera, you will have a glimpse of something rarely witnessed.

Soon, within weeks, if not days, of birth, a baby follows its mother when she goes to feed. The baby can crawl but cannot climb well for several weeks, so it hides near her feeding tree on the forest floor, usually in a hollow at the base of a tree. If there is no such hollow tree near the mother's feeding tree, it may hide under a log or in a crevice or even sit in plain sight at the base of her tree.

Spring is also the peak of the porcupine's salt craving, particularly for adult females who are losing sodium through lactation. Natural sources of salt include yellow pond lily (to which they will swim), salt-rich soil, and fresh bones of carcasses. You may capture this behavior by stationing a camera at a salt-rich site with fresh porcupine sign or perhaps by creating a salt lick in April.

In summer porcupines travel over a wider range to avail themselves of a variety of foods in different habitats. One summer, with a camera set for otters, I captured several visits of a mother and her playful porcupette visiting an open lakeshore to feed on herbaceous plants.

In late summer and autumn, porcupines enjoy mast such as acorns and apples. It can be hard to distinguish porcupine from other animal feeding sign on apples, and I have not targeted apple trees. Apples, however, are a possible bait for porcupines. Sweet, low-acid varieties, like Red Delicious, are preferred. Be sure to place the apple close to an active den or favorite feeding area so the porcupine will get it before any of the many other animals that enjoy apples.

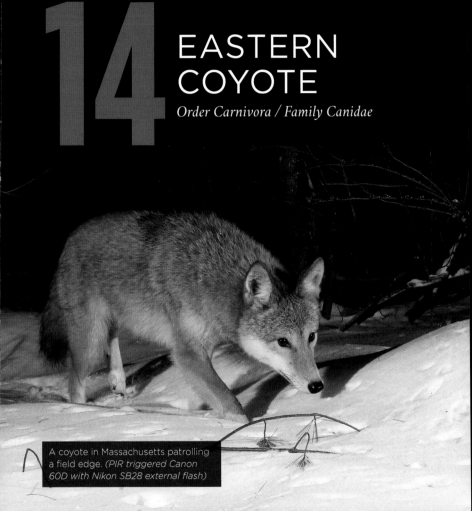

14 EASTERN COYOTE

Order Carnivora / Family Canidae

A coyote in Massachusetts patrolling a field edge. *(PIR triggered Canon 60D with Nikon SB28 external flash)*

THE "COYOTE" OF THE NORTHEASTERN AND MIDWESTERN United States is the result of extensive hybridization between the western coyote, wolf, and domestic dog. About 65 percent of its DNA comes from the western coyote, 25 percent from the wolf, and 10 percent from the domestic dog. Its physical and behavioral traits are intermediate between coyote and wolf. Southeastern coyotes, too, probably get a significant portion of their genes from wolves.

Physical Characteristics

Females average 35 pounds and males average 40 pounds. The ears are smaller than those of the western coyote and longer than those of the wolf. The tail is bushy, usually with a black tip. Most coyotes are gray brown with reddish legs, ears, and flanks, but some are blond, brown, or reddish.

Tracks and Trails

Both front and hind tracks are oval with 4 toes and a roughly triangular heel pad. The heel print is usually fainter and shallower than the toe prints. All toes have claws, which usually register in good substrate. Claw marks tend to be very fine. The outer toes usually sit close to the heel pad and leading toes, with claw marks registering so close to the leading toes that they are difficult to see. However, outer toes may point slightly outward when the toes are splayed. The track is symmetric with respect to the long axis, and the negative space between the pads usually shows an X.

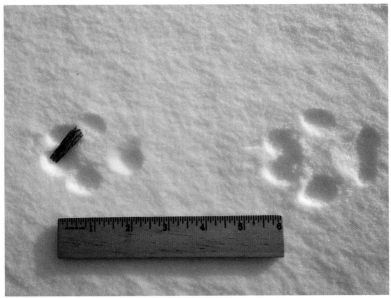

Front (at right) and hind tracks of a coyote in Massachusetts. Tracks are oval, and marks of leading claws are fine and delicate. Notice that the heel impression of the front track is roughly triangular and that of the hind track is small and circular. In these tracks the outer toes are slightly splayed, perhaps to prevent sinking through the fine crust of snow, but often they are tucked in close to the foot.

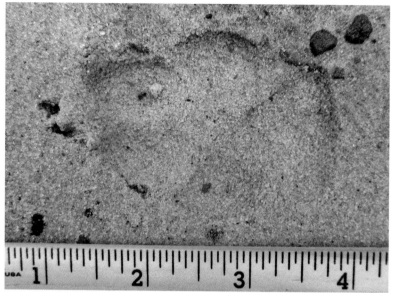

An eastern coyote front track in firm sand. The two leading claw marks are very close together, and the two outer toes and claw marks are tucked in. Domestic dog tracks are often splayed with blunt claws that point outward, even in firm substrate.

An eastern coyote's overstep walk in Massachusetts. Hind tracks fall ahead of the front tracks. This pattern is easily confused with a lope, but in that case the groups of four tracks would be spaced farther apart.

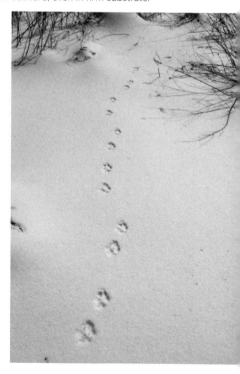

In the Northeast, front tracks are 2½ to 3½ inches long and 1¾ to 2¾ inches wide. Rear tracks are 2¼ to 3¼ inches long and 1¼ to 2 inches wide, and the heel print is smaller and rounder.

Coyote and dog tracks are easily confused. As a guideline (not a strict rule), dog tracks are rounder, the toes are more likely to stick out the sides, and the heel pad is usually more pronounced, as if the dog is more flat-footed.

Coyotes often trot and walk while traveling. An alternating trot and side trot are commonly used. The width of its alternating-trot trail pattern is

narrow, giving the impression that the tracks are almost in a straight line. Coyotes lope and gallop when they need to speed up. They may travel singly or in small groups. In deep snow they may step in each other's tracks, so that a single trail may represent multiple animals. As a general rule, coyote trail patterns appear neater and more consistent than dog trail patterns.

The straddle of an eastern coyote's alternating pattern is 2 3/16 to 6 inches, and the stride is 13½ to 26 inches. When the stride exceeds 16½ inches, it is probably a trot (Elbroch, 2003).

Diet

This highly adaptable omnivore consumes small mammals, birds, snakes, insects, fruits, berries, and carrion. It usually hunts singly, but occasionally a pack takes down large prey, especially if the prey animal is injured, ill, or disadvantaged by deep snow. Coyotes cache excess food by burying it.

Scat and Urine

Scat is usually ½ to 1¼ inches in diameter. Scat filled with fruit (particularly apple) may exceed 1½ inches. Hair-filled scat usually appears twisted and may contain small fragments from the small bones of prey. Scat and urine are common along well-used travel corridors and at trail junctions, rendezvous sites, and kill sites. Scat and urine are sometimes left on raised surfaces such as boulders and stumps. Scat and urine left on soft substrate may be accompanied by sign of scraping by the

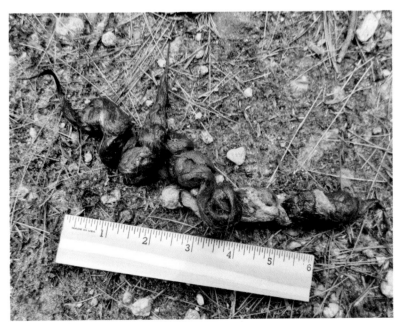

Twisted hair-filled coyote scats.

Tandem urine marking by a female coyote in estrous and her mate.

hind feet. When a breeding female is in estrus, her urine may be blood tinged, and her mate may leave his own urine next to hers. This is called "tandem marking."

Habitat

The adaptable, opportunistic coyote inhabits a wide variety of habitats, including cities, suburbs, farmland, forest, wetland, field, grassland, and desert. It prefers mixed habitats with an abundance of edges, where small prey abound. Where wolves and coyotes both range, wolves are dominant. Coyotes steer clear of their larger relatives by forgoing wilderness for human-dominated areas, as long as there are sufficient hiding and denning sites. In west-central Wisconsin, for example, wolf sign is common in prime wilderness areas, while coyote sign is more common along roads and near human dwellings.

Breeding

Mating occurs January through March, depending on latitude. In Massachusetts it is usually late January to mid-February. An average of 4 to 5 pups are born about 2 months later, in a den created or chosen by the female. Both parents and older siblings, if present, tend to the pups. Pups nurse for 6 to 8 weeks, but begin eating regurgitated meat at 3 weeks. After weaning, pups are usually moved to a rendezvous site, where they play while adults hunt. Gradually they venture farther and farther from the site, and by fall pups hunt with adults and on their own. The

rendezvous site is abandoned, though pups and adults may reconvene there from time to time throughout winter.

Camera-Trapping Tips

Coyotes present the same challenges as wolves: They travel widely, trot at a good clip, and are wary of humans. However, their sheer abundance in a wide variety of habitats throughout much of the United States makes them one of the more commonly photographed species. And they are interesting subjects. They are clever, social, and caring creatures. As a result of genetic influence from the western coyote, wolf, and dog, eastern and midwestern coyotes are quite varied in their appearance, and I find it fascinating to see this firsthand with my trail cameras.

Coyotes move along field-forest edges, streams, and lakeshores, and make use of trails created by humans and other animals. They often leave scat and urine on well-used trails, especially at trail junctions. In Massachusetts, coyotes regularly use large beaver dams as crossing structures. They pause to study the surrounds on exposed ridges and other vantage points and visit stumps and large snags to sniff or mark. All of these types of sites are good spots for photographing coyotes.

More social than western coyotes but less social than wolves, eastern coyotes are extremely flexible. A family may consist of the breeding pair and their pups, all of which disperse in fall. Or, they may form small packs, with some young remaining with parents to help with the pups of the following year. However, they do not form large packs as wolves do.

Coyote family life can be studied with trail cameras at home sites (dens and rendezvous sites). Where coyotes are heavily persecuted, they are wary of human

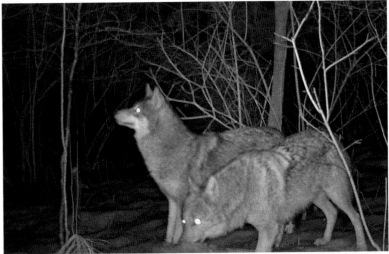

The shorter ears and broader build of these eastern coyotes, relative to those of western coyotes, are the result of hybridization with wolves. This pair was in Massachusetts. *(Exodus Lift)*

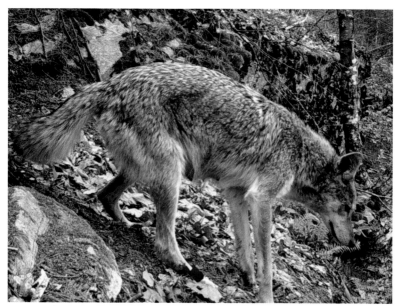
A nursing female coyote descends a ridgetop in Massachusetts. She is probably denning in a rock cave in this steep, rocky, and secluded terrain. *(Exodus Lift)*

activity and will relocate after disturbance. So it is best to station the camera during fall or winter, after the animals have moved on. Coyotes often reuse home sites for future litters, and a camera placed at an old one might capture great footage the following breeding season.

Dens are used for the first 8 to 10 weeks of the pups' lives (typically April through early June in Massachusetts). The narrowest dimension of the entry hole averages about 1 foot, and the widest dimension may reach 2 feet. There is usually a conspicuous throw mound, but unlike foxes, coyotes keep the den area clean of scats and prey remains. The female does most, if not all, of the digging and may prepare multiple dens prior to giving birth, as if she is planning ahead for relocation. Pups may be moved to a new den if disturbed and sometimes just to escape external parasites.

Den-site selection depends on the available habitats, but coyotes do prefer an area that is secluded or difficult for humans to access. They prefer to dig—whether to remodel an old groundhog, skunk, fox, or badger den—or to begin afresh. Most burrows are in well-drained soil on a hillside, mound, dune, or ridge. Vegetative cover may be sparse or dense. In forested areas, coyotes may burrow under a tree-root system or log. Not all dens are burrows. Coyotes also use caves, rock crevices, hollow logs, and dense thickets.

When pups are 8 to 10 weeks, they are moved to a rendezvous site comprised of an open area or high ground so adults can spot danger, dense cover for hiding, and a nearby water source. In Massachusetts typical spots for rendezvous sites

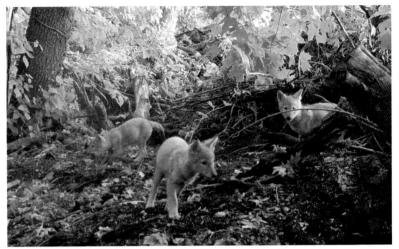

A trio of coyote pups at their rendezvous site near a jumble of logs and branches at a forest-field edge in Massachusetts. This family used the area outside the den as a rendezvous site for at least a month after the pups emerged from the den. They also tolerated frequent human visits to check cameras, perhaps because coyotes are generally not persecuted in this area. *Photo by Robert Zak (Moultrie)*

Mated pairs, or even families of coyotes, may reconvene from time to time in winter. A network of runs, lays, and prey remains are evidence of frequent use of this winter meeting site at the edge of a farm. Like rendezvous sites usually chosen for pups, this winter meeting area consists of an elevated spot with a commanding view, dense shrubby cover, and adjacent forest into which the coyotes can disappear to escape danger. The mound is where the farmer has dumped rocks and logs, which make the footing extremely difficult for nosy humans. A trail camera here yielded plenty of video footage of a pack of three.

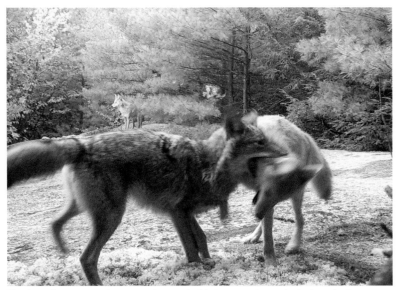

Two juvenile coyotes play as another, probably a parent, is on the lookout in the background. *(Moultrie)*

are where dense forest or brush meets a beaver meadow, an old field, an orchard, or an abandoned cranberry bog. Most rendezvous sites are within ¼ mile of a water source and at least 200 yards from the nearest human structure. Evidence of pup activity is often obvious. You may find "chew toys"—bones, antlers, corn cobs, sticks, pilfered dog toys, and even plastic bottles—in patches of flattened-out vegetation where pups play.

Where coyotes have less wolf DNA, such as in southern and western states, use of rendezvous sites may be transient or infrequent; the literature is unclear. Perhaps the purer coyote's more rapid development and greater dependence on small prey allow young to become self-sufficient at a younger age, reducing the need for rendezvous sites.

Coyotes can be attracted with bait, such as roadkill, but many are wary of commercial lures due to widespread trapping.

WOLF

Order Carnivora / Family Canidae

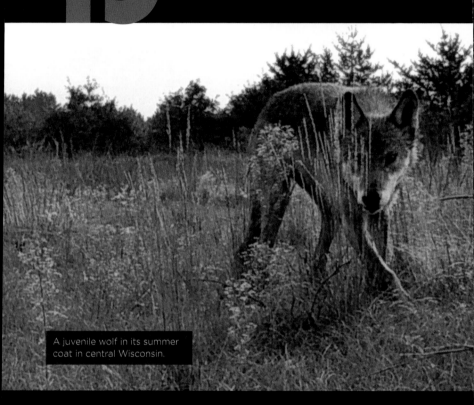

A juvenile wolf in its summer coat in central Wisconsin.

A RECENT GENETIC STUDY suggests that all "wolves" of the eastern United States are most likely gray wolf (*Canis lupus*)—coyote (*Canis latrans*) hybrids with a bit of dog DNA. Wolves of the Great Lakes region have a large proportion of wolf DNA, and they have been the subject of all of my wolf camera trapping. Formerly called red wolves, those of the southeastern United States have more coyote DNA and look more like coyotes. The only surviving wild population of these "red wolves" is in eastern North Carolina.

Physical Characteristics

Wolves in the Great Lakes region range from about 50 to 100 pounds. The male is slightly larger than the female. Most often the back is gray and the underside is white to buff, but occasional individuals are mostly black, blackish brown, or white. Compared to coyotes, wolves have smaller ears, a stockier muzzle, longer legs, and larger feet.

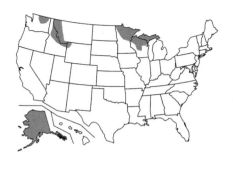

Tracks and Trails

Both front and hind tracks are oval with 4 toes and a roughly triangular heel pad. All toes have claws, which usually register in good substrate. The outer toes usually sit close to the heel pad and leading toes, but may point slightly outward when the toes are splayed. The track is symmetric with respect to the long axis, and the negative space between the pads usually shows an X.

Front tracks are about 4 to 5 inches long by 3 to 4 inches wide. Rear tracks measure about 10 to 15 percent smaller in both length and width, and the heel-print may appear smaller and rounder. Expect smaller tracks from the red wolves of eastern North Carolina, probably overlapping in size with those of the eastern coyote.

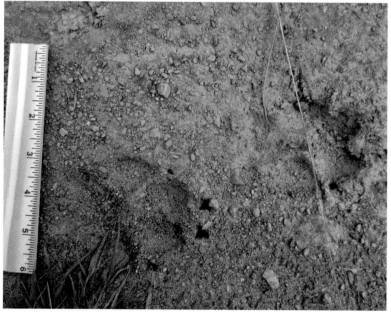

Front (left) and hind wolf tracks, found in Wisconsin.

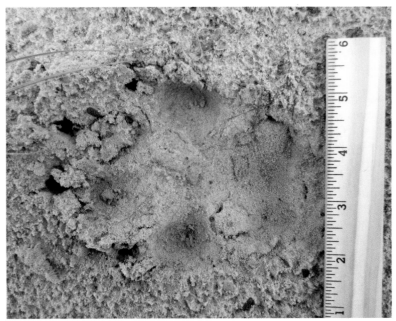
Splayed wolf track in soft sand found in Wisconsin. Note than an X can be drawn through the negative space without cutting through the pads.

Wolves use a direct registering walk or trot, or a side trot, when exploring and patrolling. The straddle of the alternating pattern is 4 to 10 inches, and the stride is 13 to 34 inches. When the stride of an alternating pattern exceeds 22 inches, it is probably a trot. Wolves often trot along travel corridors. When necessary, they speed up to a lope or gallop. Wolves are highly social and often travel in groups.

Diet
Wolves eat mainly large ungulates, such as deer, elk, and moose, and tend to select the easiest targets: the young, old, and infirm. In some areas they prey heavily on beaver. Smaller prey, such as rabbit, is taken opportunistically. The alpha pair do most of the hunting for the pack. Wolves cache excess food by digging a hole, placing the food in it, and covering it with soil and debris. They sometimes eat fruit and berries, but they are much more carnivorous than coyotes and foxes.

Scat and Urine
Scat diameter ranges from about ½ inch (for pups) to about 1 ⅝ inches (for large adults). Scat appearance depends on what was eaten (organs vs. muscle vs. hair and bones). Hair-filled scats are most often found, because they last longest in the field. They appear twisted and may contain relatively large fragments from the large bones of prey. Scats are common along well-used travel corridors and at trail junctions, dens, rendezvous sites, and kill sites. Urine may be left on the

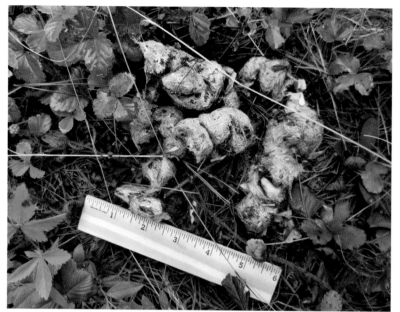
Wolf scat containing hair and large bone fragments.

ground or on raised surfaces. Scat and urine are sometimes accompanied by sign of scraping, done with hind feet. When an alpha female is in estrus, her urine may be tinged with blood, and the alpha male will leave his urine next to hers.

Habitat

Wolves can eke out a living in almost any habitat where large prey abound. But due to relentless persecution, wolves of today are often relegated to areas of low human density: the mountainous regions of the contiguous United States and the forests and tundra of Canada and Alaska. The expansive wetlands comprising a large complex of protected land in Central Wisconsin are an exception. Wolves occupy this region, feeding on white-tailed deer and perhaps recently reintroduced elk.

Breeding

Mating occurs in January through March, depending on latitude. In Wisconsin it is usually in February. About 2 months later an average of 6 pups are born in a den created or selected by the female. The male and other pack members provision her for the first 8 to 10 weeks, while she nurses the pups. Then the litter is moved to a rendezvous site. Other pack members feed them regurgitated meat. Gradually the pups wander farther and farther from the rendezvous site, and by mid to late autumn, when pups are ready to accompany adults on hunting excursions, the pack may abandon the rendezvous site altogether.

Camera-Trapping Tips

Wolves are challenging subjects for the camera trapper because they often trot, range widely, and are sensitive to human disturbance. The relatively rapid gait makes for fuzzy images, extensive travel means infrequent reappearance at a given location, and sensitivity to humans means abandonment of the home site if disturbed.

A good approach is to find travel corridors in spring and summer, when wolf movement is more predictable, because pups keep them tied to home sites. Travel corridors can be found where water, vegetation, or other landscape features funnel movement of large mammals. Dykes, beaver dams, game trails, lightly traveled human roads and trails, mountain passes and saddles, ridge lines, and the edges of streams and wetlands are all possibilities. Look for evidence of repeated use: the presence of old and fresh tracks and scats. Trail junctions would seem to double the odds of success, but wolves often cut corners.

It helps to know what dens and rendezvous sites look like and where wolves tend to establish them, so you can study aerial images to predict likely locations before an on-the-ground search. Do this during the off-season (fall and winter) to avoid putting yourself in danger or disturbing the wolves. It's worthwhile to place cameras at old home sites, for wolves often reuse them.

Dens are used for the first 8 to 10 weeks of the pups' lives (typically April through early June in Wisconsin). The entry is usually oval, with smallest

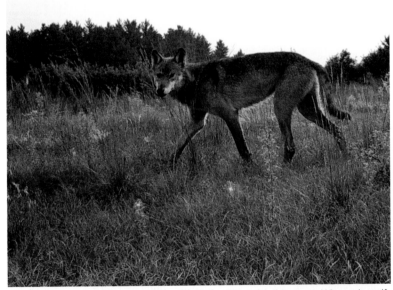

The smaller ears, broad head, and long legs help distinguish this young Wisconsin wolf from a coyote. (*Exodus Lift*)

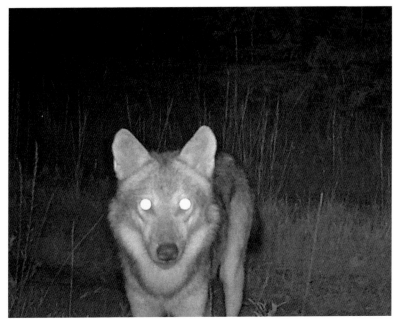

A curious wolf studies the camera stationed on a dyke used by a wolf pack as a travel corridor. *(Exodus Lift)*

dimension at least 15 inches and largest dimension up to 3 feet. Well-used trails radiate from the entry. In forested areas, wolves use hollow trees or logs or dig under the roots of large trees or stumps. Sometimes they use beaver lodges, rock caves, or crevices. In open habitats, they may use natural depressions or burrow into sandy slopes, banks, or eskers. Sometimes they enlarge the burrows of other animals. Some burrows have multiple entrances, and the main one usually has a large throw mound.

Most dens are within 200 yards, and many are within 50 feet, of water. Some studies found that wolves select for dense cover within a 50-foot radius of the den. They also seem to prefer a site with plenty of coarse woody debris or rocks, perhaps for camouflage. Where possible, adults prefer to bed under nearby conifers overlooking the den. Pups may be moved to a new den periodically, or the same den may be used throughout the nursing period. Persecuted populations tend to choose sites far from human activity and are quick to relocate if disturbed. Typically no adult scats or prey remains are found around dens.

After weaning, pups are moved to a rendezvous site, an above-ground home site where pups wait while adults hunt. It is usually a semiopen area of about ½ to 1 acre in size, adjacent to a wetland. It consists of beds, a network of runs, and "activity areas," or patches of flattened-out vegetation where pups play. Activity areas may be in forest, field, and/or wetland and are often littered with chewed bones, antlers, and fur of prey animals.

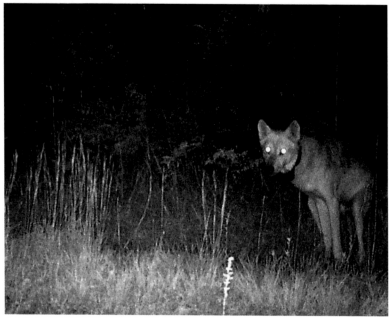

A radio-collared Wisconsin wolf squats to mark its well-used summer travel corridor. In summer wolf movement is more predictable because they are tied to their breeding dens. *(Exodus Lift)*

Pups are usually moved to a new rendezvous site every 1 to 4 weeks. Sometimes adults move the pups to a kill site, which then becomes the new rendezvous site. The final site is abandoned sometime in autumn, when the pups are ready to hunt with adults.

In winter, wolves are more nomadic, and in some regions they follow migrating herds. If you do find a travel corridor in winter, keep in mind that in deep snow wolves often travel in single file, stepping in each other's tracks. Face the camera down trail at an angle, and use the burst or video setting to capture multiple individuals.

Baits and lures get wolves to pause, allowing for better images. The best bait is a carcass that you find in wolf country. Set the camera on-site, or move the carcass a short distance to a better spot. Do this at your own risk, though, for large carnivores don't take kindly to anyone tampering with their food.

Commercial scent lures can be used to get wolves to mark, and this makes for interesting video footage. You may be able to distinguish between resident and transient wolves, for residents often raise a leg to urinate, while transients rarely do so. However, keep in mind that where wolves are hunted, trapped, or captured for radio collaring, animals may be "trap shy" and avoid lures.

16

GRAY FOX

Order Carnivora / Family Canidae

A gray fox considers its surroundings in a dry stream bed near forest-field edge habitat in Vermont. *Photo by Susan Fly (Moultrie)*

THE GRAY FOX, *Urocyon cinereoargenteus*, is the lesser known of the two fox species in the eastern United States. Its species name articulates the most obvious feature that distinguishes it from the red fox, for *cinereo* means "ash colored," and *argenteus* means "silver."

Physical Characteristics

This 7- to 15-pound canid has a grizzled gray body with orange on the ears, the sides of the head and neck, the lateral parts of the belly, and the backs of the legs. The belly, throat, chin, and cheeks are white. Part of the snout and the tip and upper portion of the bushy tail are black. The gray fox is slightly shorter and stouter than the red fox.

Tracks and Trails

The roundish tracks are usually 1 to 1 ½ inches wide, with front tracks a little bigger than the hind. Tracks are smaller and rounder than red fox tracks, and lateral toes splay slightly outward in soft substrate. The front heel impression is small and shows three lobes in excellent substrate. Often, however, it looks like a thick chevron, sometimes with a central thickening, earning the description of a "winged ball." The hind heel pad usually looks like a small dot. With such small heel pads, both front and hind tracks show a lot of negative space, but pad impressions are crisper than those of the red fox, for the gray fox's feet are less furred.

Semi-retractile claws may show in good substrate. When claws do not register, these small round tracks may look like cat tracks, but the fox's heel pad is much smaller and the toe arrangement is symmetrical.

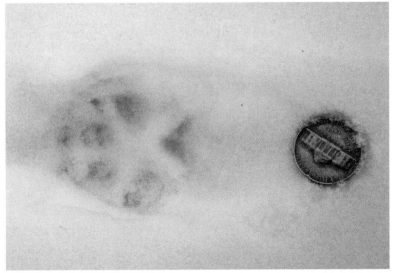

Front track of a gray fox in deep, soft snow in Massachusetts. Note that it is possible to draw an X through the track without cutting through any of the pads. This is often the case with gray fox tracks.

The gray fox usually travels in an alternating trot or walk, with a slightly smaller step length and wider straddle compared to the red fox, leaving a trail with a more noticeable zigzag. The trail width of an alternating pattern is about 2 to 4½ inches, and the stride is 6 to 18 inches. A stride over 9 to 10 inches is probably a trot (Elbroch, 2003). The gray fox uses a straddle trot more often than a side trot. Gray foxes lope or gallop when they need to speed up.

Diet

The gray fox eats rabbits, mice, voles, squirrels, rats, birds, bird eggs, insects, reptiles, carrion, fruit, grains, and nuts. It eats more fruit and insects than either the red fox or the coyote does. It appears to be a truly opportunistic omnivore, rather than a predator that settles for fruit when meat is unavailable.

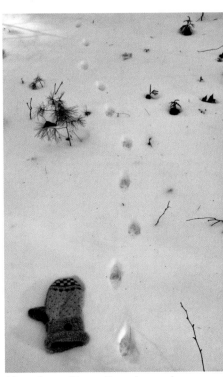

Alternating walking pattern of a gray fox. The mitten is about 8½ inches long.

Scat and Urine

Scat diameter is up to about ¾ inch, and appearance varies depending on diet. Hair-filled scats appear twisted. Scats are often placed on stumps, logs, and rocks and may punctuate travel routes. Latrines are sometimes created near dens and food resources, such as fruit trees.

Gray foxes urinate frequently, often on small saplings and stumps, and the urine has a distinctive odor, which you will learn from experience. It's as distinctive as red fox urine, but less skunky. During the breeding season, gray fox urine seems to take on more of a skunky odor, making the distinction

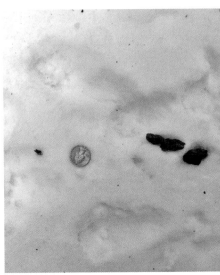

Urine and scat left by a gray fox in New Hampshire.

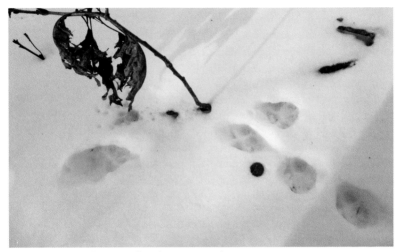
A gray fox urinated on a small sapling in Massachusetts.

from red fox more difficult. Take every opportunity to sniff the urine of these two species to learn to distinguish them.

Habitat
The gray fox prefers a landscape mosaic, often using the edges between habitat types. As such, it thrives in secret between the backyards and small forest patches of leafy suburbs. It also inhabits brushy, rocky terrain and mixed and hardwood forests. Within large forest patches, it is attracted to wetland edges and rock outcrops. It likes good cover and usually avoids the open meadows, pastures, and agricultural fields that attract the red fox and coyote.

Breeding
The mating season is late December through March, depending on latitude, and an average of 4 young are born about 2 months later. Both parents raise the young, but it appears that the male is less involved than the female. Pups emerge from den at 4 to 6 weeks and leave the den site at 10 to 16 weeks for an above-ground home site in dense thickets. No further description of these sites is in the literature, and I have never observed one, either active or abandoned. Pups reach adult weight by 5 to 6 months and disperse at 7 to 10 months.

Camera-Trapping Tips
The gray fox is often confused with the red fox, but they are in distinct genera, and some important differences allow them to occupy different niches. The gray fox is more omnivorous and avoids open landscapes, probably to avoid competition with the red fox or predation by the coyote. It's more secretive than the red fox, less common in densely populated areas, and more common in remote areas than

the red fox. And—with its rotating forearms and strong, hooked, semiretractile claws—the gray fox is a capable climber, an unusual talent for a canid.

In some ways the gray fox has more in common with the bobcat, and that goes well beyond its climbing ability. It loves to walk on logs and up angled trees and perch atop boulders to look around. And, like the bobcat, the gray fox is largely a creature of edge and ledge. In fact, virtually every individual I've tracked, camera trapped, or seen was closely associated with either edge habitat or large rock outcrops with plenty of cracks and crevices for denning and resting.

Given its habitat overlap with the bobcat, it's no surprise that wherever the bobcat is camera trapped, so too is the gray fox likely to be captured. The fox does not avoid the cat in space, but it probably avoids it in time, because bobcats sometimes kill gray foxes.

The gray fox does like forested habitat—trees can be escape routes, surveillance sites, food sources, and den sites—but its trails in the forest usually lead rather quickly to edge or ledge. It is also closely associated with shrubby habitat, such as chaparral in the West. But in the east, shrubby habitats tend to be at forest-field or forest-wetland edges, or they are a transient stage of field-to-forest succession.

To see a lot of gray fox action, look for the fox's well-used travel routes, latrines, and dens. You will know its favored routes when you find frequent urination and scats on rocks, logs, and stumps along the way. Scats are often single, but sometimes latrines are created. A camera set on a latrine will likely catch the fox in the act, which could make for a sharp photo. That's a treat for this trotting canid, which usually appears as a blur when it passes through the detection zone.

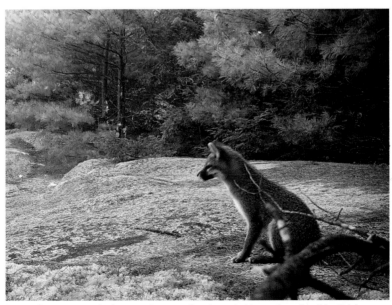

A gray fox pauses to look around on a rock outcrop in Massachusetts. (Moultrie)

Gray foxes do use human trails, but not as often as coyotes do. This is probably active avoidance on the fox's part, for the coyote is a major cause of gray fox mortality.

Gray foxes use a wide variety of natal den sites, depending on what is available. When they use underground burrows, they prefer to remodel one excavated by another animal, such as a woodchuck, or to dig their own in loose, friable soil. They also den under brush piles, rock piles, and porches and in rock crevices and hollow logs. They occasionally den in tree cavities. Compared to red fox dens, gray fox dens tend to be surrounded by denser cover.

While breeding dens may be located close to people in order to avoid coyotes, a denning gray fox family is sensitive to human disturbance and may relocate as a result. Therefore, it's best to keep your distance, or try setting the camera in winter at an old woodchuck den. In spring determine from a distance if the den is occupied, or simply leave the camera until summer and celebrate whatever decided to use the den.

Any of the types of sites used for natal dens may be used as resting sites. With snow cover winter rest sites can be identified by fox trails radiating to and from the den. To avoid stressing the animal, use the trails to find frequently used but less sensitive spots, perhaps a latrine or a lookout. In the warm seasons gray foxes may rest on large branches or boulders, but these are difficult to find without trailing the animal to its bed.

The gray fox comes readily to bait, but so do many other predators. You might try putting the bait in an easy-to-climb tree to reduce competition from the other canids, and catch the gray fox on video in the act of climbing. Suet and many kinds of meat have been used successfully to bait foxes.

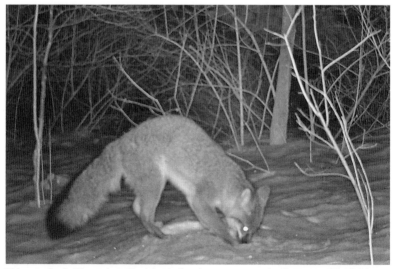

This gray fox in Massachusetts detects the deer carcass under the snow. *(Moultrie)*

17

RED FOX

Order Carnivora / Family Canidae

A red fox at a field edge in a suburb of Massachusetts *(PIR triggered Canon 60D with Nikon SB28 external flash)*

THE RED FOX (*Vulpes vulpes*) is native to the boreal and montane regions of North America, and its appearance in lowland areas of the United States was presumed to be due to the spread of European red foxes introduced to the eastern United States in the 1700s. However, recent genetic studies show that modern red fox populations in the United States actually derive mostly, if not entirely, from native red foxes. Range expansion of native red foxes into the northeastern and southeastern United States was facilitated by the clearing of forests for agriculture. Midwestern populations derive from escapes and releases from fur farms, which were originally stocked with native North American red foxes.

Physical Characteristics

The 8- to 15-pound red fox has longer legs and a more slender body compared to the gray fox. It is usually reddish orange with black legs. The belly, throat, chin, and tip of the tail are white. Occasional individuals are black, gray, or buff, but the tip of the tail is always white. "Cross foxes" show a mix of red and black color phases.

Tracks and Trails

Both front and hind tracks are roughly oval in shape, with 4 toes and often claw marks. Front tracks are usually 1 ½ to 2 inches wide. Abundant fur on the bottom of the foot causes the heel pad to appear as a chevron, leaving a lot of negative space in the middle of the track. Rear tracks are usually 1 ¼ to 1 ¾ inches wide, with a small roundish heel pad and a lot of negative space in the center.

The red fox usually travels in a direct registering, alternating trot and sometimes in a walk. The straddle of its alternating pattern is 2 to 3 ¾ inches, and the stride is 8 to 20 inches. A stride exceeding 12 inches is probably a trot (Elbroch, 2003). It frequently uses a side trot and speeds up to a lope or gallop when necessary. It occasionally uses a straddle trot, but only for short distances. Compared to the gray fox, the red fox runs faster and appears more nervous in its movements,

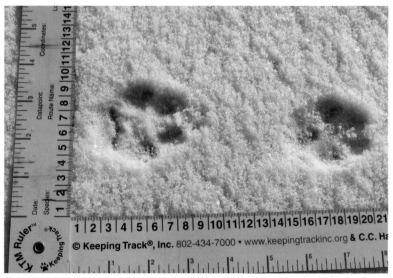

Front (at left) and hind red fox tracks found in Massachusetts. Note that it is possible to draw an X through the tracks without cutting through the pads. This is often the case with red fox tracks.

though it does slow to a walk when investigating or when in good cover. The width of its direct registering walk or trot often appears so narrow that tracks are in almost a straight line.

Diet

The red fox eats rabbits, mice, voles, squirrels, rats, birds, bird eggs, insects, reptiles, carrion, fruit, grains, and nuts. It is an omnivore but prefers meat when available, takes insects and other invertebrates opportunistically, and takes fruits, acorns, and cultivated grains in season. The fox is quite flexible and adaptable, and will switch from a favored to an alternative food source in order to avoid competition with the coyote, when necessary.

When prey abounds, the red fox may capture much more than it can consume at the moment. It usually caches each victim in a hole it digs with its

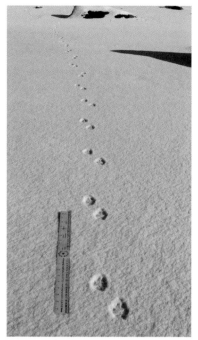

A red fox side trot transitions to a straddle trot for a short distance, then back to a side trot.

A chicken was cached by a red fox under the snow in Massachusetts. The scrape marks do not have toe prints because the fox used its nose to cover the chicken.

front paws, then uses its nose to carefully cover the cache with debris. After retrieving a cache, the fox urinates on the empty hole, perhaps as a way to remind itself that the food has already been retrieved.

Scat and Urine

Red fox scat is indistinguishable from gray fox scat. The maximum diameter is about ¾ inch, and the appearance varies depending on the animal's diet. Hair-filled scats appear twisted and may contain pieces of small bones. Scats are often placed on stumps, logs, rocks, or any other object that stands out visually, and may punctuate travel routes and trail junctions. I do not know if red foxes create latrines. Their urine has the distinctive odor of striped skunk spray, but it is far less intense and does not travel far. Red foxes often urinate on stumps, stones, and saplings and at the base of trees.

A mast-filled red fox scat placed on a white object makes a visually dramatic statement. *Photo by Robert Zak*

Red foxes often urinate on raised surfaces, in this case on the end of a log in Massachusetts.

Habitat

Like the gray fox, the red fox likes a mix of habitats and patrols the edges for small prey. It uses brushy habitats and forest, but unlike the gray fox, it's quite comfortable in open habitats, such as meadows, backyards, and farmland, where it is a well-known poultry predator.

Breeding

Pairs are monogamous through the breeding season and sometimes over consecutive years. Mating occurs December through March, depending on latitude. Usually 4 or 5 young are born after a 50- to 55-day gestation period. Both parents tend to the young. By about 1 month of age, young emerge from the den and begin rough-and-tumble play and intense competition for food. They are weaned around 2 months of age. They begin hunting with parents, and gradually venture out on their own. Most disperse sometime between late summer and early winter, but some daughters may stay in or near their parents' territory and help raise their litter the following year.

Camera-Trapping Tips

Long legs and heavily furred feet give the red fox an advantage in deep snow over the gray fox and coyote. Indeed, it ranges throughout Alaska and Canada, farther north than the coyote and much farther north than the gray fox. The 3 species are sympatric over the eastern United States, where the red fox may do better at higher elevations or in deep snow. But in general, the red fox's food and habitat preferences overlap more with those of the coyote than the gray fox.

Knowing where to find the red fox requires an understanding of the interactions between it and the coyote, and how the two species are influenced by human behavior. Both opportunistic canids like a mosaic of habitats with plenty of openings and prey-rich edge habitat, but the fox must avoid the coyote, its principal predator. Where neither species is harassed by humans, as in national parks, the coyote dominates in open fields, while the fox prefers cover. The fox makes greater use of woodlands, particularly deciduous or mixed forest, and limits its use of fields to the field-forest edge so it can quickly slip into hiding.

The situation is different in suburban and agricultural areas. Both species may be persecuted, but usually the larger coyote is more aggressively hunted and trapped. So in these areas the coyote uses cover-rich habitats, such as forests, edges, hedgerows, vegetated waterways, and lightly managed crop fields. The better tolerated fox is more likely to brave open fields and backyards and use human structures for denning, because it is relatively safe from coyotes when close to humans.

Red foxes may be fairly bold once they learn that people will tolerate them, and where that is the case, you may not need a camera trap to photograph them. More often, though, they live rather secretly among us, and the greater challenge is placing the camera where it is safe from theft.

In Michigan's Upper Peninsula and northern and central Wisconsin, wolves add another layer of complexity. They kill smaller canid species, but they are more tolerant of foxes than coyotes. In these areas it is likely that coyotes are forced to live closer to people, while red foxes share wilderness areas with wolves.

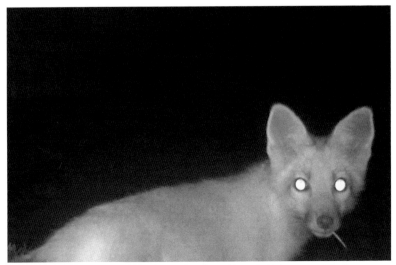

A red fox, just outside its den under an abandoned barn in Maine, peers into the camera. I'm not sure whether the object protruding from its mouth is a rodent tail, porcupine quill, or piece of vegetation. *(Exodus Lift)*

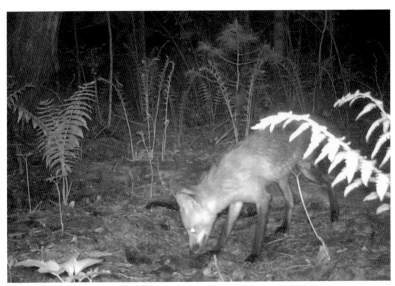

This red fox sniffs the remains of a beaver carcass in Massachusetts. *(Moultrie)*

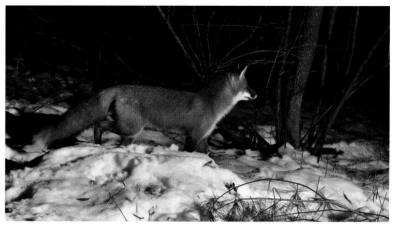

The red fox's gorgeous coat begs for a white flash. *(PIR triggered Canon 60D, Nikon SB28 flash)*

Sometimes the fox avoids the coyote temporally rather than spatially, meaning that the fox does use areas or resources favored by coyotes, but only when the coyotes are not around. Sometimes the fox does this with obvious angst and caution. With a camera stationed near a deer carcass at a forest-field edge, I captured an extremely jumpy red fox slinking in to scavenge scraps between coyote visits.

Red foxes may use human trails and roads. Their travel corridors are fairly easy to identify, because they mark them frequently with scat and their distinctive urine.

Underground burrows are preferred for raising young. The female may dig a new one, reuse one from a previous year, or remodel one excavated by another species. It usually has several entry holes, each of which measures 6 to 12 inches in diameter. Many burrows are in sandy soil on a slope in forested habitat, but close to a meadow or other opening, and within 100 yards of a water source. South-facing slopes are preferred. In human-dominated habitats, red foxes may den under structures, such as porches, decks, sheds, barns, and grain elevators, and in haystacks.

When young emerge from the den, family ties begin to relax, and young begin to hunt in small groups or singly. The father soon becomes intolerant of his offspring, but sometimes the mother reconvenes with them at a rendezvous site (also called a "rallying station") until the young disperse in fall or winter. A fox rendezvous site is probably a smaller version of a coyote rendezvous site, an above-ground home base with areas of trampled vegetation and littered with scats and food remains. However, the appearance of, and the family's activity at, rendezvous sites have not been described in the literature in any detail. This is an opportunity for a tracker and camera trapper to add to our understanding of red fox ecology and behavior.

Red foxes are enthusiastic scavengers and can be easily baited with meat.

18 BLACK BEAR

Order Carnivora / Family Ursidae

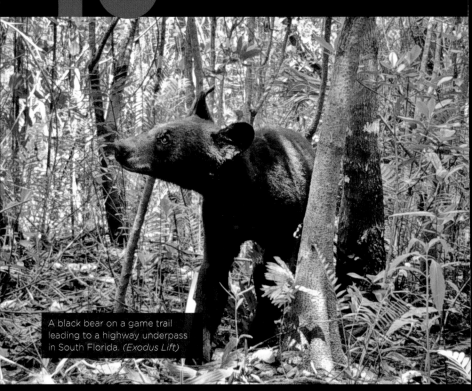

A black bear on a game trail leading to a highway underpass in South Florida. *(Exodus Lift)*

THE BLACK BEAR (*Ursus americanus*) is the smallest and most widespread of North American bears, and it's the only one present in the eastern United States.

Physical Characteristics

Adults usually weigh from 100 to 500 pounds, with males about 35 to 50 percent larger than females. Black bears have a stocky build, short tail, small eyes, and round ears. In the eastern United States virtually all are black with a brown muzzle. Some individuals have a white V on the chest.

Tracks and Trails

Like humans, bears walk with the sole of their foot flat on the ground. Both front and hind feet have 5 toes, but the innermost toes (#1), corresponding to our big toe, is the smallest and sometimes does not register. Claws usually register. In the front track, the "ball" of the foot registers reliably, but a small additional heel pad often does not. For this reason I do not measure track length. Width of the front track is about 3 to 6 inches from cub to large adult. In the hind foot the ball and heel are fused into one large pad, but the heel usually registers lightly, fading toward the posterior edge. Width is about 3 to 9 inches.

Bears usually meander in a walk, typically an overstep walk, but use a direct register walk in deep, soft substrate. The stride of an overstep walk is 19 to 28 inches, and the straddle is 8 to 14 inches. Bears trot, lope, or gallop when frightened.

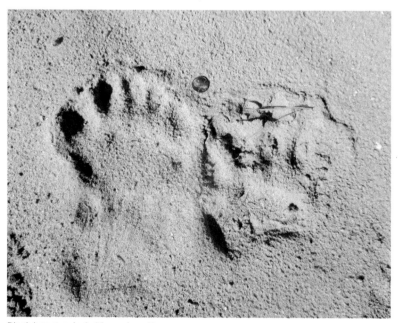

Black bear tracks in Massachusetts.

Notice the sets of claw marks on this 8-inch-diameter paper birch, indicating that a bear climbed the tree. Bears climb trees to forage, escape danger, rest, and play.

Diet

The diet of the omnivorous bear varies by season, but overall, 80 to 90 percent of its food is vegetable matter. In early spring, bears eat tender shoots of grasses and forbs, skunk cabbage, cattail rhizomes, young leaves of trees and shrubs, the catkins of aspen, the cambium of bark, and ungulate carcasses revealed as the snow melts. Insects are taken as they become available. In early summer, bears add ungulate young and bird eggs to the menu. In summer and fall they feast on a wide variety of berries, fruits, and nuts. Some favorites are serviceberries, blueberries, huckleberries, raspberries, blackberries, black cherry, apples, grapes, acorns, beechnuts, and hazelnuts. Bears also eat small mammals, garden crops, birdseed, suet, garbage, and occasionally livestock.

Scat and Urine

Scat size varies from ½ inch to over 2 inches in diameter, depending on the size of the bear, and appearance varies, depending on diet. Most bear scats are

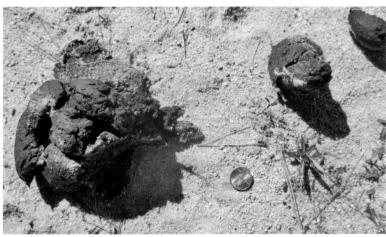

Black bear scat found in Massachusetts.

tubular, untwisted, and broken into several pieces. Small-diameter scats containing the remains of plant matter can be difficult to distinguish from raccoon, coyote, and fox scat.

Habitat
Black bears of eastern North America inhabit all types of forested habitats. An ideal home range is a patchwork of upland and lowland forest of various successional stages, from recently cleared to mature forest with wetlands and riparian zones.

Breeding
Bears usually mate in June or July, but the fertilized egg remains dormant until late November or early December, when it begins to develop. An average of 2 to 3 cubs are born in January or February while the mother is in her winter den. The female wakes after birth to clean and position them for nursing and then to respond to their cries as needed. They continue to nurse after emergence in spring, finally weaning sometime in summer. Cubs den with their mother the following winter and remain with her until the following June, when she chases them off before mating.

Camera-Trapping Tips
Bears are extremely curious about trail cameras and often pull, twist, rub, or bite them, which can reposition, damage, or even destroy the camera. Where bear

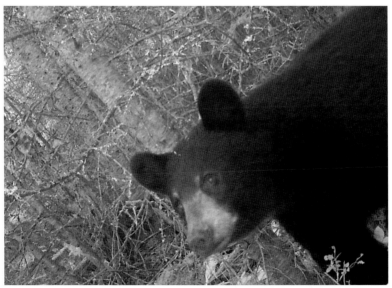

Bears often twist, pull, and bite trail cameras. This one, in Maine, twisted it and then posed for a selfie. *(Exodus Lift)*

activity is high, a metal security box and tightly fastened cable lock are essential to keeping the camera in place and intact.

When bears leave their dens in spring, they head for south-facing slopes, lower elevations, and wetlands, because these are the first places to green up. In New England this is often around beaver ponds. I have had great success in capturing black bear activity on runs near these ponds, especially near the dam, for black bears, like many other medium to large mammals, use beaver dams as crossing structures.

A mother bear spends more time foraging without her cubs as they grow. To keep them out of harm's way, she sends them up a tree to wait while she feeds. In spring, when the cubs are young, she often chooses a large conifer with low branches near a pond or wetland. The evergreen foliage provides good cover before deciduous trees leaf out, low branches make climbing easier for young cubs, and the wetland habitat provides good spring foraging opportunities for the mother. Trees that bears use for this purpose are known as "refuge" or "babysitter" trees. They do not necessarily have obvious climbing marks, for the bark of mature conifers is rough and furrowed and young cubs are light.

An interesting summer bear activity is wallowing in mud to cool off and to deter biting insects. Bear wallows may be used repeatedly, so they do make good spots for cameras. Look for them in moist, low lying areas.

In summer and into fall, shrubby patches of berries and hazelnuts and heavily bearing mast trees attract hungry bears. They tend to tolerate the presence of other bears in patches of abundant food, increasing the odds of capturing bear activity in these areas. However, it can be difficult to position the camera for good footage. In shrubby feeding areas try placing the camera near a game trail, or up high and looking down from a tree at the edge. In forests clumps of mast trees may be good sites for camera traps, especially if there are claw marks from climbing bears on some of the trees. Climbing marks are easiest to see on trees with smooth bark, such as beech.

Not all claw marks are caused by climbing. Bears often leave claw marks while they bite and rub trees and utility poles. Typically the bear rubs its back from side to side and up and down and points its nose upward to rub its forehead. Sometimes it reaches around with its mouth to bite and with a forepaw to claw. This behavior is thought to be deliberate marking, a means of communication with other bears. They revisit these "mark trees" to freshen their own scent and to mark over other bears' scent. Males mark mostly in spring and summer, perhaps to stake claim on females, and females mark mostly in late summer and early fall, perhaps to defend food resources.

Some mark trees are used repeatedly for many years by multiple bears. Look for mark trees with plenty of fresh and old sign. They may be found in many different habitats, from ridgetop to valley bottom, but they are often on trails used repeatedly by bears. Many different tree species are used for marking, but in the Northeast most of the mark trees I've seen have been red pine. Some sources say

A red pine in Vermont used by bears as a mark tree, with sign of repeated clawing, biting, and rubbing. Sometimes you may also find bear hair stuck to the tree, but the hair is not always dark, for the sun soon bleaches it pale.

that bears select large diameter trees that stand out visually in the landscape, but I have found mark trees as small as 3 inches in diameter. Utility poles and trail signage may also be heavily marked by bears.

Sometimes a section of a bear trail is itself marked in a curious way. It appears as a trail of worn ovals, caused by a bear stepping in the same spots each time it uses the trail. The bear uses a stiff-legged, stomping gait, rubbing the soles of the feet into the ground, thus depositing scent from pedal glands. It may also dribble urine, marking the vegetation in the middle of the trail, as it walks. Sometimes trees marked with bites, rubs, and claw

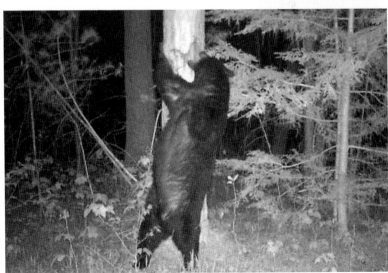

Multiple bears visit this "mark tree" in Massachusetts. Here a large male reaches around, biting and clawing at the tree. *(Exodus Lift, clipped from a video)*

A black bear marking trail, in which bears step repeatedly in the same places. Notice the series of ovals compressed by repeated foot falls. A 6-inch ruler marks one of them. This one in Massachusetts is in a mixed forest containing many mature red pines near a large wetland. Many of the nearby red pines have bear claw marks, and at least one is used repeatedly for rubbing and biting as well.

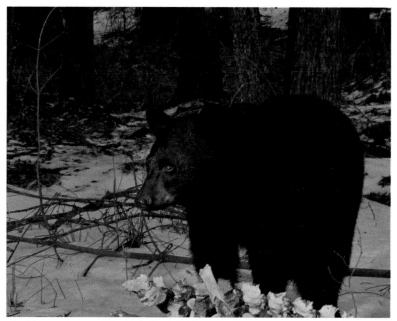
Black bears scavenge when possible. This one visits the remains of a moose found in the woods. *(PIR triggered Canon 60D)*

marks line these trails. Some sources suggest these trails tend to be near important resources.

A winter den site can be a good place for a camera. Bears may use an existing space under slash or brush, in a tree cavity, or in a culvert. They may dig to enlarge a space under a log, overturned tree, or clump of brush. Or they may excavate an earthen chamber at the base of a tree or stump.

The timing and length of hibernation depend on food availability, weather, and reproductive status. In Massachusetts, bears usually enter dens to hibernate sometime in November or early December, with pregnant females entering earliest. They remain in their dens till March, though they may wake up from time to time to forage if the weather is mild. Farther north they den earlier and emerge later, and farther south they den later and emerge earlier. In Florida only pregnant females den for most of the winter. Males and barren females may den for as little as a few weeks.

If you do set a camera trap near a den, keep your distance, keep quiet, keep your visit short, and do not return for the camera till the den is abandoned in spring. Human activity can cause bears to relocate, especially in southern states where winter dormancy is shallower and bears awaken more easily. Place your camera at least 15 feet away so you can capture behavior around the den. Bears do wake up and forage during winter if the weather is mild, and females with cubs remain attached to the den site for a couple of weeks after emerging in spring.

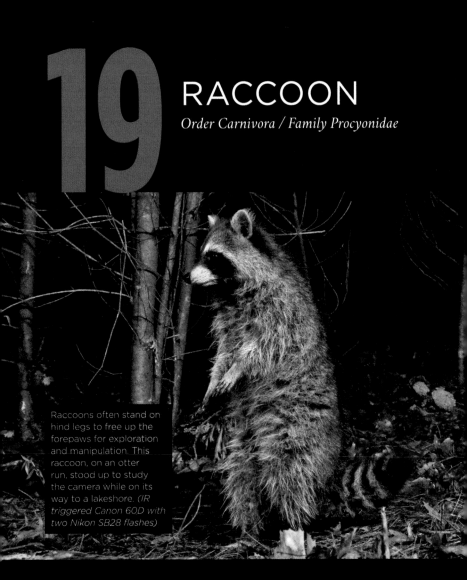

19
RACCOON
Order Carnivora / Family Procyonidae

Raccoons often stand on hind legs to free up the forepaws for exploration and manipulation. This raccoon, on an otter run, stood up to study the camera while on its way to a lakeshore. *(IR triggered Canon 60D with two Nikon SB28 flashes)*

LIKE HUMANS, THE RACCOON (*Procyon lotor*) is an intelligent, adaptable, opportunistic omnivore. It has become abundant and widespread in human-dominated landscapes.

Physical Characteristics

Raccoons weigh 5 to 33 pounds and have long grizzled gray fur and a familiar black mask on the face with white around the nose and above the eyes. The ears are edged white to buff, and the tail has light and dark bands.

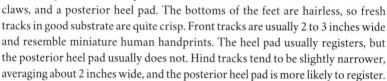

Tracks and Trails

Both front and hind tracks have 5 long toes, a large curved heel pad, short claws, and a posterior heel pad. The bottoms of the feet are hairless, so fresh tracks in good substrate are quite crisp. Front tracks are usually 2 to 3 inches wide and resemble miniature human handprints. The heel pad usually registers, but the posterior heel pad usually does not. Hind tracks tend to be slightly narrower, averaging about 2 inches wide, and the posterior heel pad is more likely to register.

The raccoon typically walks in a unique 2x2 gait, sometimes called a "couplet walk," in which the legs on the same side of the body move almost simultaneously. The stride is 8 to 19 inches and the straddle is 4 to 8 inches. Each pair consists of 1 front and 1 hind track, and the position of each switches in each successive pair. Raccoons may bound when in a hurry and use a direct register walk in deep snow. They can also swim and climb well.

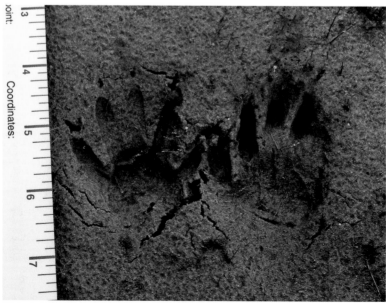

A pair of raccoon tracks within the 2x2 or "couplet walk," which is nearly unique to this species. The front track is on the left.

A raccoon's 2x2 walk. Note how the positioning of front and hind tracks alternate in successive pairs. In this example, front and hind tracks are exactly side by side, but the hind track in each pair may land slightly ahead of or behind the front track.

Diet

The raccoon eats a wide variety of plant and animal foods, depending on availability. Usually plant foods are more important, but in some locations and in some seasons, animal foods constitute the bulk of the diet. Fruit, berries, acorns, other nuts, corn, insects, worms, slugs, snails, crayfish, crabs, clams, mussels, small mammals, birds, amphibians, eggs, carrion, small livestock, birdseed, pet food, and garbage are all taken.

Scat and Urine

The size and appearance of raccoon scat varies widely depending on the

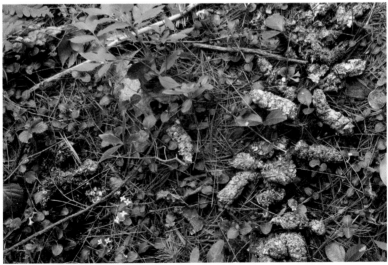

A raccoon latrine found at the base of a large tree near a wetland edge in Massachusetts. Most of the scats contain crayfish parts. These can be confused with scats of otter, which also eat crayfish and create latrines near water. However, it is rare to find a large collection of tubular otter scats, for otters are more likely to excrete poorly formed scats, and they roll in their latrines, flattening out tubular scats.

size of the animal and its diet. It's usually ½ to 1 inch in diameter and tubular with blunt ends. Scats may be dropped randomly but often are placed in latrines, which are usually located near a den or water source. The classic raccoon latrine is at the base of a large conifer near a pond or wetland where the animals forage, but they also may be under rock overhangs or on large horizontal branches, large logs, boulders, wood piles, stone walls, roofs, decks, haylofts, and the like. Avoid handling and sniffing raccoon scat, as it often contains eggs of a roundworm (*Baylisascaris procyonis*), which can spread by inhalation or ingestion. Infection in humans is rare but can be lethal.

Habitat

Raccoons use many different habitats. In less developed areas, they are closely associated with water sources, both coastal and inland. Lowland forest near ponds, streams, and wetlands are preferred. They sometimes use upland forest, especially those with nut-producing trees, cavity trees, or rock crevices for denning. They avoid wide-open upland fields, but make extensive use of forest-field edges of farmland, particularly those near cornfields. In suburban and urban areas where they have access to steady, abundant human sources of food and can den in buildings, they may reach extremely high densities.

Breeding

Raccoons can mate late winter through summer, but most mating occurs in late winter and early spring. After a 9-week gestation, 2 to 7 young are born, usually in April or May. Cubs begin eating solid food at 9 weeks, begin traveling with mother at 10 to 12 weeks, and wean at 16 weeks. Some juveniles may disperse in fall, while others stay with their mother much longer.

Camera-Trapping Tips

Whether in a developed or wilderness setting, raccoons are one of the more strictly nocturnal mammals, so a white flash is needed for color images. Beautiful photos and videos are easily captured, for the flash causes them to pause and look, but usually does not spook them. They may sniff and study the camera, but I've never known a raccoon to damage one. Capture is possible at any time of year, for raccoons do not hibernate, though in extreme weather they may hole up for days, sometimes huddling in groups for warmth.

Raccoons also make fascinating subjects, for they are curious and intelligent and their social organization is variable. Adult males may be solitary or may den and travel in bands of 3 to 5, separating briefly during the peak of the breeding season. Larger aggregations of both sexes may be seen at locally abundant food sources. Family groups consisting of an adult female and her young of the year travel and den together, but the duration of the family bond is variable. Young may disperse as early as their first fall, but others stay with their mother for over a year, dispersing as late as their second fall. Resource distribution and habitat

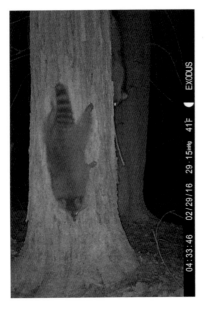

This tree near a wetland has a large cavity and a raccoon latrine at the base, making it an excellent camera-trap target. Notice that the raccoon can rotate its ankle joint, allowing for efficient headfirst climbing down trees. The info strip is vertical because the camera was turned sideways to get better coverage of climbing animals. Beware that some cameras may suffer water damage if used sideways. *(Exodus Lift)*

availability probably influence social structure.

There are many possible camera-trap sites for capturing raccoons. A den site is often productive. In less developed areas, raccoons sleep in cavities, on large horizontal branches, in squirrel dreys, under log jumbles, in muskrat lodges, and in rock crevices. Tree cavities are preferred for raising young, and rock crevices are preferred for winter denning. Urban and suburban raccoons use all sorts of human structures. They den under porches, patios, and wood piles and in sheds, garages, attics, basements, barns, and similar structures.

This raccoon in Massachusetts is using its sensitive "hands" to feel for food in shallow water. Raccoons may do this from any part of the shoreline, but small peninsulas and beaver dams seem particularly attractive to them. *(Exodus Lift)*

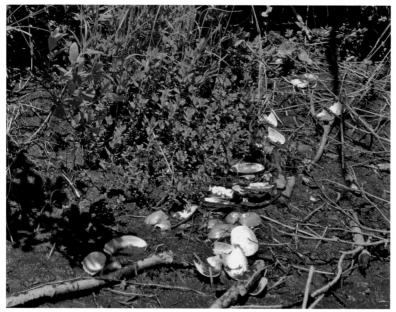

This midden of clam shells in New York was most likely left by a raccoon. Raccoons usually chew one end of the shell before prying it open. Muskrats, on the other hand, carefully pry the shells open without biting, leaving a midden of open, intact shells still attached at the hinge.

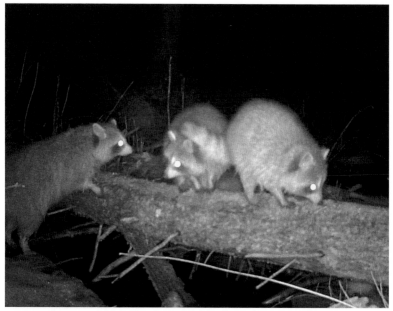

Raccoons using a log over a stream as a bridge in Massachusetts. *(Exodus Lift)*

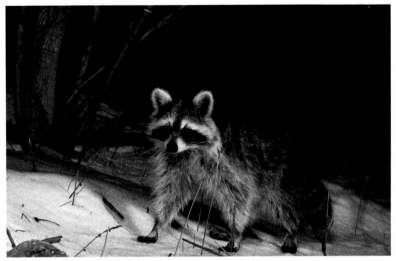
A raccoon patrolling forest-field edge habitat. *(PIR triggered Canon 60D, Nikon SB28 flash)*

Targeting a known den site will not necessarily yield frequent capture, for some raccoons use many different dens within their range and rarely use the same one for consecutive days. Others have just a few dens and may use the same one for extended periods. Mothers sometimes carry young to a new den, and once the young are able travel with her, the family may use several different dens within her range. Dens associated with large latrines are probably used more intensively.

Foraging and feeding behavior are interesting to study with video. Raccoons are highly intelligent and their feet have exceptional tactile sensitivity, especially when wet. Along waterways, they use their forepaws to pat and probe for food in such places as mud, shallow water, and between rock crevices. In less developed areas, one can study how they probe for crabs, dig for crayfish, and open clams. For optimal camera placement, look for raccoon tracks, digging, and food remains. The tracker can correlate observations of these behaviors with sign that the animals leave behind. In suburban and urban areas, one can learn how raccoons open latches, access trash bins, and forage through compost piles.

Raccoons use travel corridors regularly, making them good sites for cameras. In less developed areas, look for raccoon corridors near water sources. In the cypress strands of South Florida, raccoons travel and forage along old tram railways; in the sand plains of Wisconsin, they use dyke trails; and anywhere they may use beaver dams, log bridges, otter runs, beaver runs, and shorelines. In farmland, they travel along fencerows, hedgerows, and field-forest edges. In suburban and urban areas, they walk almost anywhere to travel between dens and feeding areas, but activity is concentrated near steady, abundant food sources.

20

FISHER

Order Carnivora / Family Mustelidae

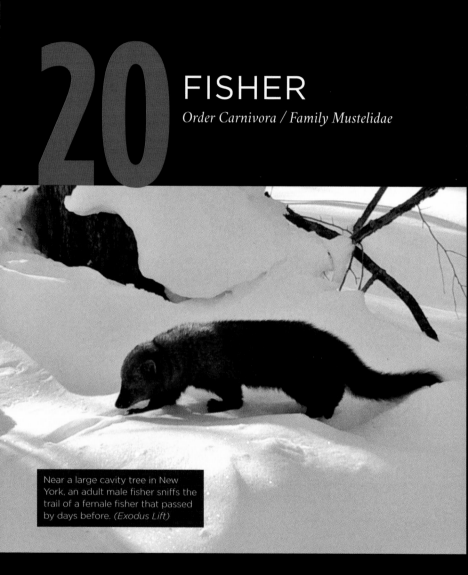

Near a large cavity tree in New York, an adult male fisher sniffs the trail of a female fisher that passed by days before. *(Exodus Lift)*

BY THE EARLY 1900S, THE FISHER (*Pekania pennanti*) was extirpated over much of its range as a result of deforestation and overtrapping. Reforestation, reduced trapping pressure, and some reintroductions have led to a dramatic recovery in the eastern United States, which is remarkable given the sluggish recovery of western populations. Success in the east may be due to the absence of larger predators such as cougar, wolf, and wolverine.

Physical Characteristics

This member of the mustelid family has the physique of a large, stout weasel. The body, short legs, and long tail are dark brown, and the head, neck, shoulder, and upper back are a pale, grizzled brown. The tail is long and bushy. The adult male has a larger crest on the top of the skull for attachment of his larger jaw muscles, giving him a

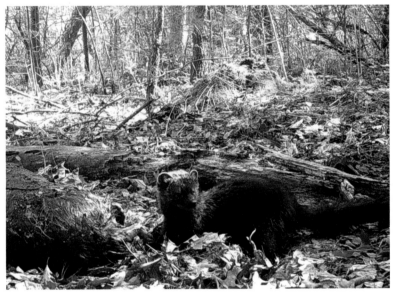

A female or juvenile fisher shows up to scavenge the remains of a beaver carcass in Massachusetts. Compare its forehead to the much broader forehead of the mature male in the previous photo (see page 141). *(Moultrie)*

broader, more domed forehead than juveniles and adult females have. Males are almost twice as large as females. Studies from Maine to California done prior to the 1990s report a weight range of 4.5 to 12 pounds, but a recent study of bone measurements of fishers in the eastern United States shows that they have evolved to a slightly larger size since reintroduction.

Tracks and Trails

Both front and hind tracks show typical weasel morphology, with a C-shaped metacarpal pad and 5 toes. The innermost toe is very small and often does not register. Fur on the bottoms of the feet results in a track with a lot of negative space between the pads. Semi-retractile claws often register. The front track

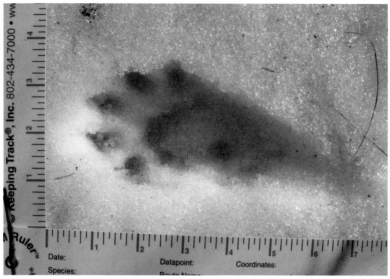

Left front fisher track found in Massachusetts.

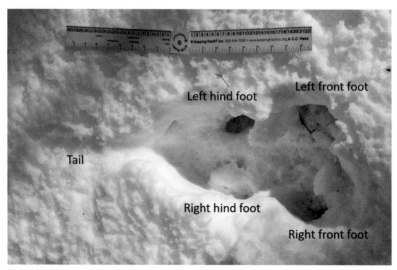

Fisher body print created by the animal jumping down from a tree trunk.

ranges from about 2¼ to 4 inches in width. It has a posterior heel pad that often registers. The hind track is slightly narrower at about 2 to 3 inches wide.

In a firm substrate, the fisher usually lopes with a stride of 17 to 45 inches. In deep, soft snow, it uses a 2x2 lope. It also frequently uses an alternating walk in either firm or soft substrate. Fishers sometimes jump down from tree trunks, leaving a body print in snow.

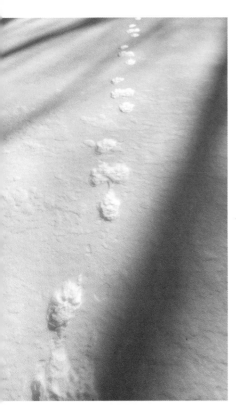

A fisher's loping trail pattern, found in Massachusetts.

Diet

The fisher is an opportunistic predator that also takes some fruit, nuts, and mushrooms when in season. They eat voles, mice, chipmunks, squirrels, rabbits, porcupines, fawns, carrion, and small pets and livestock. In the east, they consume more large-bodied prey. This may be due to greater availability of roadkill, the larger body size of eastern fishers, and/or the absence of large predators. In Massachusetts fishers are thriving primarily on gray squirrels and raccoons.

While male and female fishers have similar diets over much of their range, female fishers in New England eat more gray squirrels than males do. Perhaps this partitioning of resources reduces competition between the sexes and allows fishers to exist at higher densities.

Scat and Urine

Fisher scat is usually about ½ inch in diameter, and it is often left on stumps and stones. Its appearance depends on the animal's diet, and when it contains fur, it

Fisher scats on a stump found in Massachusetts.

is usually twisted like canid scat and has a long, tapered end. Therefore, in size, placement, and appearance, fisher scat overlaps with fox scat. Use associated sign to make the distinction. Confounding the issue is the fisher's habit of leaving scats at fox scent stations.

Fishers have the curious habit of dropping tiny scats, probably for the sake of marking purposes. I've seen them as small as 1 inch long and ¼ inch wide. Occasionally fishers leave a mucous secretion about the size and color of a penny.

Habitat

Fishers were once thought to require large expanses of softwood or mixed forests with large diameter snags and cavity trees, good canopy closure, and a lot of debris on the forest floor. That does describe excellent habitat for fishers, but we now know that they are not so picky in the eastern United States, where they thrive in suburban fragmented forests, including more open, hardwood forest, where gray squirrels abound.

Breeding

Little is known about the mating behavior of wild fishers, but the timing is usually early April. The embryo develops only to the blastocyst stage and then remains dormant until late February of the following year, when it implants in the uterus and development resumes. About 30 days after implantation, in late March, 1 to 5 young are born. A few weeks after giving birth, the female mates again to produce next year's litter. The female alone raises the kits. She uses a cavity in a snag or live tree for the natal den, and she moves the litter several times as they grow to larger cavities. Kits are completely weaned by about 4 months, probably independent by 4 to 5 months, but remain in their mother's territory until 9 to 12 months.

Camera-Trapping Tips

The fisher can be a challenging subject. Except for females using breeding dens for weeks, fishers don't revisit the same spots with regularity. They don't use human trails or beaver dams as travel corridors, they don't usually create large latrines, and they don't use the same rest sites for extended periods. However, fishers do make consistent use of relatively discrete habitat patches, where your chances of capture are good.

Late winter is a great time to find such a discrete patch. There may still be sufficient snow for tracking, and the male begins to use certain areas—probably where he has located females—more intensively. He circles back on his own trails and follows the trails of females. He deposits his scent frequently in these areas, rolling on saplings and leaving urine and scat on raised surfaces. Setting a camera on one of these scent stations might capture some interesting behavior, for he sometimes reuses them. It would also be interesting to see if females visit them.

Around the same time, the female begins evaluating snags and cavity trees for possible natal dens. And, because mating occurs shortly after the female gives

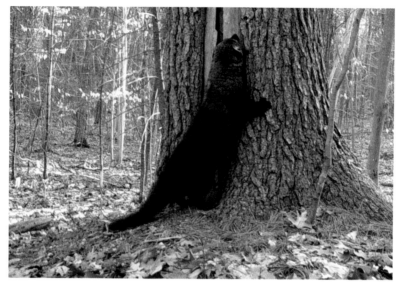

In early spring this male fisher rubs a cavity tree, probably leaving his scent, should a female choose the tree for denning. *(Exodus Lift)*

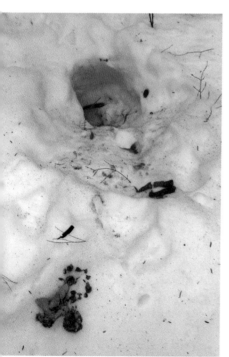

A fisher's snow den with scats and urine at the entry found in New Hampshire.

birth to the litter conceived the previous year, the male will be visiting them, as well. He may check for the presence of a female and leave his scent at the base of the tree.

The female usually chooses a snag or tree of around 20 inches, but no smaller than 14 inches, in diameter. Most studies say she chooses a forest with plenty of conifers and high canopy closure, but this may be less important in the east, where she feeds heavily on the gray squirrel, a creature of deciduous and mixed forests. Target the cavity tree with your camera, and if you get a female climbing and descending repeatedly, it could mean she has chosen it for a natal den. You may eventually see her carrying kits, one by one, down the tree to transport them to a larger den.

While female fishers almost always choose cavities in trees or snags for raising young, both male and female

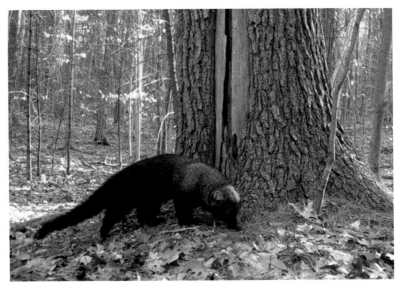
Large cavity trees are critical resources for the fisher, which uses them for hunting, resting, and breeding. *(Exodus Lift)*

fishers use a variety of types of resting sites. In warm weather they use large branches, witches' brooms, raptor nests, and squirrel dreys. In cold weather they prefer ground-level sites, such as hollow logs, brush piles, rock jumbles, abandoned beaver lodges, and underground holes. Many rest sites are used only once. Those used repeatedly may have scat accumulations at the entry and would be good targets for a camera trap.

In deep snow fishers sometimes create "snow dens." These are tunnels in the snow that lead to a subnivean chamber, a ground burrow, or a ground-level shelter. All three of the snow dens I've found had urine, and one had a few scats, at a 6- to 8-inch entry hole.

In any season, you may get fisher footage in a prime hunting habitat. If conditions are poor for tracking, choose a mature mixed forest with some conifers for cover and some mast trees, such as oak, to feed the fisher's rodent prey base. Other preferred habitat elements are cavity trees, stumps, and plenty of woody debris to provide hiding places for rodents and their caches, as well as resting spots for the fisher. Within this habitat, good targets are large logs, (along which fishers tend to run), rodent caches and feeding stations, and jumbles of debris or rocks with hiding spaces for rodents.

Fishers do scavenge at carcasses, of course, and a camera set on a carcass in an appropriate forest habitat stands a good chance of capturing fisher. Beaver carrion is said to be a favorite.

21

AMERICAN MARTEN

Order Carnivora / Family Mustelidae

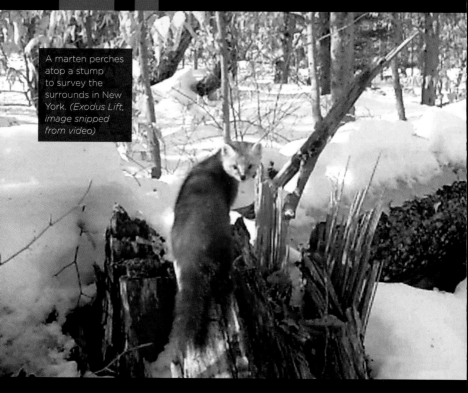

A marten perches atop a stump to survey the surrounds in New York. *(Exodus Lift, image snipped from video)*

WITH ITS LUSH COAT AND LARGE, SNOWSHOE-LIKE FEET, the semi-arboreal American marten (*Martes Americana*) is well adapted for life in the northern forests. It shares many preferences and behaviors with its larger cousin, the fisher, but its foot loading (body weight per unit area of footprint) is less than half that of the fisher, giving it a competitive advantage in the far north and at high elevations. Where snow is shallow for most of the winter, the larger fisher excludes the marten, and in intermediate areas the two species may coexist.

Physical Characteristics

The marten has the classic mustelid physique: a long, thin body with short legs and long tail. Its long, lush coat is usually reddish to dark brown, but shades of grayish to buff to golden brown are occasional. Legs, feet, and tail are slightly darker than the body, and the head is slightly paler. It has a throat and chest patch of white, cream, or orange. At about 1 to 3 pounds, the marten is about the same size as its cousin, the mink. Males are 20 to 40 percent larger than females.

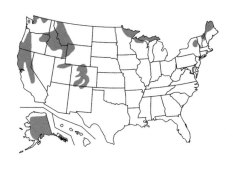

Tracks and Trails

Tracks show typical mustelid morphology, with a C-shaped metacarpal pad and 5 toes. The innermost toe is very small and often does not register. Martens have a lot of hair on the bottoms of the feet, so tracks show small pad impressions with a lot of negative space. Claws usually do not register. Front tracks are about 1¼ to 2½ inches wide. There is a posterior heel pad that sometimes registers. Hind tracks are slightly smaller, at 1⅛ to 2¼ inches wide.

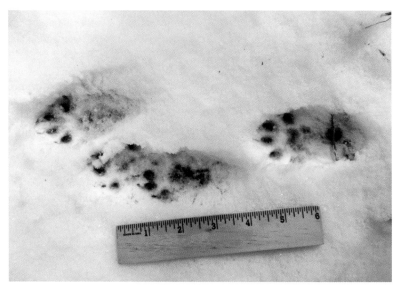

A single group of marten tracks from a 3-4 loping pattern. From right to left: right front, left front, left hind, and right hind. Heavy fur on the bottoms of the feet usually obscures track morphology, but in this case some of the pads are remarkably clear. Note the relatively clear lobes of the metacarpal pad of the right front track.

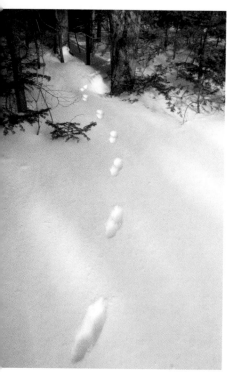

Marten tracks in a 2x2 loping pattern in deep, soft snow found in New York.

The marten often lopes when hunting, using a 3x4 gait in shallow substrate, with a stride of 8 to 32 inches. It moves in a 2x2 lope in several inches or more of snow. It rarely walks unless stalking. Like the fisher, the marten sometimes jumps from logs or tree trunks, leaving a body print in snow.

Compared to the fisher, the marten walks less often, and in deep, soft snow, it sinks less and takes longer strides. The marten appears to glide over the snow, where the fisher labors.

Diet

More arboreal than its fisher cousin, the marten often hunts in trees for red squirrel, a favorite prey species, but also eats snowshoe hares, chipmunks, voles, mice, shrews, grouse, other birds and their eggs, amphibians, reptiles, insects, and carrion. It often pursues voles, red squirrels, and grouse in their subnivean tunnels. Like the fisher, the marten also eats some fruit and nuts.

Scat and Urine

Scat is usually about ¼ to ½ inch in diameter and is often left on elevated surfaces along travel routes, and it may accumulate near resting sites. Appearance depends on what the animal has been eating. Fur-filled scat usually appears twisted and tapered. Martens often urinate at the base of large trees and sometimes rub their bellies on the ground, leaving scent from the abdomen and anal glands.

Habitat

Unlike martens of western North America, which seem to require predominately coniferous forest with high

Marten scat left on a large stone on a human trail in New York.

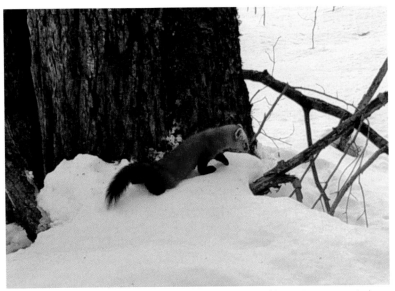

With its hind legs spread and its lower abdomen dragging, this marten appears to be scent marking at the base of a large diameter cavity tree in New York. *(Exodus Lift)*

In New York a marten loped to the base of a large tree, where it dragged its abdomen in the snow. Sometimes a spot of yellow, presumably either urine or secretion from scent glands, can be found on the drag mark.

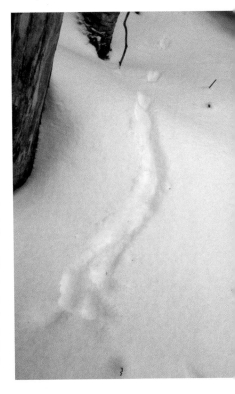

canopy closure, martens of the east are less particular. In the Adirondacks of New York, I have found them to be quite common even in relatively open, predominately deciduous forest. What they seem to need everywhere are large swaths of mature forest, with frequent pockets of old growth characteristics: large diameter trees and snags and piles of coarse woody debris.

Martens are sometimes described as reclusive creatures that avoid crossing roads and open areas, but in the Adirondacks they run across lightly used roads and parking lots and have even been known to steal food from picnic tables and rummage through backpacks.

Breeding

Mating occurs in late June to early August. The embryo develops to the blastocyst stage and then remains dormant till the following February, when it implants and development resumes. In late March an average of 2 to 3 young are born, usually in a cavity in a snag. The female is the sole caregiver, and she may move them several times to larger dens as they grow. Kits are weaned at 6 weeks and usually disperse in the fall.

Camera-Trapping Tips

In the eastern United States, martens range only in far north of the Northeast and upper Midwest, regions with significant snow depth and continuous snow cover through winter. Snow facilitates tracking of this species, which may spend more time on the ground in winter, hunting for voles and other animals in their subnivean tunnels. And, because it appears to be at least as active during daylight as it is during darkness, color photos are possible with IR flash cameras.

Where the marten is common, as in the High Peaks region of the Adirondacks, its trails seem to course anywhere and everywhere throughout suitable forest habitat without much regularity. Martens do have travel corridors, but only broadly speaking. They don't create well-worn paths like deer or step in their own footprints like bobcats and coyotes do. They don't need to. The marten's light weight and relatively large feet allow it to run almost effortlessly over deep, soft snow.

Martens do use human trails on occasion, but frequently loop in and out of the woods along the way. For best results in camera trapping, don't focus on runs or

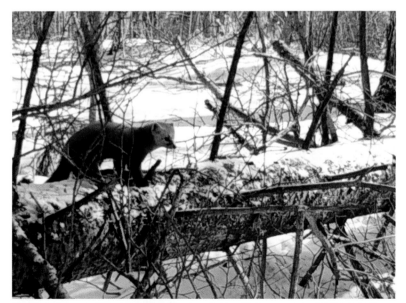

Martens often run along large logs. This one, in New York, pauses on the log to look around before jumping to the ground. *(Exodus Lift)*

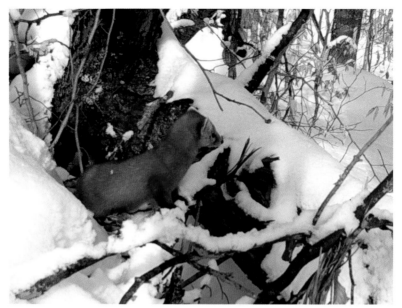

Trails to and from the base of this tipped tree in New York suggested a marten was denning under it. A camera trap confirmed it. *(Exodus Lift)*

human trails. Instead, follow a marten's trail to its favorite haunts and set your cameras there.

Fortunately these places are easy to identify, and marten presence is easy to confirm with snow tracking. Look for jumbles of logs, tipped trees, branches, and boulders near snags and cavity trees, for these are marten hot spots. The larger the diameter of the logs and trees, the better. In the most attractive spots, some exceed 18 inches in diameter. Martens explore these debris medleys intensively for prey, rest in nooks and crannies, and den in snags and tree cavities. At a well-used jumble, marten trails course over logs, pause at the base of large trees and snags, and enter holes. Fresh and old trails radiate to and from the debris pile, indicating repeated use.

You can set the camera back for videos of the marten moving among the debris, but for a closer study of more specific behaviors, look for the animal's preferred microsites. A trail that begins with a body print near the base of a snag might indicate a favorite resting spot, or, if in late winter, a future birth place for a marten litter. Martens do create scent stations, so look for scats, urine, and sign of rolling on logs, stumps, and stones and at the base of large trees and snags. Look for where the animal accesses the subnivean space to hunt. It usually tunnels to find small animals through snow breaks at angled logs, large tree trunks, stumps, snags, root masses, rocks, low branches, and small conifers.

Winter rest sites tend to be at ground level, typically under a log, root ball, rock pile, or brush pile, and warm weather rest sites are usually above ground, usually

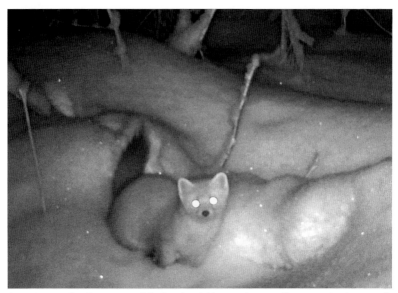
A marten studies the camera. Whether by sight, sound, or smell, many animals are well aware of IR flash cameras. *(Exodus Lift)*

on large branches, in witches' brooms, and in cavities in live and standing dead trees. Some rest sites are used only once. A scat accumulation near one indicates repeated use and makes the site a good camera target.

In spring the pregnant female marten chooses a den site, typically a cavity in a standing dead or live tree of at least 16 inches in diameter. She usually locates it where food and cover are abundant—at exactly the type of hot spot just described. She may begin to evaluate cavities for suitability in late winter, so targeting large-diameter snags and cavity trees near a well-used debris medley in late winter could yield photos of the female, and maybe even a peek at her young in spring. It is best to leave the cameras till summer, to avoid unnecessary disturbance to the young family. The mother usually moves them at least once, and there is some evidence that, unlike the natal den, maternal dens are more likely to be at ground level.

Mating behavior in summer has not been well studied and is difficult to deduce from tracks and sign without the benefit of snow cover. Scent marking does increase at this time, however. Look for scats placed on elevated surfaces and at the base of large trees. These could be productive camera stations.

Beaver meat, with its musky odor and high fat content, is said to be the most attractive bait for martens. Muskrat is said to be effective as well.

22 WEASELS

Order Carnivora / Family Mustelidae

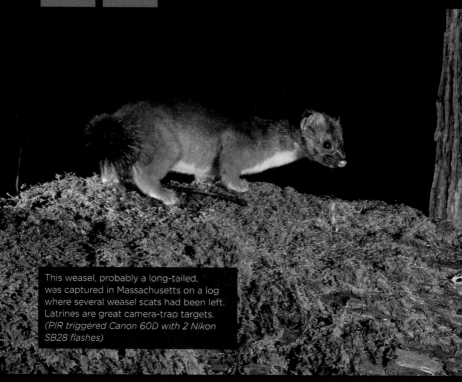

This weasel, probably a long-tailed, was captured in Massachusetts on a log where several weasel scats had been left. Latrines are great camera-trap targets. *(PIR triggered Canon 60D with 2 Nikon SB28 flashes)*

THESE TINY CARNIVORES are notorious for regularly killing animals larger than themselves. The short-tailed weasel (*Mustela erminea*) is often called the ermine, for its white winter coat, but all three species turn white in winter in cold climates. Both the short-tailed weasel and the least weasel (*Mustela nivalis*) range into the far north. The largest species, the long-tailed weasel (*Mustela frenata*), ranges farthest south.

Physical Characteristics

All three species have long skinny bodies and short legs. All are brown with paler undersides. The long-tailed weasel has a cream, yellow, or orange belly, throat, and chin. The least and short-tailed weasels have a white to cream belly, throat, chin, and toes. Weight ranges from 1 ounce for the smallest least weasels, up to 10 ounces for the largest long-tailed weasels. Males are larger than females.

The long-tailed weasel's black-tipped tail is more than half the head and body length. The short-tailed weasel's black-tipped tail is less than half the head and body length, and the least weasel's tail is very short and tipped with just a few black hairs.

North of plant hardiness zone 5, most individuals of all species turn white in winter. South of zone 5, most do not turn white. In zone 5, some turn white, some remain brown, and some are pied in winter.

Short-tailed Weasel

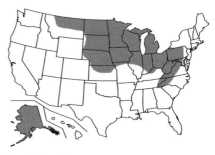

Least Weasel

Long-tailed Weasel

These tiny weasel tracks, found in northern New York, were probably left by a female short-tailed weasel, since the least weasel does not live in that area.

Tracks and Trails

Tracks of all three species show typical weasel anatomy, with 5 toes, a C-shaped metacarpal pad, and sometimes an additional heel pad. It is rare to find clear tracks of these tiny creatures with furry feet, and trail pattern

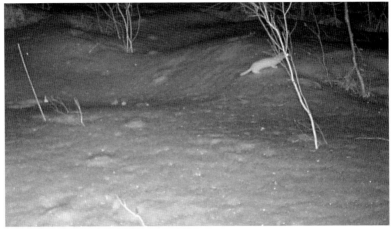

A white short-tailed weasel in winter in Maine.

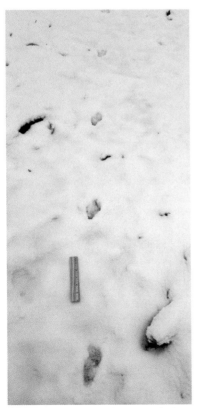

Long-tailed weasel tracks in a 2x2 loping
pattern found in Maine. The ruler is 6
inches long.

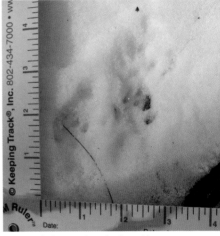

Long-tailed weasel tracks found in
Massachusetts.

is usually more helpful in distinguish-
ing them from other small mammals.
Weasels usually move in a 2x2 lope in
snow and sometimes with a squirrel-
like bound. Because their tiny tracks
are usually indistinct, I measure the
width of a pair of tracks within a 2x2
lope pattern. This reduces the error
a bit. The numbers here are based on
the high and low measurements pooled

from my own work and that of Elbroch (2003) and Rezendes (1999). Note that there is overlap even between the largest and smallest of the three species. There is also overlap between the long-tailed weasel and mink.

Trail width for 2x2 lope:
Least weasel: ¾ to 1⅝ inches
Short-tailed weasel: ⅞ to 2⅛ inches
Long-tailed weasel: 1½ to 3 inches

Diet

Weasels eat small mammals, birds, bird eggs, and insects. The smaller species—the short-tailed weasel and the least weasel—are experts at hunting small burrowing mammals underground and under snow. In the coldest parts of their range, they rely heavily on voles and lemmings, but they do venture above ground and kill larger animals from time to time. The long-tailed weasel is more of a generalist. It competes with larger predators, exploiting a wider range of prey, including rabbits, hares, squirrels, muskrats, grouse, and ducks, though voles and mice usually comprise the bulk of its diet.

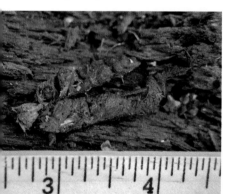

One of several weasel scats on a log in Massachusetts. The animal probably had a den in or under the log.

Scat and Urine

Scats are usually fur filled and twisted, about ⅛ to ¼ inch in diameter. Weasels leave scats where they meet or cross paths with another weasel, at territorial boundaries, along travel routes, and in latrines within burrows. They deposit anal sac secretions throughout their home ranges. They also deposit scent from glandular tissue in the abdominal region by rubbing their bodies during aggressive encounters with other weasels, when caching a kill, or when taking over another weasel's den.

Habitat

Weasels use virtually all habitats except desert. They especially like edge habitat for its abundant prey and overhead cover. All three species climb trees and swim well, but the long-tailed weasel is the most likely to swim and the most closely associated with ponds and streams.

Breeding

Short-tailed and long-tailed weasels mate June through August, but implantation in the uterine wall is delayed until the following March or April. A month later, a

short-tailed weasel gives birth to 4 to 8 young, and a long-tailed weasel to 4 or 5 young. Young are weaned at 2 to 3 months and disperse at 3 to 4 months.

Least weasels mate at any time of year, except for early mid-winter, and 5 or 6 young are born 5 weeks later. This opportunistic breeding strategy allows them to quickly respond to surges in populations of voles and lemmings, with which they are tied in boom–bust cycles. Young are weaned at 1 month and disperse at 2 to 4 months.

Camera-Trapping Tips

As small, fast-moving creatures, weasels can be hard to capture with a trail camera. But on the other hand, they are widespread and common so they are fairly frequent incidental captures on cameras set for other species.

Like the larger marten, the small weasels use travel corridors, but they do not usually create specific runs, so it's best to key in on places that a weasel is likely to visit repeatedly: favorite hunting grounds, caches, and dens.

Weasels hunt wherever there is sufficient prey and cover. Rabbit runs, rodent burrows, fencerows, stone walls, log piles, snags, cavity trees, thickets, overgrown fields, haystacks, vegetated river banks, barns, and chicken coops all attract weasels in search of the small animals that occupy them. Look for sign of intensive interest: weasel trails that loop around and poke into nooks and crannies.

Weasels are sometimes detested for their "killing sprees," wherein they kill far more than they can possibly consume in one meal. But this behavior is a critical survival strategy, especially for weasels in cold climates. Long skinny animals lose heat quickly, and since weasels do not hibernate, they need to eat a lot to stay

A weasel (probably a long-tailed) investigates the entry hole of a woodchuck burrow on a steep slope in Massachusetts. The large dark area is the throw mound of the burrow. (Exodus Lift)

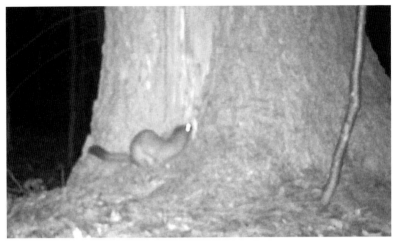

Here a weasel (long-tailed or short-tailed) is probably hunting for small mammals living in a large cavity tree in Massachusetts. *(Exodus Lift)*

warm. Surplus killing and caching are hard-wired behaviors to prevent starvation in times when prey are scarce. Some kills are cached within burrow chambers, and some are cached outside, but near a den. If you are lucky enough to find a weasel's cache, you may be in for some informative video footage. A weasel does not necessarily retrieve all its caches, but thieves make interesting camera-trap subjects, too!

Weasel dens, whether for resting or for raising young, are usually underground. Weasels do not excavate their own burrows; they co-opt those of their prey, often using the victim's fur for bedding. Least weasels use small rodent burrows, and short-tailed and long-tailed weasels use burrows made by larger species. Other possible dens sites are under boards, brush, logs, or rocks and in tree cavities, root masses, moss hummocks, grassy tussocks, or hay bales. Large latrines, containing as much as a handful of weasel scats, are sometimes located near the mouth of the den.

A weasel may have one to several resting burrows, and not all are used repeatedly. Finding an active den in spring or early summer could give you the chance to see a weasel family emerge from it. Finding one in winter could mean a lot of photos or videos, for in winter weasels concentrate their activity near the den.

A collection of weasel scats or a belly rub in the snow could be good places for a camera trap. In addition to creating large latrines near their dens, weasels leave scats at territorial boundaries and where they cross trails with other weasels. A belly rub sometimes indicates a nearby den or cache.

Weasels are often said to be most active at dawn and dusk, but activity is influenced by the risks of over-chilling and of predation. So, for example, a weasel may choose to hunt more during daylight when nighttime temperatures are extremely low and where the greatest threat of predation is an owl.

23 NORTH AMERICAN RIVER OTTER

Order Carnivora / Family Mustelidae

The social river otter is often seen in small groups. These two are visiting a latrine site along a well-used run between a lake and a pond in Massachusetts. *(PIR triggered Canon 60D with two Nikon SB28 flashes)*

A STREAMLINED BODY, WEBBED FEET, and dense coat make the North American river otter (*Lontra canadensis*) well adapted to its semiaquatic lifestyle. Because it eats fish and is sensitive to chemical pollutants, the river otter is an indicator of aquatic ecosystem health.

Physical Characteristics

With its long, streamlined body and short legs, the 11- to 30-pound semi-aquatic river otter is one of the larger members of the weasel family in North America. Its lush, waterproof coat is dark brown with silver on the belly and throat.

Tracks and Trails

Tracks show typical mustelid anatomy, with 5 toes on each foot and a C-shaped metacarpal pad. Both front and hind feet are webbed, and all toes are clawed. The front track is 2 to 3 inches wide, and the innermost toe is very small. It has a posterior heel pad that sometimes registers. The hind track is about 2¼ to 3½ inches wide, and the innermost toe is very long and set back.

Otters often lope, and in deep snow it's a 2x2 lope, with a stride of 15 to 40 inches and a straddle of 4½ to 7 inches. Their tracks and trails are easily confused with those of fisher, but behavioral characteristics help distinguish between the two species. In snow, otters usually slide frequently, leaving a 6- to 9-inch-wide slide mark. Their trails usually start and end at water sources and follow a relatively straight line. Otters also create well-worn runs. Fishers, on the other hand, rarely slide and tend to meander through upland forest as the animal investigates snags and logs in search of prey.

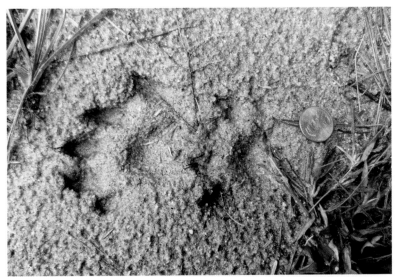

Left hind (at left) and front river otter tracks on a lakeshore in Massachusetts. The innermost toe ("thumb") of the left hind track is set back, making the track noticeably asymmetric.

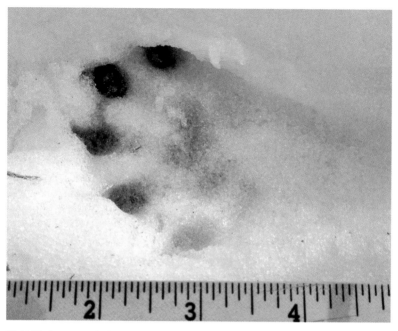

Right hind otter track, found in Massachusetts, showing the lobes of fused metacarpal pads.

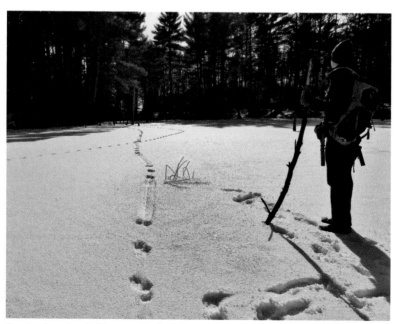

An otter loped and slid across the ice in Massachusetts.

Diet

Otters eat mostly fish, but also take crayfish, shellfish, frogs, and, occasionally, ducks and small mammals. They prey on many species of fish but typically choose abundant bottom dwellers. Cooperative hunting has been observed, particularly in coastal areas, and prey species and abundance probably factor in to the social structure of otter groups.

Scat and Urine

Otters defecate on land, and scat appearance depends on diet. A diet of amphibians or scaleless fish may result in a brown or blackish poorly formed scat. A diet of crayfish results in a more formed scat containing pieces of crayfish exoskeleton. Well-formed tubular otter scats are easily confused with raccoon scats, but a large accumulation of them is probably the work of raccoons, for otters roll on their latrines, flattening the scats

Otter scats may be deposited singly or in latrines. In either case, the animal sometimes creates a scent mound by scraping up a mound of debris, on which it then urinates or defecates. Latrines may be shared by group members and vary in size from a few feet in diameter to 20 feet of shoreline. Large, well-used latrines may have over 20 scent mounds and many scats of various ages. There may also be flattened dead vegetation due to rolling behavior and the acidity of excretions.

Otters also excrete a yellow-brown to whitish gooey substance from some-where in the intestinal tract, though the exact origin and function of this substance are unclear.

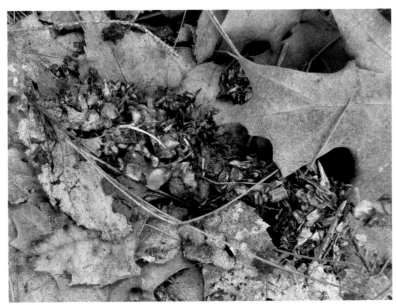

An old otter scat full of fish scales found in Massachusetts.

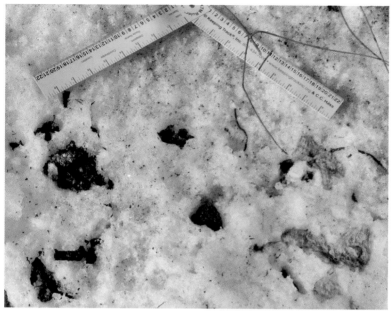

Otter scats and dried yellowish "otter jelly" at a latrine in front of a den in Massachusetts.

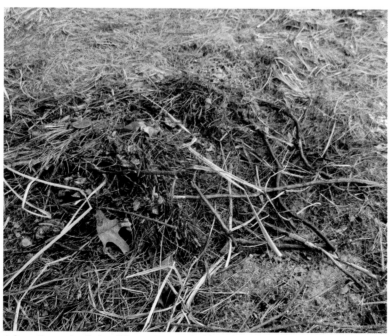

A few otter scats sit atop this scent mound within a large latrine site in Massachusetts.

Habitat
River otters inhabit ponds, lakes, rivers, streams, swamps, and even coastal areas. They are strongly associated with beaver wetlands, where old lodges and bank burrows function as dens and resting sites, fish is plentiful, and herbaceous cover is abundant. They can hunt in salt water, but they need a nearby source of fresh water for drinking and bathing to remove salt from their fur to maintain its insulating properties.

Breeding
In early spring 2 to 4 young are born. Mating takes place shortly after birth, but embryos don't implant for another 8 to 9 months. A juvenile or adult female helper, usually from a previous litter, may assist the mother with the young. Young remain with their mother for 8 to 12 months.

Camera-Trapping Tips
Charismatic, socially complex, and still poorly understood, the river otter is an excellent subject, especially for videos. Otters may be solitary and territorial, or highly social and tolerant of home-range overlap. The most consistent social structure is a mother and her young, but small groups of adult males are also common. You may catch them loping along runs, swimming in ponds, or sliding down hills or over snow-covered beaver dams. But perhaps the best site for capturing social activity is the latrine.

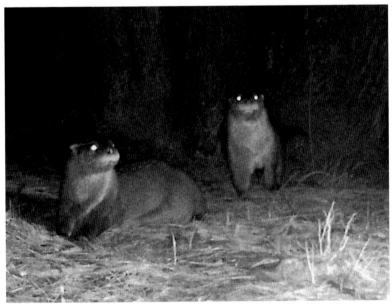

A pair of otters at a latrine site under a large tree at the edge of a pond in Massachusetts. *(Exodus Lift)*

Latrines are where otters spend time scatting, rolling, and grooming. They are located near dens and elsewhere along the shoreline, often near boulders and large trees, under bridges, on peninsulas, and on islands within ponds and lakes. Latrines may also punctuate well-used runs that connect water bodies.

Latrine activity is thought to relate to spacing and competition for food, but it remains the subject of debate. My own observations of otter latrine activity in the Northeast suggest that it relates more to breeding. Latrines at den sites are used at any time of year, but are not often seen, because dens are usually well hidden. The two spring/summer dens I have found were accessible only by kayak and had massive scat accumulations all around them at least through mid-summer. One of my camera traps showed otters resting for up to 3 hours at a latrine outside the den.

In spring, otters use additional latrines. A typical visit at one of them lasts just 15 to 30 seconds. They are not used for resting, and they are not necessarily well hidden. I have found several near well-used human trails and many others that were relatively easy to access. These latrines are quiet in summer and winter, but in fall, there is an additional small peak of activity. I believe the large spring peak relates to the breeding season, when otters may be communicating social status or "advertising" for a mate. The small autumn peak may be a recrudescence of breeding behavior triggered by day length, as it declines to what triggers breeding in spring. It is brief because day length soon becomes too short to stimulate sex hormones. Whatever their purpose, these seasonal latrines make excellent camera sites. Deploy the camera as soon as activity begins in early spring.

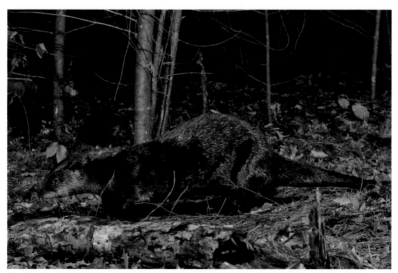

An otter passing through a latrine on its way back to the lake in Massachusetts. Its dry fur indicates that it has been on land for a while. Otters spend more time on land than in the water, but they are seen more often in water. They are probably much more secretive on land, where they are more vulnerable. *(PIR triggered Canon 60D with two Nikon SB28 flashes)*

A river otter winter den under the root mass of a tipped tree in Massachusetts. Note the latrine at the entry hole.

Dens are also excellent camera sites. They are hard to find, but easy to recognize due to the abundance of scat nearby. Dens may be in old beaver lodges, under logs or roots, or in dense vegetation, but they are almost always near water. Occasionally, otters use old woodchuck burrows, but they do not excavate burrows themselves.

A camera that can record audio is a plus, because otters use a variety of vocalizations. They whistle when alarmed, chirp to call each other, and make a low grunting chatter when gathered in groups. Familiarity with these sounds through trail-camera videos can add a new dimension to your tracking, for when otters are active it is sometimes possible to localize them by sound.

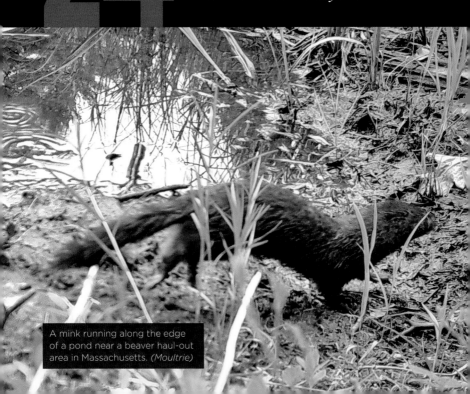

A mink running along the edge of a pond near a beaver haul-out area in Massachusetts. *(Moultrie)*

females. It is usually dark brown with a small white patch on the chin and sometimes on the throat and chest. The fur is very soft and dense.

Tracks and Trails

Tracks show typical mustelid morphology, with a C-shaped metacarpal pad and 5 toes. The innermost toe is the smallest and often does not register. Claws usually register. Only the front foot has a posterior heel pad, which often registers. Both front and hind tracks are about 1 to 1¾ inches wide.

The mink often lopes, and in soft substrate it uses a 2x2 lope, usually with a 1- to 3-foot stride and a 2- to 3½-inch straddle. It may bound through open areas. It slows to a walk when exploring nooks and crannies for prey. It sometimes slides downhill in snow, producing a 3- to 4-inch-wide trough, and occasionally tunnels under snow. Sometimes it creates well-worn trails to hunting areas.

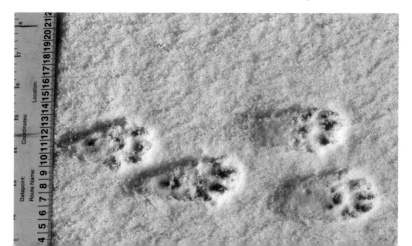

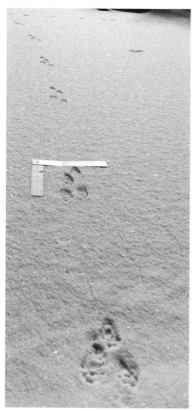

Mink usually lope, but they may bound for quicker passage through a wide open area, as this one did to cross a frozen pond.

A mink slide found in Massachusetts. Mink slides are much narrower and much less common than otter slides.

Diet

The mink is a strict carnivore, but it eats a wide variety of both terrestrial and aquatic prey, depending on availability. It feeds on voles, mice, rats, rabbits, squirrels, young muskrats, fish, crayfish, crabs, frogs, young snapping turtles, snakes, birds, bird eggs, waterfowl, and occasionally poultry and their eggs. Crayfish are usually important on the summer menu, while fish are taken more often in winter. It sometimes caches food near its den.

Scat and Urine

Scats are about ⅜ inch in diameter, and their appearance depends on diet. Scats containing fish remains may be poorly formed, like otter scats. Those containing hair from mammalian prey are twisted. Scats are often left on logs and rocks along water resources. Mink occasionally create latrines on elevated surfaces near important resources, such as dens and rest sites.

Habitat

Mink are found along streams, ponds, lakes, swamps, marshes, and saltwater coastal areas. They prefer areas with plenty of holes, nooks, and crannies for denning and hunting. They adapt well to human activity, but where human activity is high, they tend to exist at low density.

Breeding

Mating takes place January through April, depending on latitude. Mink can ovulate while already pregnant, and a litter can consist of the offspring of multiple males. Fertilized eggs remain dormant until mating season is over, at which time all implant and develop simultaneously. Implantation is therefore delayed 1 to 6 weeks for each egg, depending on when it was fertilized. Total gestation is 40 to 75 days, but embryonic development is only 30 to 32 days. The average litter size is 4. Young are weaned at 5 to 6 weeks, and they begin hunting for themselves at 8 weeks but remain with their mother until fall.

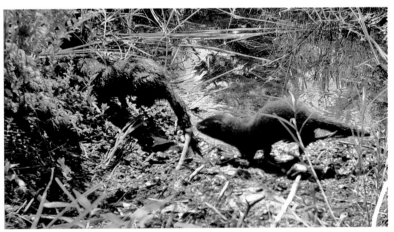

Mink are solitary animals except when mating and raising young. These two mink, at a beaver haul-out in July in Massachusetts, are either litter mates or a mother and her offspring. *(Moultrie)*

Camera-Trapping Tips

Mink live near water, in both forested and unforested habitats. But wherever they are, they need holes for resting, hiding, and reproducing, and they prefer some kind of cover while traveling.

In open habitats, such as marshes and prairies, mink are often closely associated with muskrat. They use muskrat lodges for resting, muskrat bank burrows for resting and raising young, muskrat pushups and haul outs for access to water through ice, and occasionally muskrat young for food. Look for mink scat among collections of muskrat pellets on prominent stones and logs near water, for mink often mark muskrat latrines. Such a latrine would be a good camera target for both species.

Mink prefer to use existing burrows, such as those of woodchuck, skunk, and badger, but they also use nooks and crannies among tree roots, rocks, and logs. They occasionally excavate their own burrows.

Mink are probably most abundant near water in forested habitat, where there is plenty of shrubby cover and holes for hunting and resting. Steep stream banks where soil erosion has created holes under roots of trees and shrubs are favored. Brush piles, rock piles, stumps, snags, hollow trees, root balls of tipped trees, and logjams that create pools where fish accumulate all provide excellent cover and hunting opportunities. Mink move among these resources, sometimes with enough regularity to form runs.

Mink also form travel corridors under overhanging stream banks, on logs, alongside logs, and through hollow logs. Because they prefer to travel over land, entering the water only to hunt for aquatic prey, a log that spans a stream too wide for the mink to easily jump is a highly attractive crossing structure.

A mink run snaking through the grass to a small pond in Massachusetts.

It can be difficult to get good trail-camera photos of the fast-running mink, so it's best to follow their runs to latrines, natal dens, and maternal dens. All of these offer excellent opportunities for photos and videos. Marking activity may be observed at a latrine site, a mother's repeated visits may be observed at a natal den, and playful young may be observed at maternal dens. Feeding and caching often take place under cover in or near rest sites, but many rest sites are used infrequently or only once, so are not as desirable for camera trapping.

Mink in forested habitats are often associated with beaver. Large beaver dams and the stick skeletons of old abandoned beaver lodges are full of holes for small prey that attract hungry mink. Mink may also take shelter in old lodges and large dams.

While mink in northern climes are less active in winter, their tracks are easier to find in snow, and their movement is more predictable, for they need to enter the water where it is not frozen. Look for mink tracks along unfrozen sections

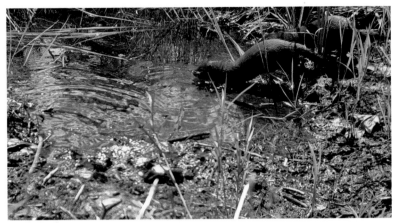

These two mink are hunting at a beaver pond, an excellent source of aquatic prey. *(Moultrie)*

of large or rapidly moving streams. Mink also use muskrat pushups and beaver haul-out areas in winter. All of these are promising sites for camera traps.

In the breeding season, female mink seek quiet, secluded ponds or streams with plenty of cover and an abundant food supply. Natal and maternal dens are probably larger and more concealed than rest sites. Some sources say the female prefers to raise her young in an underground burrow, though other types of holes are used.

Mink can be baited and lured, and the fur-trapping literature is replete with suggestions. Fish (including canned sardines) make excellent bait, but decompose rapidly. Muskrat, squirrel, rabbit, and poultry have all been used with success. A popular method is to secure the bait in an existing hole, such as a hollow log, or in a hole that you create in appropriate habitat.

"Mink musk," the contents of a mink's anal sac, is reputed to be a fine lure, especially in the mating season. Fish oil makes a good lure in any season. Some of the old-timers swore by unexpected substances, such as oil of peppermint or oil of anise, and it could be interesting to experiment with them.

Another way to entice a mink is to create certain habitat elements, if you cannot find them. You might try piling rocks, branches, or brush near water, or placing a log along the edge of the water. Or, place a log across a large stream to create a bridge. Trapper's lore suggests that logs greater than 6 inches in diameter make the most appealing crossing structures for mink. Do check the wetlands regulations and bylaws in your state and community, however, for these sorts of alterations may not be permitted.

25

AMERICAN BADGER

Order Carnivora / Family Mustelidae

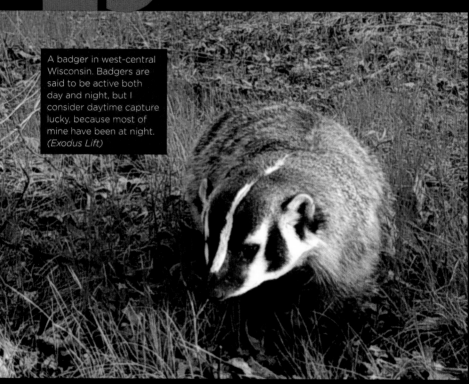

A badger in west-central Wisconsin. Badgers are said to be active both day and night, but I consider daytime capture lucky, because most of mine have been at night. *(Exodus Lift)*

THIS BURROWING MEMBER OF THE WEASEL FAMILY has a large range, but east of the Mississippi River, the American badger (*Taxidea taxus*) is limited to the midwestern states and possibly western Pennsylvania. Its declining population makes it an important study subject, and its clever hunting strategies make it an interesting one.

Physical Characteristics

A flat body, broad neck, and short, powerful legs make the badger uniquely suited to digging. It usually weighs 11 to 26 pounds, and its coat is grizzled gray brown with a buff to white underside. It has blackish-brown and white facial stripes, white cheeks and ears, and a small gray tail.

Tracks and Trails

Front and hind feet have a large heel pad and 5 toes. The smallest toe is on the inside of the foot, and it often does not register in the track. Front feet are larger, and front toes and claws are longer. Front feet also have a posterior heel pad at the posterior, outer edge, but it usually does not register.

Adult badger front tracks are about 3¼ inches long (including the claws) and about 2 inches wide. Hind tracks are about 2¼ inches long with nails and 1¾ inches wide. Long claws of front feet often register, but may be overlooked because they fall well beyond the toes.

Badgers walk while foraging, with a stride of 5½ to 9¾ inches and a straddle of 5 to 7½ inches. They trot and lope while traveling and, for a broad-bodied, short-legged animal, at impressive speeds as evidenced by blurry camera-trap photos on badger travel corridors! Toes point inward while walking or trotting and may appear to curve inward, as well.

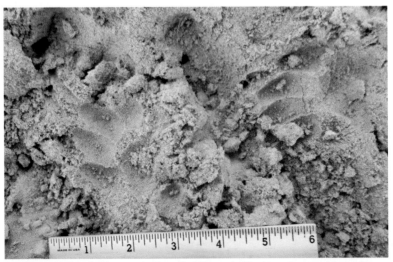

Left and right front badger tracks found in Wisconsin. The long claws register well beyond the toes. Two claw marks are clearly visible on the left track, and at least one is visible on the right track.

Diet

The badger hunts a wide variety of burrowing animals, including ground squirrels, woodchucks, prairie dogs, chipmunks, pocket gophers, woodrats, voles, and moles. It takes other prey opportunistically, and sometimes eats large insects and mast. It usually digs prey out of its burrow and consumes it underground.

Scat and Urine

Most scat is deposited underground and does not appear to be important for scent marking. Instead, the badger often rubs its body near its den, presumably depositing secretions from its anal and/or abdominal glands and leaving a visible drag mark.

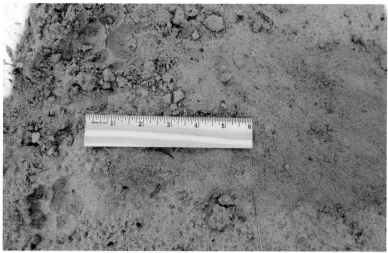

Body drag mark of a badger found in Wisconsin. Tracks are at left, and subtle fur marks are at right and center.

Habitat

A creature of open land, the badger thrives in prairie and desert scrub and sometimes uses savanna. It uses wetland-associated habitat if there is nearby friable, well-drained soil for denning. It can thrive in lightly managed agricultural fields, but it does poorly where machinery and pesticides are used heavily.

Breeding

Mating takes place from late July through August. Implantation of the embryo is delayed until the following January or February. In March or April the female digs a natal den and gives birth to 1 to 5 young. Juveniles emerge from the den at about 6 weeks of age, and disperse in summer at 3 to 4 months. Males are not involved in raising young. Badgers are solitary except during mating and while raising young.

A fresh badger dig in Wisconsin, with badger tracks on the fan-shaped throw mound. The ruler at the entry hole is 6 inches long.

Camera-Trapping Tips

The badger's preference for open landscape creates some challenges. Suitable trees for mounting a camera are usually few and far between, in which case you will need to improvise. A tripod made from sticks found on-site and placed near a clump of vegetation can make a fairly inconspicuous set.

Another problem is that, in prairie habitats, grasses may obscure this short-legged creature by early summer, or trigger the camera incessantly. This isn't so bad in warmer climates, because you may be able to camera trap badgers year-round. But in cold climates badgers may remain underground in torpor for weeks at a time in winter, limiting camera-trapping opportunities to short periods in spring and fall in some grasslands. In that case you need to step up your game and find a spot of very high badger activity. In Wisconsin I had great success in spring by placing cameras on a bottleneck, a small strip of land connecting two large open areas. Water on either side forced animals to travel on the narrow strip of land, which itself was riddled with ground squirrel holes and old badger digs. I targeted several holes with cameras and got many nice photos.

To home in on badgers, look for their conspicuous digs. Most are in open fields, but look also in road cuts, railroad rights-of-way, dykes, and walls of sandpits. Badgers may be present in almost any open area, within their range, where their favorite prey—small burrowing mammals—abound.

The entry hole of a badger dig is 6 to 11 inches in diameter. A dig may be a sleeping burrow, breeding den, hunting dig, or a combination. Badgers often

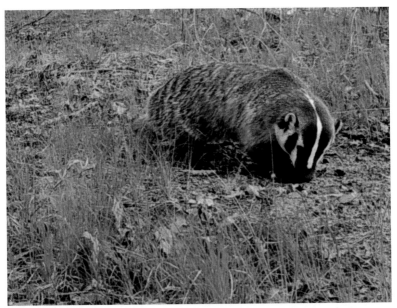

A badger in Wisconsin noses the hole of a ground squirrel. Badgers often dig up ground squirrels for food. *(Exodus Lift)*

sleep where they have excavated and consumed other animals, in which case the sleeping burrow and hunting dig are one and the same. The throw mound of a sleeping den is about 3 feet in diameter, but the throw mound of a breeding den may be 6 feet wide, for burrows with young are larger and more complex. A throw mound smaller than 3 feet in diameter is probably a hunting dig that wasn't used for sleeping.

While dens are easy to find, fewer than 10 percent of them are active at any given time, for badgers may use a different one nearly every day, either excavating a new one or reusing an old one. Badgers do revisit their old digs from time to time, but an old, isolated dig may not be a productive camera target. A much better target is a cluster of fresh and old badger digs among ground squirrel or vole holes.

You should be aware of seasonal behaviors before placing cameras. Early spring is an excellent time for camera trapping, especially if you find a breeding den. Look for a large, fresh throw mound with badger tracks on it. Leave the camera there for a few months, and you might be rewarded with late-spring footage of young badgers playing around the entry hole.

Summer presents some challenges and opportunities. This is a time of a lot of above-ground activity, for young badgers are dispersing. However, this is also the time of year when both males and females dig a new den nearly every night.

Summer is also a good time to capture interesting hunting behavior. After ground squirrel young have emerged from their natal dens, they are more difficult to catch, so the badger employs a couple of strategies that would make for

A cluster of badger digs on a slope in Wisconsin.

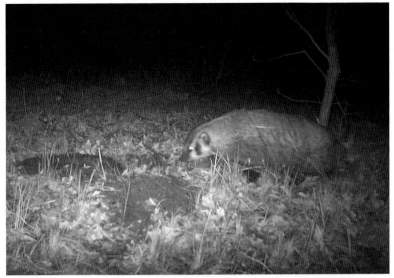

A badger enters the scene to investigate a ground squirrel's hole. The throw mound can be seen at left. Badgers are constantly investigating holes as they search for edible occupants, temporary shelter, and, in summer, potential mates. *(Browning Strike Force HD Pro)*

wonderful video footage. One is to plug the alternate exit holes of its victim's burrow. If there is insufficient soil in the immediate vicinity, the badger may even gather rocks and other debris to plug the holes.

Another summer hunting strategy is to team up with a coyote. The clever canid leads the badger to fresh hunting ground and waits outside a hole while the powerful mustelid digs, thus trapping the burrow occupants and ensuring a meal for at least one of the two predators. This rarely observed hunting partnership is most common where neither species is hunted or trapped, because higher population density and a longer life span increase the likelihood that they will encounter each other and develop a relationship. It is also more common in brushy habitat, presumably because the vegetation makes it harder for the coyote to hunt by sight, creating an incentive to partner with a badger. The likelihood of recording this interaction is low, but success would be tremendously rewarding.

Mid- to late summer is the mating season, when badgers spend more time above ground than at any other time of year. This is an excellent time for camera trapping if vegetation is sparse. Then, as summer warmth yields to chilly fall weather, badgers spend more and more time in their dens.

26 BOBCAT

Order Carnivora / Family Felidae

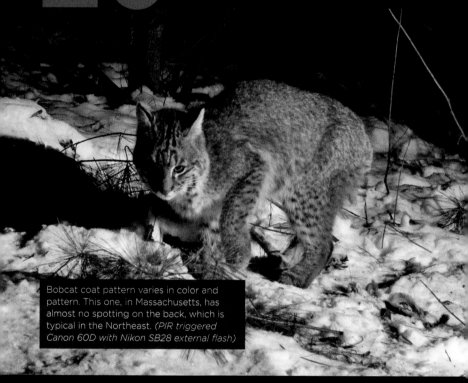

Bobcat coat pattern varies in color and pattern. This one, in Massachusetts, has almost no spotting on the back, which is typical in the Northeast. *(PIR triggered Canon 60D with Nikon SB28 external flash)*

THE BOBCAT (*Lynx rufus*) is the most successful wildcat in North America. Its beauty, grace, and elusive nature make it one of the most desirable subjects for the camera trapper. This animal can be baited, but once you become an accomplished bobcat tracker, you won't need to bait it, and you won't want to. It's so much more satisfying to use your knowledge of tracks, sign, and behavior to capture the bobcat in its normal routine.

Physical Characteristics

At 11 to 40 pounds, the bobcat is a bit more than twice the size of a house cat. Males are a third larger than females. It gets its common name from its approximately 5-inch "bobbed tail." Its spotted coat is reddish in summer, and buff to gray in winter. The tip of the tail is black on top and white underneath.

Tracks and Trails

Both front and hind tracks usually show 4 toe prints and a large, roughly trapezoidal heel pad. Toe arrangement is asymmetric. The second toe from the inside is the leading toe and the outermost toe is set furthest back. The heel pad has a bilobed leading edge and a tri-lobed posterior edge. Because bobcats can retract their claws, tracks usually do not show claw marks.

Front tracks are roundish, with a diameter of 1½ to 2½ inches, and the heel pad is 1 to 1½ inches wide. There is usually little negative space between toe and heel prints. Hind tracks are slightly oval, about 1⁄16 inch longer and narrower than the front tracks. The heel pad is slightly smaller, leaving more negative space between toe and heel prints.

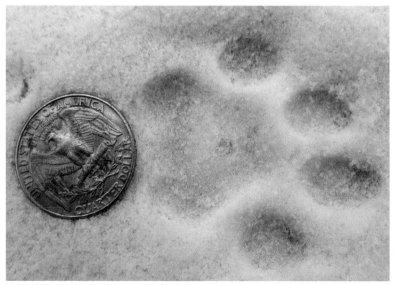

A left front bobcat track. Notice that the toe arrangement is asymmetric in the same pattern as the fingers on the human hand, excluding the thumb. The second toe from the inside, corresponding to your middle finger, is the leading toe, and the outermost toe, corresponding to your pinkie, is farthest back. Note that it is not possible to draw an X through the track without cutting through any of the pads.

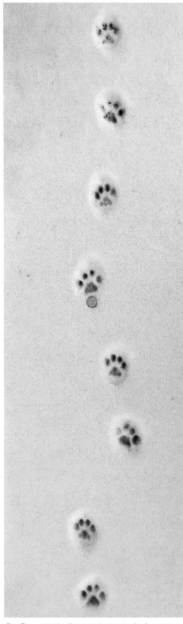

The bobcat usually uses an overstep walk in shallow substrate, and a direct registering walk in deeper substrate. The stride of the direct register walk is 6 to 14 inches with a straddle of 4 to 9 inches. The bobcat can also trot, lope, and gallop.

Diet

Like its cousin the lynx, the bobcat particularly enjoys dining on rabbits and hares, but the more versatile bobcat can survive on other small prey, such as squirrels, muskrats, voles, mice, snakes, frogs, grouse, and other birds. The larger males are more likely than females to take larger prey, including adult deer. This "niche partitioning" makes it possible for male and female home ranges to overlap.

Scat and Urine

Scat is about ½ to 1 inch in diameter and often segmented. It usually appears untwisted. Resident adult cats usually do not cover scats, but transient animals and juveniles often cover it with soil or debris. Scat often contains hair, does not contain large bone fragments, and generally does not contain vegetation. Bobcats sometimes create latrines of scat, usually close to a den.

Bobcats also create 5- to 6-inch-wide scrapes with their hind feet, depositing scent from pedal glands. In suitable substrate, the scraping produces a small mound of debris. The cat may then urinate and/or defecate in the scrape or on the mound.

The urine has the same distinctive odor as house cat urine. Bobcats frequently spray vertical surfaces with urine as they travel, spritzing just like a house cat sprays, onto stumps, rocks, and trees.

On firm or shallow substrate, bobcats often move in an overstep walk, producing this pattern. From bottom to top, tracks alternate front, hind, front, hind. Notice that the hind tracks have smaller heel pads.

A bobcat scat in a scrape in Massachusetts. The mound of debris was scraped up by the cat's hind feet before the scat was dropped.

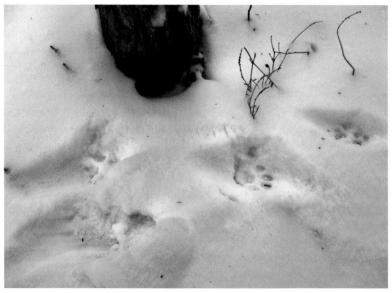

A bobcat breaks from an alternating walk to stop at a stump. A quick sniff indicated that the cat had sprayed the stump with urine. Bobcats sometimes revisit these scent stations, so they make good camera targets.

Habitat

This adaptable feline can eke out a living in forests, thickets, orchards, swamps, bogs, and arid rocky areas. It can use fields with brushy edges, but avoids large open areas. In addition to productive hunting grounds, the bobcat needs good cover for hiding, resting, and raising young. It frequently uses caves on rocky hillsides and spaces between boulders, but can also den in abandoned woodchuck burrows, brush piles, hollow logs, hollow trees, and dense thickets.

Until recently the bobcat in Massachusetts was limited to the western two-thirds of the state, and this was thought to be due to the absence of ledge and boulder fields for denning. However, its numbers are on the rise in eastern Massachusetts, where I believe it does den in dense thickets.

Breeding

Bobcats usually mate in February and March. About 2 months later, the female gives birth to 1 to 4 kittens. They emerge from the den at 4 to 6 weeks and disperse in the fall. There is only 1 litter per year, and the female is the sole caregiver. A mother may use the same den for consecutive years.

Camera-Trapping Tips

Despite its secretive behavior, the bobcat is not a difficult animal to capture on camera. Its normal gait is a relatively slow walk and it frequently pauses, or even sits down, to scan the surrounds. That means it's likely to remain in the detection zone long enough for the camera to capture the whole body in good focus. However, it's not always easy to get color photos if the camera has an infrared flash. Bobcats are generally crepuscular, most active around dawn and dusk. I've had better luck getting daytime captures where human activity is low. They may be more nocturnal in developed areas.

Bobcats tend to use regular routes for hunting, which begin and end at a den or bed. These corridors are good locations for wildlife cameras, especially in deep snow, which forces the animal to repeatedly use not just the same general route, but the exact same path, to save energy. They mark frequently with urine as they travel. This is very helpful if the substrate is poor and you are able to identify only a few tracks every so often. Sniffing stumps and rocks can help you fill in the blanks and stay on the cat's trail. And the scent station itself is a good camera target, for bobcats do revisit them.

Bobcats usually avoid crossing wide-open areas, but they do use human trails and walk on logs and stone walls, especially if it allows them to avoid deep snow or wet substrate. In dense forest they will take advantage of natural openings, such as exposed bedrock, for easier travel, and I have had success placing cameras in such areas.

During the warmer months this stealthy predator often hunts at the edge of a wetland or meadow, lurking in brush, unseen and unheard by the small animals that occupy those habitats. Beaver wetlands are excellent hunting grounds, and

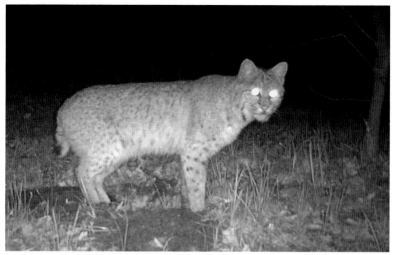

A bobcat using a dyke as a crossing structure in Wisconsin. *(Browning Strike Force HD Pro)*

while it's hard to predict exactly where the bobcat will hunt, it regularly uses beaver dams as crossing structures. Place the camera at one end of the dam and give it a few weeks or months.

Bobcats make use of other types of bottlenecks, as well. In Wisconsin, one regularly used a dyke, which was also home to excellent prey, including cottontail rabbits and ground squirrels.

An exception to my comments about the use of bottlenecks is southwest Florida, where panthers and alligators reign supreme. There, bobcats are infrequent users of the old tram trails that cougars often use as travel corridors and alligators for sunbathing. I've had more success finding the Florida bobcat in marginal islands of forest. They might also frequent Florida suburbs, where insufficient prey or conflict with humans precludes the panther.

A good way to home in on a bobcat trail is to first find sign of its favorite prey species. In some locations deer are taken frequently, and bobcats hunt them by ambush at their beds. In snowy conditions look for deer bedding areas under conifers on south-facing slopes. These are good camera-trap sites for hunting bobcats and other predators, as well as deer.

In orchards, brushy fields, and forest edges, I often discover bobcat trails by first finding evidence of its favorite menu items. Where rabbit or hare activity is high, there's a good chance that a bobcat is patrolling the area. In the orchards and agricultural fields of Massachusetts, for example, eastern cottontails use brush piles and brushy edges for both food and cover. Bobcats hide in nearby thickets and hunt the cottontail feeding areas. In more rugged terrain, bobcats travel between their rocky dens and the shrubby forest understory where rabbits or hares feed.

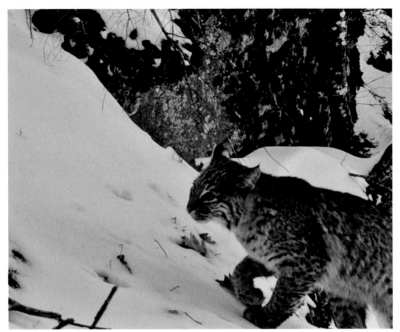

A bobcat ascending a cliff in mid-March in Massachusetts. The site was chosen for a camera trap because bobcat tracks appeared there on a regular basis. Rock crevices in steep cliffs are preferred for shelter in winter and for breeding in spring and summer. *(Exodus Lift)*

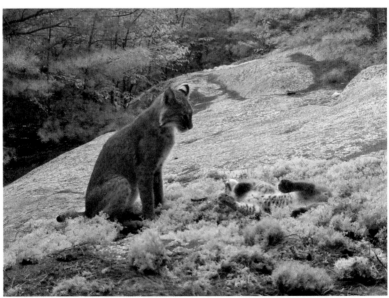

A bobcat mom and kitten on a ridgetop in Massachusetts. Their den is likely in a crevice in the face of the cliff. Notice how reddish the summer coat is. *(Moultrie)*

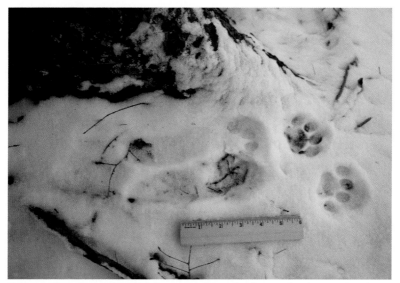

Bobcats often sit down to watch for prey, and in soft substrate they leave a nice sit-down print, like this one. Front tracks are on the right, prints of hind feet and lower legs are at center, and the butt is at left. Because sit prints tend to be in favorite hunting grounds and vantage points, they may indicate a good area for a trail camera.

It's not necessary to get close to a bobcat's den to get good photos, and I don't recommend doing so. Maintain a respectful distance to minimize stress on the animal. Bobcat dens are usually quite difficult to approach, anyway, as they are often within steep cliffs or dense thickets. Instead, identify the approximate location of a den as evidenced by bobcat tracks and scent posts radiating from a likely den site. Then try to identify nearby lookout areas, openings with good views, where the cat pauses to look around. These are excellent places for trail cameras, and if the den is a breeding den, you might get photos of mom with her kittens.

Bobcats can be baited with roadkill, cat food, and the like. I have not had success using catnip as a lure, though captive bobcats are said to react to it the same way house cats do. Perfumes containing a synthetic form of civetone, a pheromone found in scent gland secretions of the African civet, have been used to lure jaguars to camera traps and may be effective for other wild felines, but I have yet to try them. A gadget that mimics distress calls of prey species is an effective bobcat lure, but it wastes the hungry cat's time and energy, which can be deadly for an animal on the edge of survival.

27

CANADA LYNX

Order Carnivora / Family Felidae

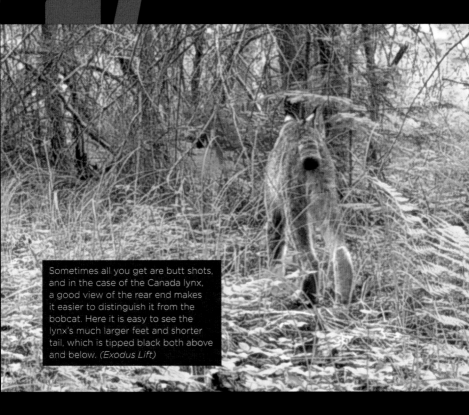

Sometimes all you get are butt shots, and in the case of the Canada lynx, a good view of the rear end makes it easier to distinguish it from the bobcat. Here it is easy to see the lynx's much larger feet and shorter tail, which is tipped black both above and below. *(Exodus Lift)*

A CLOSE RELATIVE OF THE BOBCAT, THE CANADA LYNX (*Lynx canadensis*) is specially adapted to the extreme cold and deep snow. Its large snowshoe-like feet allow it to almost glide over deep snow, through which a bobcat would labor. Its population in Maine was at an all-time high of 750 to 1,000 animals in 2006, due to an abundance of young spruce-fir forest. Its future in northern New England will be influenced by climate change, natural forest disturbances, and forest management.

Physical Characteristics

With males averaging 25 pounds and females 19 pounds, the lynx is about the same size as the bobcat, but appears larger due to its longer winter coat, longer legs, and larger paws. Its tail is shorter than the bobcat's, and the tip is black all around. Its winter coat is faintly spotted and light grayish, and its shorter summer coat is reddish brown. Its ear tufts are longer than those of the

bobcat, and the facial ruff is more pronounced. Bobcat–lynx hybrids occasionally occur in Maine, and these animals have intermediate characteristics.

Tracks and Trails

Compared to the bobcat, the lynx has much longer toes, which splay in deep snow to minimize sinking. Track size varies greatly depending degree of toe splay. Front track width ranges from about 2½ to 5½ inches, and hind track width ranges from 2¼ to 5 inches.

When toes are fully splayed, the 2 lateral toes stick outward, creating a very large track with a characteristic cross shape. The typical feline toe asymmetry (see Bobcat Tracks and Trails) shows in clear tracks. Four toes usually register, and retractable claws usually do not. Thick fur on the bottoms of the feet usually make

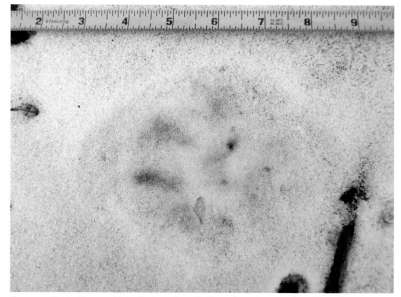

Because the bottoms of lynx feet are heavily furred, tracks are often blurred and pads may appear very small, as they do in this track.

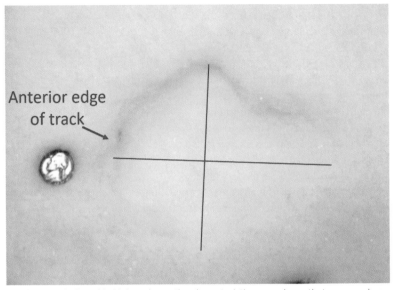

Anterior edge of track

This lynx track, found in Maine, shows the characteristic cross shape that occurs when toes are splayed. The shape is often recognizable even in very poor conditions.

Canada lynx tracks in a direct register walk in Maine. *Photo by Jessica Schindler*

toe pads and heel pad appear small with abundant negative space, though this varies with substrate.

The typical gait is a walk, direct registering in deep snow, and overstepping in shallow substrate. The stride of the direct register walk is 11 to 18 inches and the straddle is 5 to 9½ inches. The lynx also trots and gallops.

Diet

Unlike its adaptable cousin, the bobcat, the lynx is a snowshoe hare specialist. In Alaska and Canada, lynx numbers rise and fall with the snowshoe hare population, on a cycle of about 10 years. In Maine, the southern limit of the lynx range, hare and lynx exist at lower densities and fluctuate irregularly, but lynx are still largely dependent on hares. Lynx sometimes take red squirrels, flying squirrels, voles, grouse, and other small prey, especially

in summer. Red squirrels are an important alternative when hare numbers are low. Lynx occasionally take deer fawns and rarely adult deer.

Scat and Urine

Like the bobcat and the cougar, the lynx uses passive scent marking to maintain its home range without aggression. Lynx scat is of the same size and appearance as bobcat scat and often is placed, uncovered, on a small mound of snow. Kittens tend to cover their scat, but adults do not. Urine is sprayed backward onto vertical surfaces for marking purposes.

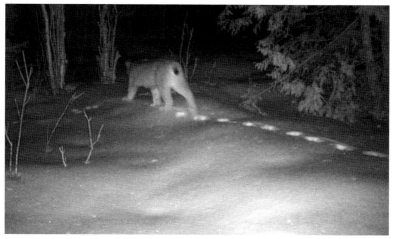

A lynx leaving a walking trail of characteristic large, round tracks with relatively short step length in Maine. *(Moultrie)*

Habitat

Snowshoe hare density determines habitat quality for this specialized predator. In northern Maine, 20- to 40-year-old spruce-fir forest provides the food and cover needed for hares to thrive. Hares prefer the densest cover, while lynx hunt in moderate cover, where hares are more vulnerable. Like bobcats, lynx tend to avoid large open areas and trot to cross them when necessary.

Breeding

Lynx have 1 litter per year. In Maine, they usually mate in March and give birth to 2 or 3 kittens in mid- to late May. The mother is the sole caregiver. Kittens emerge from the den at 4 to 6 weeks. They stay with their mother for nearly a year, hunting cooperatively with her in winter. They disperse the following spring, just before the mother is about to give birth to her next litter. Males are tolerant of kittens during breeding season, and an occasional male has been observed with a female and her kittens in late spring.

Camera-Trapping Tips

Like other felines, the lynx moves over the landscape relatively slowly, pausing often, increasing the chances of crisp photos. It's active day and night, especially in early morning and late afternoon, providing the opportunity for daytime color photos with an IR flash. A good way to narrow the search for lynx tracks is to head for young spruce-fir forest and find snowshoe hare sign. Where hare activity is abundant, a lynx is likely on the prowl.

Snow tracking helps one to localize the best spots for camera placement, but the changing snow depth makes it tricky to position cameras at the appropriate height for the target animal. I usually check the cameras after the snow melts in spring, and lower them as necessary.

I have found that within young, dense spruce-fir stands, lynx activity is high in small forest openings of about 50 to 100 square feet. Often multiple lynx trails intersect in these areas, suggesting that lynx check them frequently. Hares are more abundant in denser cover, but perhaps lynx hunt the small openings because there the hares are more vulnerable. They are excellent spots for trail cameras, and they're where I've had the most success. The openings also allow you to get nice photos and videos without many triggers due to moving branches.

In spring and summer, hares may seek succulent vegetation at wetland and meadow edges. Such areas may yield lynx images, but at this time of year, consider the possibility of plant growth robust enough to block the camera's view.

Spring through summer is also a good time for capturing a mother with young kittens. Breeding females den in hollow logs and dense thickets and under large

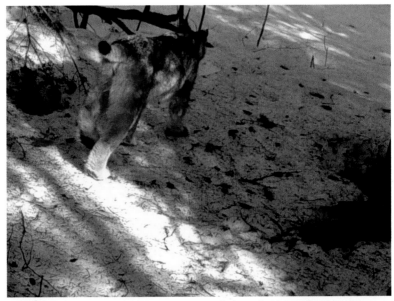

Canada lynx in a small opening in young spruce-fir forest in Maine. *(Exodus Lift)*

logs and tipped-up root systems. Since large logs and tipped-up root systems are more common in older forests, and hares are more common in young forests, lynx often den in mature forests near the ecotone—where young and old forest meet.

Lynx do use logging roads and human trails, especially when human use is low, and these are options for camera traps if a less "natural" backdrop is acceptable. However, higher road density allows the more aggressive bobcat, which could not otherwise compete with the lynx in deep snow, to move in. To find lynx, stick with more remote areas with low road density.

Like bobcats, lynx spray urine onto vertical surfaces, such as rocks, stumps, bushes, and so on. I have a video of one spraying the tip of a stick protruding from the top of a beaver lodge. They may return to spray repeatedly at the same spots, so these scent posts make good camera-trap targets. In snow look for hind tracks backed up to these surfaces and sniff the area for that characteristic feline urine odor. Lynx urine smells a lot like house cat urine.

28

COUGAR
Order Carnivora / Family Felidae

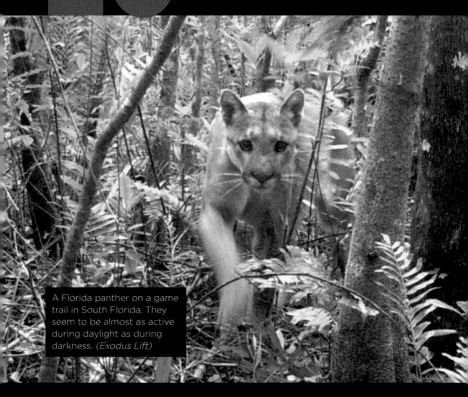

A Florida panther on a game trail in South Florida. They seem to be almost as active during daylight as during darkness. *(Exodus Lift)*

THE ONLY KNOWN BREEDING POPULATION OF COUGAR in the eastern United States is the endangered Florida subspecies, known as the Florida panther (*Puma concolor coryi*). Its status as a subspecies is in dispute, but legally it remains an endangered population. There are an estimated 100 to 180 adults and sub-adults, living primarily south of the Caloosahatchee River, a hindrance to range expansion. However, in 2017, panther kittens were confirmed north of the river for the first time in over 40 years. Still, the population is considered very fragile due to ongoing development in Florida.

Physical Characteristics

This is a large feline with a long, black-tipped tail. Compared to cougars of the western United States, Florida panthers are slightly smaller, with males averaging about 120 pounds and females 80 pounds. Pelage is shorter, less luxurious, and slightly darker. The skull is broader and flatter, with highly arched nasal bones, creating a rounder profile.

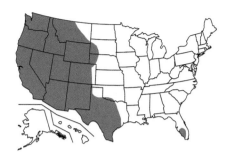

Prior to the 1995 introgression of 8 Texas cougars, many Florida panthers had genetic abnormalities indicating inbreeding depression. These included a kinked tail, a mid-dorsal cowlick, atrial septal defect, and undescended testicles. The introgression restored genetic diversity, reducing the incidence of these defects. However, the population remains isolated, and the incidence of these defects is again on the rise.

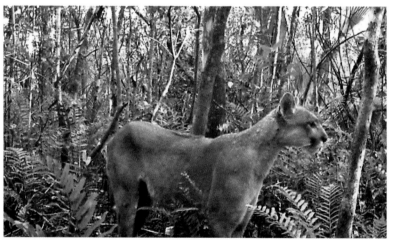

A cowlick, a genetic defect indicative of inbreeding, can be seen on this Florida panther's back. *(Exodus Lift, clipped from a video)*

Tracks and Trails

Panther tracks are larger than bobcat tracks, but are of the same structure, with roundish overall shape, 4 toes, a large trapezoidal heel pad, and an asymmetric toe arrangement with the second toe from the inside leading. Retractable claws usually do not register. Hind tracks are slightly longer and narrower than front tracks.

Measurement of heel pad width is more accurate than total track width because it is not affected by splaying of the toes. Maehr (1997) found that the Florida panther front heel pad width averages 2.2 inches for males, and 1.9 inches for females, and hind heel pad width averages 1.9 inches for males and 1.7 inches for

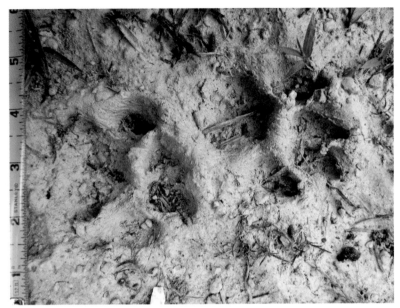

Front (left) and hind Florida panther tracks. Claw marks are absent because cougars can retract their claws.

females. I have found hind tracks with a heel pad as small as 1.5 inches, which overlaps with the front heel pad of a large bobcat.

Cougars usually use an overstep walk in shallow substrate, and a double registering walk in deeper substrate. Elbroch (2003) found that the cougar's overstep walking pattern has a stride of 19 to 32 inches and a straddle of 5 to 9 inches. Trail measurements for the Florida subspecies are probably slightly smaller. Cougars can also trot, lope, and gallop.

Diet
Panthers need large prey to thrive. White-tailed deer and feral pigs are top menu items, but panthers do take small- to medium-size prey opportunistically. Unlike their cold-climate cousins, they do not make substantial seasonal movements, because their favored prey do not do so. Also, they must hunt more often than their western relatives, because the hot, humid climate renders prey inedible within a couple of days.

Scat and Urine
Panther scat is segmented and the surface is smooth, but there may be some twisting. It usually contains hair and sometimes bone fragments. Western cougar scat ranges from ¾ to 1 ⅝ inches in diameter, often placed in scrapes, and may be covered or left in the open. The slightly smaller Florida panther likely produces slightly smaller scats. The two scats I found were ⅞ and ¹⁵⁄₁₆ inches in diameter,

and they were left in the open on the side of the trail. Like other felines, panthers spray urine backward onto stones, stumps, vegetation, and the like. Urine is said to smell similar to that of the house cat.

Habitat

Panthers prefer forest cover and use a variety of forest types, including pine flatwoods, cypress swamps, and cabbage palm woodlands. But within their home ranges, panthers use hardwood hammocks most intensively. Islands of productive upland forest of up to 50 acres in size, hardwood hammocks are found within other forest types, grasslands, and wetlands. Their mast-producing trees and shrubs attract the panther's favorite prey, white-tailed deer and feral pigs. Panthers hunt in both forest interior and field-forest edge.

Saw palmetto, a low-growing palm that can reach a height of about 8 feet, is an extremely important plant for the Florida panther. Under dense cover of palmetto fronds, the panther hunts deer, hogs, raccoons, and turkeys, all of which come to feed on palmetto fruit. Female panthers often den in saw palmetto thickets of upland forests and pine flatwoods.

Breeding

Breeding can occur at any time of year, but mating peaks in early winter, and births peak in spring, about 3 months after mating. Litters consist of 1 to 4 kittens. The female is the sole caregiver and does not breed again until her young disperse, when they are 12 to 18 months old.

Camera-Trapping Tips

The Florida panther is not difficult to capture by trail camera. Or, since the future of this endangered cougar population is uncertain, I should specify that it was not difficult from 2015 to 2017. There are some factors that make it an easier subject: Its normal gait is a relatively slow walk, and it regularly uses travel corridors.

Some of the panther's preferred routes are not hard to find, due to human land-use history and the predominance of wetland habitats of southwest Florida. During the rainy season, water levels in the swamps are high, and panthers make frequent use of the old tram railways created for logging in the cedar swamps from the 1930s to the 1950s, many of which are currently maintained as hiking or ATV trails.

My camera-trapping data suggest that, perhaps out of habit, panthers continue to use the trams quite regularly even during the drier months, when one might expect them to forgo the open trams for forest cover. Look for tracks on the edges of the trams, as panthers seem to hug the forest cover on either side. Try the trams with less human activity or with proximity to highway underpasses.

Panthers also make use of game trails that lead to highway underpasses. Images captured on these narrow trails have a more natural, wild look. Black bears also use these trails and can't seem to resist pulling and biting at the camera, so a security box and cable lock are desirable.

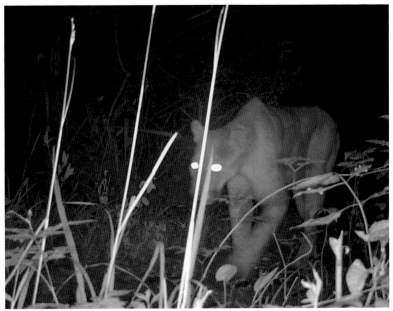

A Florida panther on the prowl on an old tram railway, now maintained for hiking and biking. *(Exodus Lift)*

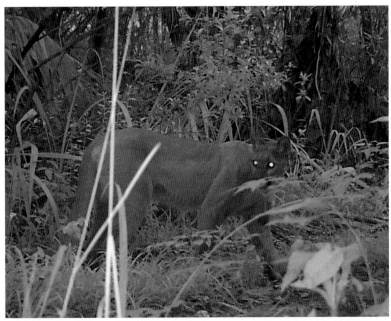

This old tram railway is an especially popular travel corridor, perhaps because of its proximity to a highway underpass used by cougars to access excellent habitat.

The cluster of trees just right of center is a hardwood hammock, a preferred habitat for the Florida panther.

In theory, a camera trap in a hardwood hammock might capture a panther hoping for a meal of venison or pork, especially in fall, when deer and pigs forage for mast in these areas. My only such attempt was in a 1-acre hardwood hammock surrounded by prairie. In this marginal hammock, the only cat I captured within a 2-month period was a bobcat. Perhaps the surrounding landscape was simply too open for panther movement. One might have better luck where the hammock is adjacent to some other forest type rather than surrounded by prairie.

Although panthers use saw palmetto thickets for hunting and breeding, the dense, low vegetation makes camera trapping difficult. Perhaps a game trail leading into saw palmetto would be productive.

In winter, when water levels are very low, panthers use alligator holes to drink and to hunt for other animals seeking water. These water holes are excellent camera-trap targets.

Fakahatchee Strand Preserve State Park, the northwest corner (Bear Island) of Big Cypress National Preserve, Picayune Strand State Forest, Corkscrew Swamp Audubon Sanctuary, and Florida Panther National Wildlife Refuge are some good places to track panthers. However, if you desire to place a trail camera on any of these properties, be sure to request permission first. Also inquire about burn management. Some of these organizations periodically burn fire-dependent habitats, and you won't want your camera there when that happens.

29

WHITE-TAILED DEER

Order Artiodactyla / Family Cervidae

A white-tailed doe with her fawn in a field near forest edge in Wisconsin. *(Exodus Lift)*

WHITE-TAILED DEER (*Odocoileus virginianus*) numbers hit a low around 1900, due to overhunting and poor land management. But by 2000, the deer population equaled or exceeded precolonial numbers. The resurgence resulted from hunting regulations, loss of large predators, and various land-use patterns that resulted in favorable deer habitat. Abandonment of farmland, logging in closed canopy forests, and suburbanization all created early succession or edge habitat that deer need to thrive.

Physical Characteristics

White-tails weigh 50 to 300 pounds, with males about 20 percent larger than females. The coat is grayish in winter and reddish brown in summer. The belly, the edge of the rump, and the underside of the tail are white. The male's antlers have one main beam with vertically directed points branching off of the main beam. Females do not have antlers. Fawns are reddish brown with white spots.

Tracks and Trails

Front tracks can range from about ½ to 4 inches long and ½ to 3 inches wide, from young fawn to large buck. Hind tracks are slightly smaller. Hooves are cloven: The two toes of the hoof register to create a heart-shaped track with a central ridge. There are two additional toes, called dewclaws, situated higher up on the leg, that usually do not register. When the animal is running, or when substrate is deep and soft, the two toes of the hoof can splay and the dewclaws can register. Deer use an alternating walk when foraging, and direct register in deep substrate. The stride of the walk is 13 to 26 inches, and the straddle is 4 to 10 inches. Deer speed up to a trot, gallop, or bound. They often travel in groups and create well-used runs.

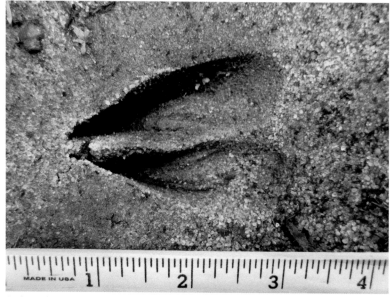

A classic heart-shaped deer track found in Wisconsin.

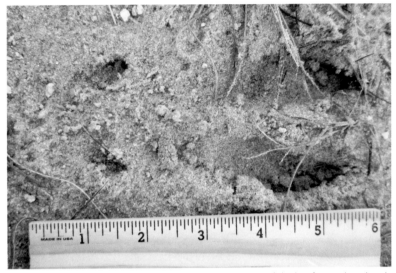

A deer track found in Wisconsin. In this soft sand, the toes of the hoof are splayed and the dewclaws registered.

Diet

Like moose, deer have small rumens and need rich, low-fiber plant foods. Diet varies by season. Mostly forbs, tender young grasses, and young leaves are taken in spring and early summer. Berries, fruit, nuts, mushrooms, and crops supplement

This fawn in Massachusetts noses ground lichen, which is not common on the white-tailed deer's menu. Perhaps the fawn and its mother were visiting this windy ridge to avoid biting insects. *(PIR triggered Canon 60D)*

green forage as they become available mid-summer through autumn. Favorite crops include apples, pears, alfalfa, corn, clover, soybeans, chicory, and turnips.

Their winter diet consists mainly of twigs and bark. They harvest twigs by tearing them between their lower incisors and upper hard palate, leaving characteristic frayed edges. This is usually seen at a height of 1 to 3 feet, but can be much higher due to snowpack. They feed on cambium by using their incisors to scrape young trees with smooth bark. Favorite trees and shrubs are oak, apple, maple, basswood, hemlock, blueberry, raspberry, and sumac.

Scat and Urine

Like many herbivores, deer excrete pellets, but the appearance varies with diet. In winter, when deer feed on woody browse, pellets are discrete and usually about ¾ to 1 inch long, and ¼ to ½ inch wide. Pellets may be almost round to long and thin. In the warmer seasons, when deer feed on moist, rich foods, they excrete clumped pellets. On snow, urine usually appears brownish.

Habitat

Deer need a mixture of habitats to satisfy requirements for food and cover. Mature forest provides cover and a variety of foods, but the most tender forage is out of the deer's reach. Early succession habitat and edges are abundant sources of young, succulent greenery, mast, and woody browse, well within reach of this medium-size ungulate. Deer readily forage in agricultural fields.

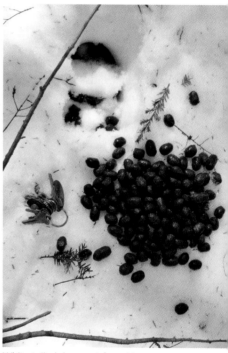

White-tailed deer scat found in Massachusetts.

Breeding

Deer mate in October through January, depending on latitude (late October through early December in Massachusetts), but at any time of year in South Florida. A few days before giving birth in spring, pregnant does drive off their young of the previous year. One to 3 fawns are born 6 to 7 months after mating. A few hours after birth, the doe moves the fawn to thick cover, where it stays hidden while she forages nearby, returning 2 to 3 times a day to nurse. Fawns begin eating some vegetation at 2 to 3 weeks of age and travel more with their mothers. They are totally weaned by 8 to 10 weeks. Yearling daughters may rejoin their mother and younger siblings sometime in summer.

Camera-Trapping Tips

White-tailed deer are so abundant and accustomed to people in some parts of the country that a camera trap is hardly needed for photography. In central Wisconsin I've seen up to a dozen a day while hiking in state wildlife areas. Deer are not as easily seen where I live in Massachusetts, but they're common enough that many of my deer photos are captured incidentally by cameras set for other species. But there is much information available about deer movement and behavior, for those in pursuit of deer footage and photos.

Deer must travel between their foraging grounds and their beds, which are usually in thick cover on slopes with a commanding view. They choose the safest and easiest travel routes, which become well-worn runs. For safety they need cover, and for ease of movement they avoid deep water and steep slopes. You can predict deer runs using topographic maps, aerial images, and on-the-ground knowledge of habitats.

There are some typical travel patterns: Deer travel through or hug the edge of dense cover, such as a regenerating clear-cut, for as long as possible before heading out to more open feeding areas. They cross hilly terrain over saddles rather than hilltops. They make use of "benches," stretches of level land along hillsides. Finally, like many large mammals, deer travel on narrow strips of land between bodies of water, such as beaver dams in New England, dyke trails in central Wisconsin, and old trams in South Florida.

Expect to see deer in small groups most of the time. Groups tend to be larger in more open habitats, where extra eyes help to spot predators. Doe-led groups consist of a mother and her fawns of the year, and sometimes daughters from the previous year. Bucks live in bachelor groups of 2 to 5 unrelated animals.

Favored feeding areas vary by season. In spring, deer are eager to forgo woody browse for more nutritious vegetation. They follow green-up, which

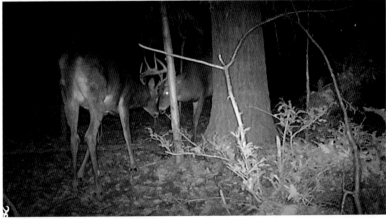

A pair of white-tailed bucks sparring. The camera was targeting a cluster of rub trees visited by two or three different bucks.

often begins around wetlands, ponds, lakes, and streams and at forest-field edges. By mid-summer lush greenery is widely available and it's more difficult to predict where deer will be.

In late summer through early fall, deer supplement leaves with berries in regenerating clear-cuts, nuts in mature forests, fruit in orchards, and crops in fields. Deer sometimes bed in farm fields and hedgerows, which can make camera trapping difficult at this time of year.

By fall bachelor groups break down, as bucks turn their attention to breeding. Early in the rut, they begin rubbing the bark off young trees with their antlers and foreheads, creating a gleaming yellow visual signal with scent from the buck's preorbital glands. One tree may be used repeatedly by several bucks, and sometimes rub trees are clustered together. A cluster of trees with fresh rubbing is a good target for a trail camera.

In September the velvet sloughs off antlers, and bucks begin sparring, a ritualized mock fight used to reinforce the dominance hierarchy. As the breeding season progresses, antler rubbing becomes less frequent while activity picks up at "scrapes." The scrape itself appears as a 2- to 3-foot-diameter patch of earth, scraped bare by the animals' hooves. There is another important element: a thin, low (about 4 feet off the ground) branch overhanging the scrape. Both bucks and does nose and mouth the branch, imbuing it with their own scent and interpreting the scent of others. At least bucks, and possibly does, urinate in the scrape, but only bucks, as far as I know, scrape the pit with their front hooves.

A fresh white-tailed deer antler rub. *(Massachusetts)*

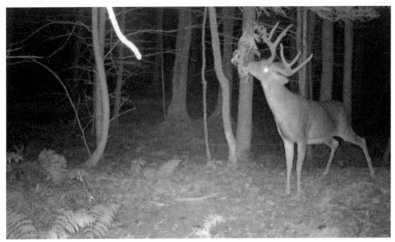

A Massachusetts white-tailed buck at a scrape. The overhanging branch is in his mouth and the scrape is the smooth, bare area before him. *(Exodus Lift)*

A fresh deer bed found in Massachusetts, with mittens for scale. The front legs are at left, the hind legs are tucked in at right, and the curve of the back is in the upper part of the photo. Note the tracks created when the animal stood up.

Scrapes are usually located on deer runs, often near wetlands, and they may be used repeatedly by multiple bucks and does. Scrapes also attract other species. I have video footage of a coyote leaving urine and scat at the scrape, and a moose consuming the overhanging branch after visiting repeatedly. With all of this activity, deer scrapes make excellent trail-camera targets.

The frayed ends of these dogwood twigs, found in Massachusetts, are the result of either deer or moose browsing. Moose feeding sign may be found much higher than deer feeding sign, but snowpack allows deer to reach up higher than expected.

In winter deep snow impedes travel, making deer extremely vulnerable to predation, so they take to conifers, which provide poor forage, but good cover from predators and shelter from wind. Conifers also hold much snow, minimizing snow depth on the forest floor. A softwood forest on a south-facing slope is ideal. When deer congregate in such an area, it is known as a "deer yard." Look for a cluster of beds, scat piles, and runs of packed snow. Cameras near winter deer yards may capture the activity of deer and other species. Coyotes and bobcats use the runs to save energy and to patrol the yards for weakened deer.

In favored winter-foraging areas, deer leave abundant sign of winter feeding: the frayed ends of twigs ("browse sign") and incisor scrape marks on tree bark ("barking"). In good mast years, deer supplement this poor forage with acorns. Deer can smell them through the snow, which they scrape away with their hooves. You'll see sign of scraping, deer tracks, and pieces of crushed acorn shells and meats. Cameras placed near abundant sign of browsing, incisor scraping, and acorn foraging could capture these feeding behaviors.

MOOSE

Order Artiodactyla / Family Cervidae

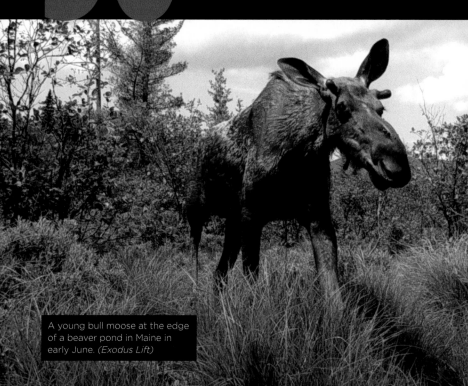

A young bull moose at the edge of a beaver pond in Maine in early June. *(Exodus Lift)*

MOOSE (*Alces alces americanus*) disappeared from most of New England during the 1700s and 1800s due to overhunting and the clearing of forest for agriculture. But abandonment of farmland and the subsequent reforestation permitted the return of many woodland species, including the moose. Now tens of thousands of moose roam the Northeast once again.

Physical Characteristics

Weighing 660 to 1,300 pounds, this is the largest species in the deer family. Adults are usually brownish black with grayish white legs. Moose have long ears, long legs, and a long nose. A long dewlap ("bell") on the chin is comprised of a "bag" and a "rope" in the male, and a rope only in the female. Bulls have huge, palmate antlers, and cows have no antlers. Calves are reddish brown and, unlike deer and elk, are not spotted.

Tracks and Trails

Front tracks are about 3 to 6 inches wide. Hind tracks are slightly smaller. Feet are cloven hooves. The two middle toes register to create a heart-shaped track with a central ridge. Two outer toes, the dewclaws, are situated higher up on the leg and often do not register. When the animal is running, or when substrate is deep and soft, the 2 inner toes can splay and dewclaws can register. Dewclaws are more likely to register in moose tracks than in deer tracks. Moose use an alternating walk when foraging, with a stride of 28 to 44 inches and a straddle of 8½ to 20 inches. They also trot, gallop, and bound.

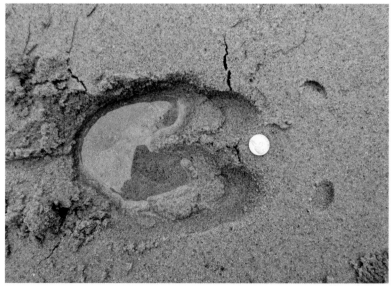

Moose track found on a lakeshore in Massachusetts. The dewclaws are barely registering. A nickel was placed for scale.

Fresh moose incisor scraping on striped maple in Maine. This is usually found between 3 and 7 feet off the ground. Deer also scrape with incisors to harvest cambium, but the sign appears much lower, unless snowpack allows them to reach higher.

Diet

Because moose have small rumens, they do not digest tough, fibrous grasses very well and require tender, young, nutrient-rich vegetation. In early spring they eat catkins and, when available, the leaves of trees and shrubs, such as willows, aspens, and white birch. Deciduous trees and shrubs are preferred, though sometimes certain conifers are consumed. In the Northeast, balsam fir may be taken in large quantities. In summer moose need a rich source of minerals, which, in eastern North America, they find in aquatic vegetation. In late summer and fall, moose supplement greenery with mast. In winter, when lush vegetation is unavailable, moose browse on twigs by tearing them between their lower incisors and upper hard palate, leaving characteristic frayed ends. They also use their incisors to scrape the bark of young trees, such as red maple, striped maple, and aspens.

Scat and Urine

Moose excrete discrete pellets in winter when feeding on dry, woody browse, and clumped pellets or even large pies in spring and summer when

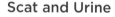

Clumped summer moose pellets result from a diet of rich vegetation. These were found in a wetland in Massachusetts.

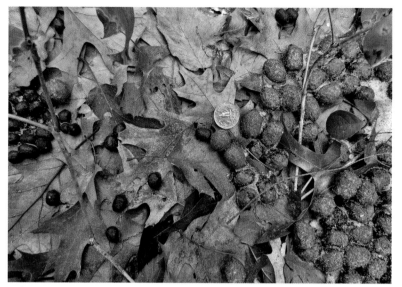
Old, dry moose scat (right) compared to fresher deer pellets.

forage is moist and rich. Pellets are nearly round to blocky and usually measure 1 to 1½ inches long by about ¾ inches wide.

Habitat

To find the young, nutritious vegetation that moose need, they forage in early succession habitats, such as regenerating clear-cuts and burnt areas, beaver meadows, and other disturbed areas. They also need forest for cover and lakes, ponds, streams, or wetlands for aquatic vegetation and for cooling off in summer.

Breeding

Most mating takes place in late September or early October. In May or early June, the female chooses a secluded place to give birth to 1 or 2 calves. Calves begin eating solid food within a few days, but continue to suckle for about 5 months, weaning in early fall, when cows begin to breed again. Calves remain with their mothers until they are almost a year old, at which time the cow drives them off in preparation for the birth of new calves.

Camera-Trapping Tips

At up to 7 feet tall at the shoulder, moose are enormous creatures, so be sure to account for that when setting your camera. It helps to have a friend stand in the target area while you adjust camera placement. Luckily these huge animals usually display no more than mild curiosity about trail cameras, for they could easily destroy them. Moose move slowly when foraging, so it is possible to get nice, clear photos.

In general, any area with sign of repeated, or at least recent, moose activity is a good choice of camera location. Deciduous forests may be used more often in spring, coniferous and mixed forests more often in winter, and regenerating forests are popular any time of year. But to really home in on the hot spots, it helps to understand moose behavior in greater detail.

In spring and summer, both cows and bulls feed heavily on aquatic vegetation in wetlands, ponds, lakes, and streams. Beaver ponds are particularly attractive. Bulls and barren cows sometimes play in water at this time of year, both individually and in small groups. For footage of moose feeding, playing, swimming, or diving, station the camera way back. Moose move slowly and pause frequently to look around while feeding, so short video clips might miss a lot. Set the camera to take at least 15-second clips, or use a camera with a short video recovery speed.

Moose sometimes create runs along wetlands in summer, and these are productive camera spots for both moose and other animals sharing the trails. In Maine in early summer, a lynx used a game trail along a beaver pond as often as a moose did.

In late summer and fall, moose, bulls especially, are more focused on breeding than feeding and begin creating rut pits. Both females and males scent mark by rubbing small-diameter trees with their heads. Cows rub during the peak of the rut, perhaps to advertise readiness. Bulls rub late in the rut, perhaps to attract cows who have not yet bred. Bulls also thrash shrubs with their antlers, leaving broken branches and rubbed spots. Any area with a lot of rubbing or thrashing might

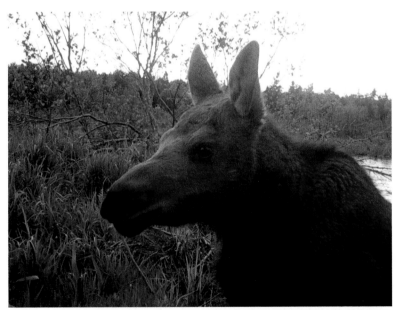

A moose calf in Maine in early June. Two weeks later the grass was tall enough to block the camera's view. *(Exodus Lift)*

A moose rubbed and thrashed this white pine sapling in Massachusetts. Notice the height of the action.

capture moose action, but it must be fresh. Freshly rubbed spots on trees and shrubs are gleaming yellow, while those from previous years are gray and scarring.

A rut pit is perhaps the best spot for camera trapping at this time of year. In late summer bulls create rut pits by scraping mud, depositing urine, and splashing urine-soaked mud onto bell and antlers. The scent is highly attractive to cows, and may influence their estrous cycle. Look for 3- to 10-foot-long muddy scrapes near wetlands. Both bulls and cows make rut pits, but the larger ones made by bulls are where the action is. Cows find them irresistible. In fact a cow may push the bull out of the way to wallow in it, and may compete for it with other cows. Bulls keep returning to see if a cow has visited his pit. Bulls also begin friendly sparring and, eventually, serious fighting for mating rites.

In late October the breeding season draws to a close and bulls may begin to form fraternal groups, resting and feeding together in early succession habitats.

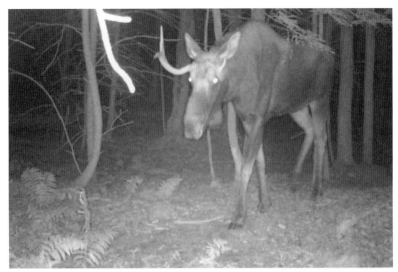

Animals are often attracted to the scent stations created by other species. This young bull moose is at a white-tailed deer scrape in fall. The scraped spot is in front of his leading hoof, and the overhanging branch that the bucks chew is just above his back. This bull and a cow moose both visited the scrape repeatedly. Eventually one of them ate the overhanging branch, at which point the deer abandoned the scrape.

They engage in friendly sparring from time to time. Antlers begin to drop in mid-December, and once a bull has lost his antlers, he withdraws from the group.

In winter moose usually spread out to reduce competition for food but occasionally "yard up" in areas of good woody browse. In a moose yard, you'll find abundant evidence of moose activity, and if they spread out, it's still not difficult to find moose sign. Look for the ragged edges of browsed twigs, concentrated areas of fresh incisor scraping on young trees (red maple and striped maple are favorites in the Northeast), and beds in snow. Moose sometimes create red maple thickets by browsing heavily over the years, and these are good spots for capturing winter feeding.

In late winter crusted, deep snow greatly impedes travel, but allows lighter predators to move efficiently over the surface. So, for safety, moose spend much time in coniferous forests, where dense shade prevents crust formation. If they travel to other habitats, they create runs for easier movement. Other species may share these runs, making them good camera-trapping possibilities.

31 ELK

Order Artiodactyla / Family Cervidae

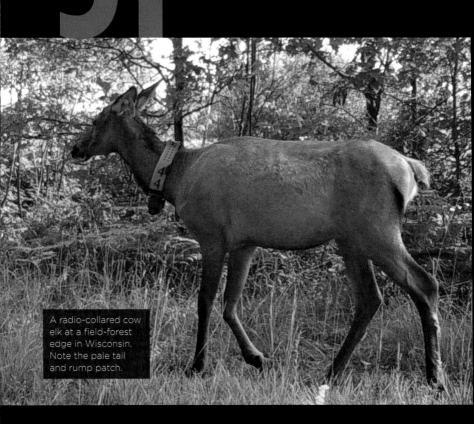

A radio-collared cow elk at a field-forest edge in Wisconsin. Note the pale tail and rump patch.

WHETHER THE ELK IS A DISTINCT SPECIES or a subspecies of the European red deer has been a matter of debate for many years, but recent genetic studies suggest it is most likely a distinct species, *Cervus canadensis*. Elk once ranged over most of the United States, but they were extirpated, or nearly so, from the eastern United States by the early 1900s. Reintroduction efforts have restored small populations in Kentucky, Wisconsin, Michigan, Pennsylvania, North Carolina, Tennessee, and West Virginia.

Physical Characteristics

Elk weigh in at 400 to 1,100 pounds, with males larger than females. The body is medium to pale brown, and the head, neck, and legs are dark brown. Both males and females have manes, though the male's is shaggier. The short tail and rump patch are buff. The male's antlers have 1 main beam and usually 6 points. Females have no antlers. Calves are brown with white spots.

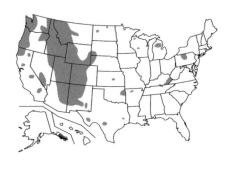

Tracks and Trails

Elk tracks overlap in size with both deer and moose tracks, but elk tracks are noticeably rounder. The front tracks of an adult elk are about 4 inches long and wide. Hind tracks are smaller and narrower, about 3½ inches long and 3 inches wide. Hooves are cloven: 2 middle toes register to create a print

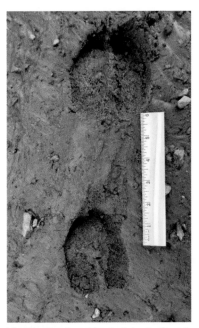

Hind (bottom) and front elk tracks found in Wisconsin.

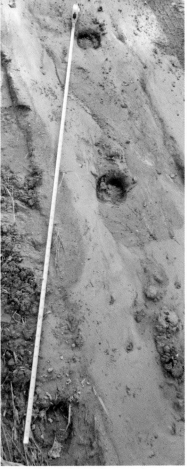

Elk tracks in an alternating walk pattern found in Wisconsin.

with a central ridge. Two outer toes are dewclaws situated higher up on the leg, and they usually do not register. Inner toes may splay in soft substrate or when the animal runs. Elk usually travel in groups and use an alternating walk when foraging, with a stride of 18 to 35 inches and a straddle of 6¾ to 13 inches. They speed up to a trot, lope, or gallop when frightened.

Diet

Elk are primarily grazers, but they also browse, especially in winter, when green forage is unavailable. In spring and summer elk feed on grasses, sedges, forbs, and leaves of trees and shrubs, such as aspen, willow, serviceberry, and chokeberry. Some aquatic plants, including succulent cattail stems, are also taken. In winter they paw through the snow for grass and eat the twigs and bark of trees, particularly aspen. Compared to deer, elk rely more on grass. Compared to moose, elk consume more grass and less aquatic vegetation. Elk also eat crops, and some state wildlife agencies plant crops for them to maintain tourist viewing areas.

Scat and Urine

Elk excrete pellets of about ¾ inch by ½ inch. Dry forage results in discrete pellets, while moist, lush forage causes pellets to clump. During the rut, bulls urinate in wallows, spraying some of it up into their mane.

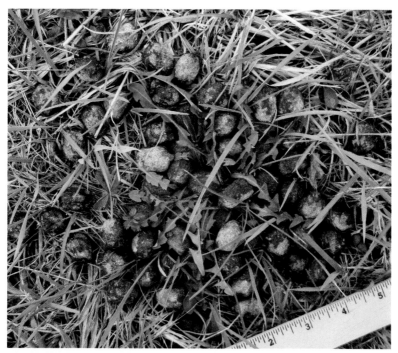

Elk scat found in Wisconsin.

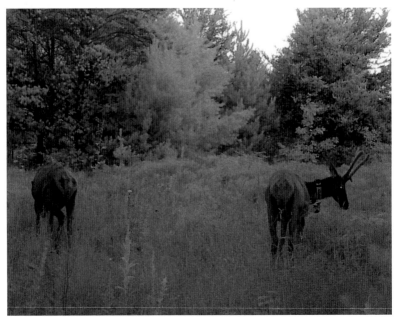

A pair of Wisconsin cow elk feeding in a field.

Habitat

Elk prefer a mosaic of habitats to satisfy requirements for food and cover. Forest provides shade, cover, and winter browse; edges provide young, succulent browse; open land provides grasses, sedges, and forbs; and wetlands provide water and aquatic vegetation. Disturbances, such as forest fire and logging, benefit elk by exposing the forest floor to sunshine, which encourages growth of grasses, herbs, and young woody plants.

Breeding

Mating usually occurs in September and October, when bulls compete for females and establish and defend harems. In June a single calf is born in the shelter of forest cover. Soon the cow leaves her hidden calf to feed with the herd, returning frequently to nurse and to sleep with it at night. Calves are born large and grow quickly, so that by 2 weeks old they are ready to join the herd, where calves hang together in "creches." Weaning occurs at 2 months, but calves maintain close contact with their mothers until the rut of the following fall. After the rut, calves rejoin their mothers in the herd.

Camera-Trapping Tips

Compared to deer and moose, elk are noisier and more gregarious. If you want videos, use a camera that records audio so you can capture their squeals, barks,

squeaks, and bugles. Be sure to set the camera far enough back to capture inter-actions between large animals.

Like moose and deer, elk move about the landscape according to seasonal availability of favored foods. But because grasses comprise a larger portion of the elk's diet, elk are more often found in open fields. This puts them at higher risk of predation, especially where wolves range. They counter that risk by staying close to edges, where they can quickly find tree cover, or by feeding in larger herds. More eyes help spot danger, and being one of many reduces the risk on each individual. Herds may consist of hundreds of animals in the West, where elk sometimes feed in large grasslands, but in the East, elk herds are smaller because the landscape is more heavily forested.

Winter is a good time to track elk because tracks, scat, and beds are easy to see on snow. Winter feeding sign, such as incisor scraping on trees, ragged edges of browsed twigs, and evidence of pawing through snow for grass, is also conspic-uous. Aspen groves are good bets for sign of browsing and incisor scraping, and south-facing slopes and low elevations, where snow is shallower, are good places to look for sign of digging. Elk may return to these feeding areas, making them possibilities for camera trapping.

As winter gives way to spring, elk head for low elevations, where fresh green growth first appears. They then follow the receding snow line back up the hill sides, feeding on emerging young, nutritious growth. They are attracted to wetlands, ponds, and riparian areas, where they can feed on lush vegetation and bathe to cool off and escape biting insects. Elk also take refuge from insects on windy ridges.

As summer draws to a close, elk begin to move down slope again, toward winter feeding areas, consuming drying grasses and sedges as they go. Shortening late summer days herald the rut, which spans September and October in the North, but may be more spread out in warm climates. For bulls, this is a noisy and exhausting period, and it offers great opportunities for camera trappers.

Three distinct marking behaviors are described for rutting bulls: thrashing and rubbing; thrash-urinating; and wallowing. Bulls may bugle before, during, or after any of these behaviors.

Bulls thrash and rub small trees with their antlers, leaving behind broken branches and stripped bark. Thrash-urinating involves beating low vegetation, goring the soil with the antlers, and flinging up debris, all while urinating onto the neck and surrounding vegetation. These sites may be used repeatedly, and may be a good target for a camera. Thrash-urinating often immediately precedes aggressive encounters between bulls.

A bull creates a "wallow" by scraping up soil with the front hooves and some-times the antlers, then urinating onto his neck and into the scrape. He then sits down into the pit and rolls his neck, caking his mane with urine-soaked mud. He may rest in the pit for several minutes thereafter. The wallow appears as a churned-up muddy area or large puddle. Look for wallows in openings with moist, soft soil.

A wallow pit is an excellent target for a trail camera, because the bull revisits his pits (he may make several), and cows and calves are drawn to the odor. Cows scrape and roll in them, and both cows and calves jump around them.

Any area that funnels travel of large animals is a possible spot for capturing elk in transit. In Wisconsin a camera placed on a dyke trail within an expansive wetland system captured many photos of elk. Natural mineral licks also attract elk and may be good spots for camera trapping.

32 WILD TURKEY

Order Galliformes / Family Phasianidae

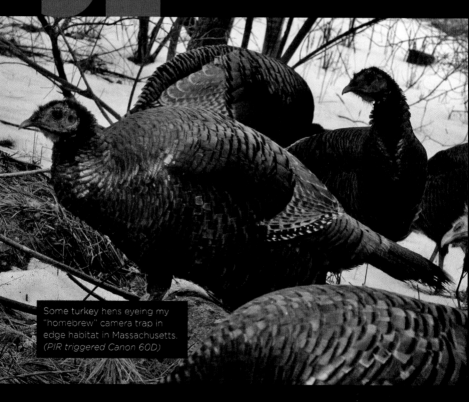

Some turkey hens eyeing my "homebrew" camera trap in edge habitat in Massachusetts. *(PIR triggered Canon 60D)*

AS A RESULT OF UNREGULATED HUNTING AND DEFORESTATION, the wild turkey (*Meleagris gallopavo*) was eliminated from some states during the 1800s. By 1958 it had reoccupied most of these states, thanks to restocking programs. Now wild turkeys thrive in both suburbs and wilderness.

Physical Characteristics

Adult males average 46 inches in length, and adult females 37 inches. Plumage is dark and iridescent, with white bars on the flight feathers and rusty bars on the rump and tail. Males and some females have a blackish breast tuft. Females and immatures are duller than males.

The bald head is blue and pink, with caruncles on the head and neck, wattles on the throat, and a snood—a small protuberance—above the bill. The male's snood is larger than the female's and extends to hang down over the bill when he is excited.

Tracks and Trails

Tracks are 4 to 5½ inch wide, with 3 forward-pointing toes and 1, the hallux, pointing backward. The metatarsal pad and the 3 forward-pointing toes register well. The hallux usually registers, but more lightly than the other toes, and sometimes the claw registers. The turkey walks and runs with a stride of 5 to 33 inches. It often travels in flocks.

Diet

The omnivorous turkey eats acorns, nuts, seeds, berries, roots, grasses, leaves, insects, amphibians, and reptiles, as well as human sources of food such as waste grain and birdseed. Hens eat snails as a source of calcium for eggshell production. Hard mast is a most important dietary component, and acorns, hickory nuts, chestnuts, and hazelnuts are highly attractive. In winter turkeys eat hemlock buds, evergreen ferns, and club mosses, especially in poor mast years or when they can't reach acorns or roots through snow.

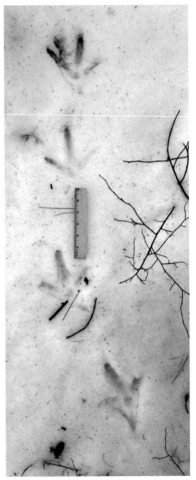

A wild turkey's walking trail in Massachusetts.

Scat

Most turkey droppings are cylindrical and white at one end. Adult male droppings are ⅜ to ⅝ inch in diameter, while those of females and juvenile males are less than ⅜ inch in diameter. Males tend to produce J-shaped scats, while females excrete loops, coils, and clumps. With that said, wild turkey droppings vary widely in appearance, depending on diet, and many defy classification by sex. Both sexes also produce "cecal droppings," brown to black splats or poorly formed blobs.

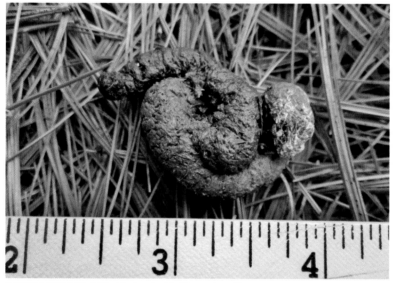

A typical dropping from a turkey hen in Massachusetts.

Habitat

Hardwood and mixed forests with a diversity and abundance of mast-producing trees, such as oak, pecan, hickory, hackberry, cherry, dogwood, sweet gum, and tupelo, provide essential food, cover, and roosting sites. Dense brush or tangles of vines provide nesting habitat. Open landscapes, such as prairies, savannas, agricultural lands, and marshes, round out the diet with additional plant and animal foods and provide spring strutting sites and summer brood habitat.

Breeding

The hen alone tends to the nest, eggs, and young. After mating in spring, she scrapes a depression about a foot in diameter and an inch deep, in good cover, and lays 1 egg per day, to a total of 8 to 17. Eggs are white to buff, heavily speckled with brown to purplish brown, and measure 2½ by 1¾ inches. After each egg is laid, she usually covers it with a few dead leaves, which fall to the bottom of the nest the following day, when she sits to lay the next one. In this way, a thin lining

This wild turkey nest, found in a suburb of Massachusetts, was up against the foundation of a house under sparse cover. *Photo by Pat Jao*

is created for the chicks, which hatch after about a month of incubation. They can leave the nest to forage with the hen within 24 hours.

Camera-Trapping Tips

Wild turkeys are so common in some locations that incidental photos of them may be captured frequently. But their interesting behaviors can be studied with a more targeted approach, if you know where and when to look and listen.

Feeding sign is easiest to find in winter through early spring, when flocks spend a lot of time scratching for acorns and other hard mast, creating large clusters of debris piles and dinner plate–size bare spots. A few droppings may punctuate the scene. Look for this sign in open forest with plenty of nut-producing trees. An abundance of scratching suggests a favorite foraging spot that the flock may revisit, so a well-positioned camera may capture their action.

Winter is also a good time to begin searching for a roost, a tree or group of trees where the flock sleeps at night. Roosts are usually mature trees with horizontal branches stout enough to support heavy birds. In mild weather they may choose a hardwood stand on a slope that affords a good view and clear sailing. In stormy weather they may choose conifers for protection against the elements. In Florida turkeys tend to roost in cypress trees, perhaps because the surrounding water

provides a moat of protection from climbing predators. In most areas, turkeys tend to reuse roosts. They may have several favorite sites, using one for several consecutive nights before switching to another. Or they may shift among favorite sites almost every night.

One way to find a roost is to notice the accumulations of droppings beneath. Another is to look for turkeys in trees around sunrise and sundown. This will be easier if you also learn turkey vocalizations, using online recordings, and localize the birds by sound. Hens yelp upon awakening at daybreak, and they cackle as they fly down from the roost. Except in winter, when males and females travel in mixed flocks, adult males roost in separate flocks. Males, too, yelp and cackle in the morning and may gobble before alighting.

Finding a roost helps you learn the flock's daily routine, for this is where it all begins. But it's not the only place where males gobble, especially during the breeding season, when they are on a mission to find mates. After leaving the roost, the male prefers to show off in open areas, such as fields and open woodlands, where hens can hear him gobble and admire his splendor. When a hen and tom find each other, he displays by strutting, puffing out his feathers, dragging his wings, fanning his tail, and elongating his snood. In good substrate you can find sign of his dragging wings associated with tracks. He tends to use a few favorite locations repeatedly, so it's worth placing a camera where you see or hear evidence of this behavior.

Listen for gobbling in early morning, when it peaks, and again in late afternoon, for a second, smaller peak. Males may gobble in any season, but it is most common at the beginning of the breeding season (mid-April in South Carolina)

This heavy accumulation of turkey droppings on the forest floor is evidence of a roost. This one spanned about a quarter acre in an oak–pine forest in Massachusetts.

The lines on either side of the trail were made by the dragging wings of a strutting male in early April in Massachusetts.

and 2 to 3 weeks later, when most hens are nesting.

A tom may mate with more than 1 hen, and a hen may mate with more than 1 tom before she leaves the flock to find a nest site. She chooses a spot on the ground, usually with good cover in the form of brush, overhanging branches, or thick grasses. She might find this in forest understory, shrubland, or even a hayfield. In Florida, patches of saw palmetto within open forest are preferred. In the Northeast, turkeys like to nest in forest with dense understory, at the base of a large tree or near a log. Suburban turkeys that have adapted to human activity may nest among grasses and weeds in rough edges of backyards, and even under foundation plantings.

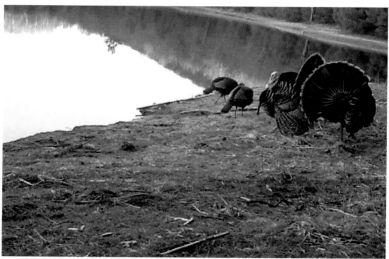

Two toms displaying to two disinterested hens in early spring on an open lakeshore in Massachusetts. Notice that one of the males is dragging his wings. *(Exodus Lift, video snip)*

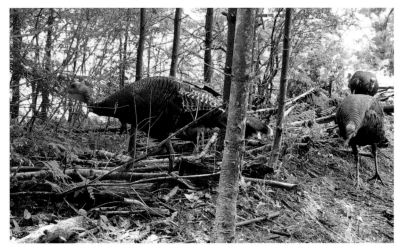

As large birds that spend a lot of time walking, turkeys sometimes use crossing structures, just as many mammals do. Here they are using a beaver dam to cross a stream. *(Moultrie)*

If you do find a turkey nest, be sure to respect the American Bird Association's code of birding ethics, and keep your distance. Do not remove any vegetation to improve the view for a camera, for reducing cover could make the hen and eggs more vulnerable to predation.

A camera at a turkey nest may capture hatching, but not much after that, for the hen and her precocial young abandon the nest the day after hatching. Hen and poults usually feed in open habitats of ½ to 3 acres in size, with 1- to 2-foot tall grasses and forbs, tall enough to hide young but low enough for them to glean insects and for the hen to watch for predators. Savannas, prairies, hayfields, orchards, road shoulders, and utility rights-of-way can satisfy this need. In Florida cypress woods that are not flooded provide excellent brood habitat. In Massachusetts I once monitored a hen with brood for most of the summer on an open lakeshore.

As summer progresses, turkeys return to forest and edge habitat as berries and nuts become available. Hens with broods join up to form larger flocks, which stay together through winter, and sibling adult males form their own flocks.

A favorite turkey activity in any season is dust bathing, which presumably helps them remove parasites. The birds lower themselves to the ground and wiggle their bodies and flap their wings so the substrate will fall between their feathers. Any place with dry, loose substrate and good cover will do. Sandy shores, dirt roadsides, and field edges are often used, and cool, shady locations are preferred in summer. An adult turkey's dust bath is an oval of about 1½ feet in length. A flock's dust-bathing site may be quite large, with at least 1 bowl for each flock member. Because it may be reused for many days, a dust bathing site provides a great opportunity for camera trapping.

RUFFED GROUSE

Order Galliformes / Family Phasianidae

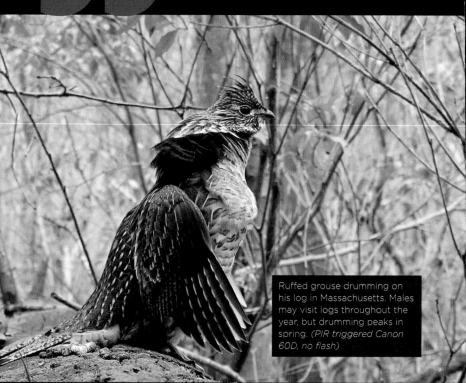

Ruffed grouse drumming on his log in Massachusetts. Males may visit logs throughout the year, but drumming peaks in spring. *(PIR triggered Canon 60D, no flash)*

THE RUFFED GROUSE, *Bonasa umbellus*, is a chicken-like ground nesting bird that relies on early successional habitat resulting from forest disturbance, such as logging, beaver activity, fire, storms, insect outbreaks, and tree death due to natural aging.

Physical Characteristics

Adults are 16 to 19 inches long, with a small crest on the head. They are mostly gray brown overall, with a buff chin, a blackish ruff, and eye spots on the back. The long, rounded multibanded tail has a wider and darker subterminal band. The female's subterminal tail band is broken in the center. The male has a small, orange-red comb above the eyes. Juveniles have white chins and lack the heavy, subterminal tail band. There is a red morph and a gray morph, and the difference is most noticeable in the tail.

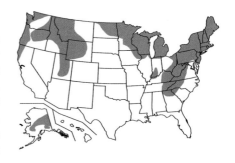

Tracks and Trails

Tracks of adults are 2 to 2½ inches wide, with 3 forward-pointing toes and a hallux pointing backward. The hallux usually registers, but more lightly than the other toes, and sometimes only the claw shows. It walks and runs with a stride of 3¼

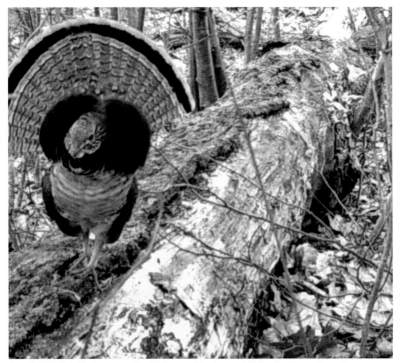

A red morph ruffed grouse displaying on his drumming log in Massachusetts. (*Exodus Lift*)

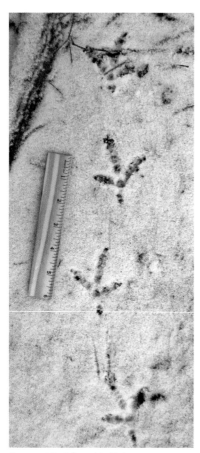

to 10½ inches, with feet turned slightly inward. Except for hens with chicks, ruffed grouse usually travel singly.

Diet

Winter diet consists largely of buds and twigs of aspens, willows, birches, hazelnut, alder, apple, blueberry, hop hornbeam, cherry, and maple. Male catkins of aspen, birch, hazelnut, and/ or alder are essential for winter survival. Grouse also eat ferns, seeds, and dried fruits in winter. Buds and catkins are taken well into spring, with leaves and insects taken as they become available. Many kinds of berries and fruits are consumed in summer and fall.

Scat

Slightly curved, cylindrical droppings are about ⅜ inch in diameter and ¾ to 1 inch long. They are usually white-washed with uric acid on one end. Cecal droppings are dark-brown splats or blobs. Piles of scat are found at roosts in snow or on the ground and on logs, stumps, or large stones, where males drum and display in spring.

A grouse trail found in Maine.

Habitat

Habitat needs vary by season. In fall and winter, grouse need younger forest for thick cover and berries, interspersed with more mature forest for hard mast, buds, and twigs. Seeps, which provide herbaceous foods even in winter and early spring, are desirable. Males need spring drumming sites, large-diameter logs, stumps, or rocks in dense cover of shrubs or tree saplings. Hens prefer relatively open canopy forest with dense understory for nesting. Hens with chicks need small openings with predominately herbaceous cover and some brambles, shrubs, and tree saplings.

Breeding

Mating occurs in spring, and eggs are laid April through June. The hen alone tends to the nest, eggs, and young. She scrapes a small depression in the ground, lines it with bits of vegetation, and lays 2 eggs every 3 days to an average of 11 eggs. Eggs

are buff in color, sometimes speckled with brown, and measure 1 ¼ by 1 ½ inches. After the last egg is laid, she incubates them for 23 to 24 days before they hatch. Precocial young can leave the nest and feed themselves the day after hatching. They travel and feed with their mother until they disperse at 16 to 18 weeks of age.

Camera-Trapping Tips

Camera-trapping opportunities are best at drumming stages, where males drum and display in spring. The key features of these sites are elevation, so that the bird can be heard and seen by other grouse, and dense cover for protection from predators. He spends a great deal of time standing in one spot on his stage, at all hours of the day, so the chances of getting some nice images in favorable lighting are good. Even average trail cameras, which are not designed to focus on small objects at close range, can get decent shots of this bird.

The most common drumming stage is a mossy log of at least a foot in diameter, but stumps, rocks, stone walls, and old foundations are occasionally used. The stage is surrounded by tree saplings or shrubs at least 5 feet in height. The male typically stands in the same spot on his stage where a pile of his droppings accumulates, though sometimes he has a few secondary stages as well, or stands in a few different spots on one log. He often reuses his stage(s) the following year. A good stage may be used year after year by successive males, for as long as site characteristics remain desirable.

A drumming site may be located by looking for a pile of droppings on an appropriate stage in the proper cover, or by listening for drumming in late winter

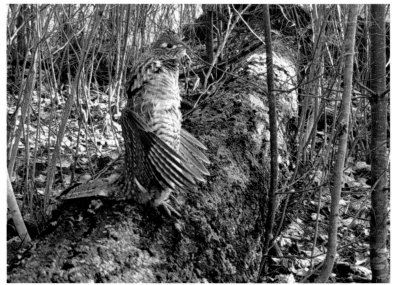

A male ruffed grouse at the start of a drumming sequence on a classic drumming log under cover of dense saplings in Massachusetts. *(Exodus Lift)*

A grouse scat accumulation on a drumming log in Massachusetts in early spring. Piles may be much larger later in the season, after the bird has been drumming repeatedly in the same spot. Usually droppings are whitewashed on one end with uric acid, but in this case rain has it washed away.

through spring. The best time to listen is in early morning or late afternoon, when drumming peaks, though males may drum at any hour, day or night. The sound is produced by the forward and upward motions of repeated wing strokes, and sounds like a lawn mower starting up.

The drumming itself is an interesting audio and video to capture, and it's followed by additional displays when another grouse approaches. The appearance of another male may elicit strutting, hissing, bowing, head twisting, head shaking, and sometimes fighting. The appearance of a female elicits similar behaviors but may culminate in copulation rather than fighting.

Stationing the camera can be tricky at a drumming stage. The surrounding shrubs and tree saplings are usually poor mounting sites and may cause incessant triggering as they sway with the wind and/or obscure the bird. However, it's best to resist the temptation to clear away vegetation, for the male may abandon the site if cover becomes inadequate. A mounting bracket screwed into the log might work well. Obviously the camera will need to be placed relatively close to the site of activity of this small subject, so you may want to consider a camera such as the Bushnell NatureView Cam HD Live View that can focus on small animals at close range.

If you mount the camera on a tree beside the log, be aware that male grouse often face the same direction for each drumming session. To get a front view of the bird, you might try to determine which way he is facing by noting the placement of his droppings on the log and on the ground to one side of the log.

A grouse snow roost in Massachusetts. The bird tunneled into the snow at top center and slept at bottom left, where the droppings accumulated, before flying out. Note the feather marks outside the hole.

After mating, the male's job is done, and the female searches for a nesting site. She prefers to nest against a solid backdrop, such as a tree, log, stump, or brush clump, to prevent ambush from behind. She also likes to be near good habitat for feeding her brood: a small opening with herbaceous growth and young woody cover. If the drumming stage satisfies these requirements, she may nest on the ground against it.

The precocial young leave the nest within a day after hatching, and within the first week or two the mother may lead them several miles away, so a trail camera at a nest may capture little activity after hatching.

In winter there is no center of highly concentrated grouse activity, as far as I know, so capturing grouse on trail camera is more of a shot in the dark. I would love to get a video of a grouse entering or exiting a snow roost, a hole that the bird makes in deep, soft snow to sleep, but I do not know if grouse roost repeatedly in the same small area. I have seen as many as three snow roosts within a 10-foot radius, but I do not know if they were made on different nights by the same bird, or in one night by a group of birds.

It is possible to bait grouse with birdseed, for they occasionally feed on sunflower seed or cracked corn on the ground or on platform feeders.

34 GREAT BLUE HERON

Order Pelecaniformes / Family Ardeidae

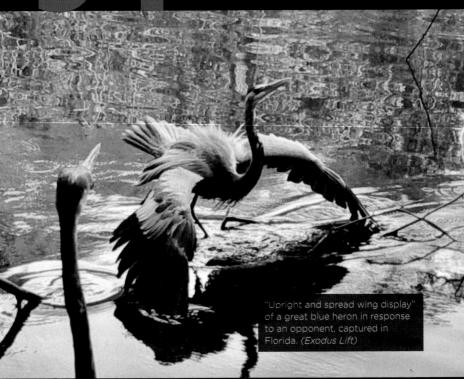

"Upright and spread wing display" of a great blue heron in response to an opponent, captured in Florida. *(Exodus Lift)*

ONCE EXTIRPATED IN PARTS OF ITS RANGE, due to pollution and over-hunting, the great blue heron (*Ardea Herodias*) has rebounded due to conservation measures. The numbers of this spectacular, large wading bird are now stable in over most its range.

Physical Characteristics

Adults are 36 to 54 inches long and grayish blue with a paler head, a white face, and black plumes above each eye running to the back of the head. The neck is rusty gray with black-and-white streaks in front. The thighs are red brown. Plumes adorn the lower neck and, at the start of the breeding season, the lower back. The dull yellowish bill is briefly orange at the start of the breeding season.

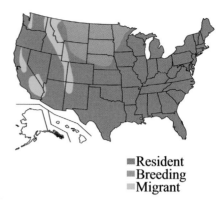

■Resident
■Breeding
■Migrant

In Florida there is an all-white population with shorter plumes and larger bills. It was once considered a distinct species, but it's now considered a subspecies of great blue heron. In addition, leucistic individuals occasionally appear in other subspecies.

Tracks and Trails

Tracks are 6½ to 8½ inches long. Three forward-pointing toes and a backward-pointing hallux all usually register well, but the metatarsal pad may not register at all. There is webbing between the 2 outer toes. This bird walks with a stride of 10 to 18½ inches and usually travels singly.

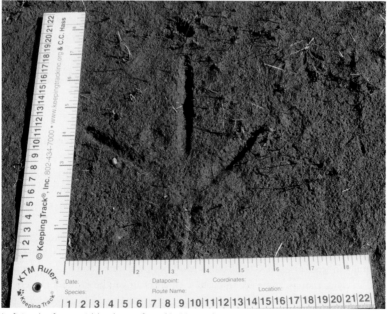

Left track of a great blue heron found in Massachusetts.

Diet
Fish and amphibians are most important, but invertebrates and small birds, reptiles, and mammals are also taken.

Scat
Droppings are large, white, pasty splats, usually appearing on the bank of a stream or pond where the bird hunts. Herons also regurgitate pellets of indigestible material.

Great blue heron scat found in Florida.

Habitat
This adaptable generalist hunts in all types of wetlands, water bodies, and water courses, both fresh and saltwater, from seacoasts to forest ponds to prairie potholes. Its population is increasing in some areas due to a resurgence in beavers, whose ponds provide excellent hunting and breeding habitat for great blue herons.

Breeding
Courtship begins late winter to early spring, depending on latitude. Egg laying begins in late March in Ohio and mid-April in New York. They usually nest communally in "rookeries" of 3 to 50 pairs. Most nests are near good hunting habitat and in trees, though some are in bushes, on cliffs, or on the ground. Dozens of nests may be within the crown of a single tree, or they may be scattered 1 per snag, in a beaver pond, for example. The male gathers sticks from the ground,

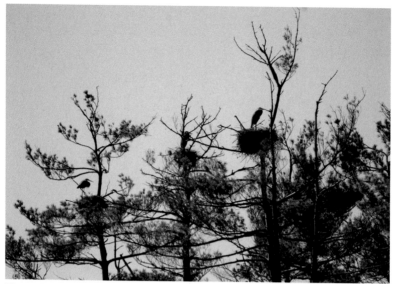

Three nests within a heron rookery in Massachusetts. *Photo by Susan Fly*

trees, shrubs, and unguarded nests, and the female places them in the nest in a tree or snag. They add to old nests in subsequent years, so the outside diameter can range from 2 to 3½ feet. The female lays an egg every other day to an average of 4. Eggs are pale bluish green and average 2½ by 1¾ inches. After the last egg is laid, parents incubate them for 26 to 27 days before they hatch. Both parents brood nestlings for 3 to 4 weeks, and both parents feed them regurgitated food. Young leave the nest in 7 to 8 weeks, but return to the nest for an additional 3 weeks to take food from parents.

Camera-Trapping Tips

Interesting heron behaviors can be captured by trail cameras placed at favored foraging grounds. It is easy to identify good hunting areas, for these large birds are easily observed standing still in shallow water or at the water's edge, waiting to snap up a fish. Frequent heron sightings, heron splats on the shore, an abundance of fish in the water, and a nearby rookery suggest that herons might use the area frequently.

Most courtship behavior occurs at the nest, far out of range for the average camera trapper, unless you are lucky enough to find the occasional heron nest located in a shrub or on the ground. If you place a camera near a nest, do not visit it until young have fledged, for nest failure has been linked to human activity in some great blue heron populations.

Some territorial displays occur on the ground or in the water at foraging areas, and a well-placed camera may capture them. Some courtship and agonistic displays are similar, making it difficult to interpret heron social behavior on the

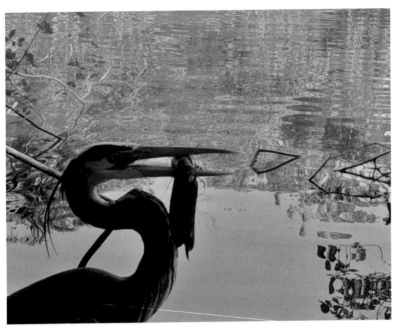

A successful hunt by a great blue heron from the shore of a pond in Florida.
(Exodus Lift)

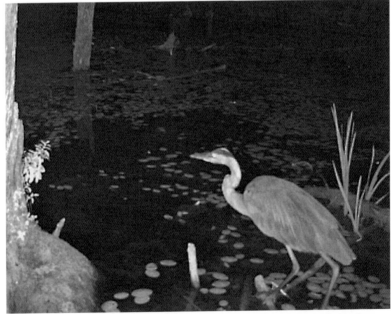

Great blue heron in Massachusetts hunting at night, when the moon was just a sliver.
(Exodus Lift)

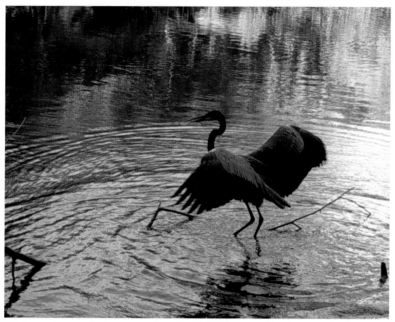

This heron in spread wing posture may be just drying its wings. Compare this to the "upright and spread wing display", in which the bill is pointing upward and the plumes are erect, shown on page 236. *(Exodus Lift)*

ground, especially if interpreted through a trail camera, which captures short snippets that occur within a small field of view.

Be sure to set the camera far enough back from the focal area for this 4-foot tall bird. And get the camera there by the start of the breeding season, when birds are defining their territories. In Florida the breeding season commences as early as November, but elsewhere it begins early March to April, depending on latitude, and ends in July.

A number of territorial displays have been described, but perhaps the most dramatic is the "upright and spread wing display," given when opposing herons meet. They stand with the neck extended and slightly tilted over the back. The head and bill point upward, wrists droop away from the body, and body plumes are erected. After the birds display, they either move apart or begin a chase.

The adaptable great blue heron usually hunts by standing in the water, or dropping to the water from the air or from a perch. It also hunts on land, occasionally for small mammals in upland areas, far from its typical aquatic habitat. It usually hunts by day, but thanks to its excellent night vision, it can hunt at night, even on nearly moonless nights.

35 RUBY-THROATED HUMMINGBIRD

Order Apodiformes / Family Trochilidae

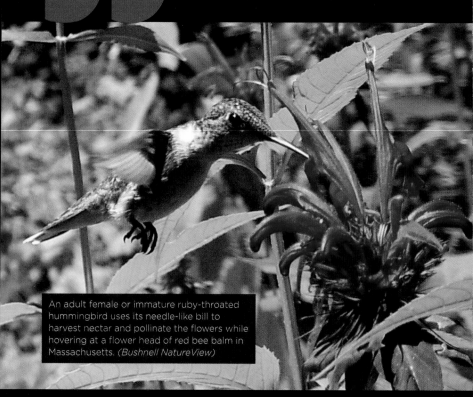

An adult female or immature ruby-throated hummingbird uses its needle-like bill to harvest nectar and pollinate the flowers while hovering at a flower head of red bee balm in Massachusetts. *(Bushnell NatureView)*

THE RUBY-THROATED HUMMINGBIRD (*Archilochus colubris*) has the largest breeding range of any North American hummingbird, and it's the only one regularly seen over much of the eastern United States. Like other hummingbird species, it uses its needle-like bill to harvest nectar, and in the process, pollinates the flower.

Physical Characteristics

Adult females weigh ⅛ ounce, and adult males are slightly smaller, at ⅑ ounce. Weight doubles with heavy feeding prior to migration. Both sexes are metallic green above. The male's chin is black, and its throat is brilliant red but looks black in poor light. His sides and flanks are dusky green, underparts are white, and tail is forked. The female's throat is dull grayish white, sides and flanks are buff, underparts are grayish

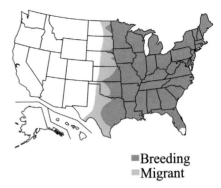

■Breeding
■Migrant

white, and tail is shaped like a fan. Immature birds look like adult females, though some males have a golden cast on the upperparts, and some begin to show red spotting on the throat by early fall.

Tracks and Trails

Weak, short legs preclude walking or hopping, so tracks are not seen. These birds can shuffle sideways on perches, but most movement is by flight, during which they have exquisite control. They can hover; stop in an instant; adjust position up, down, and sideways with precision; and even fly backward.

Diet

The hummingbird feeds by day on flower nectar, tree sap, and small insects. Most nectar is obtained from red tubular flowers, but many other flowers are used as well. Sap is taken at yellow-bellied sapsucker wells. Mosquitoes, gnats, and fruit flies are captured by hawking. Butterfly larvae, aphids, and insect eggs are gleaned from bark and leaves, and some insects are gleaned at sapsucker wells.

Scat and Urine

I have never seen hummingbird droppings, but I suspect they are very tiny and may accumulate under feeders.

This male ruby-throated hummingbird in Massachusetts appears to have a black throat, but viewed from the front and in good lighting, the throat appears red. *(Bushnell NatureView)*

Habitat

These tiny birds prefer mixed and hardwood forest, especially forest edges near orchards, stream borders, meadows, old fields, gardens, and parks. They also use pine forests in the Southeast.

Breeding

Breeding begins in late March in the South, and early June in the North. The female alone builds the nest, incubates the eggs, and cares for the young. In a walnut-size nest in a tree or shrub, 2 white ½ by ⅓-inch eggs are laid, 1 to 3 days apart. Incubation begins after the first egg is laid, and continues for 12 to 16 days. Eggs may hatch 1 to 3 days apart. Hatchlings are helpless, fed by regurgitation, and brooded for the first 9 days. Young fledge when they are 18 to 20 days old. The mother continues to feed them for up to a week after fledging. There are 2 or 3 broods in the South, and 1 or 2 broods in the North. A nest with eggs was seen in Ohio as late as mid-August, indicating a second, or even a third, brood. In Massachusetts I regularly see males making the U-shaped courtship flight display in mid-summer, so I suspect second broods are not uncommon that far north.

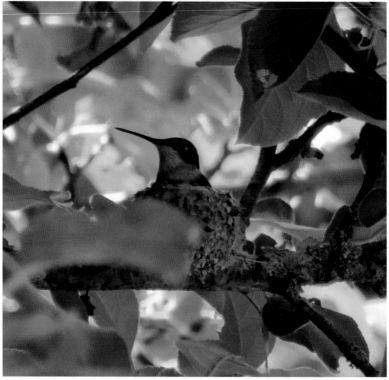

A female ruby-throated hummingbird sitting on eggs in her walnut-size nest in an apple tree. *Photo by Tamara Anderson*

Camera-Trapping Tips

Camera-trapping opportunities are limited to the breeding season, for this migratory species spends the rest of the year in Mexico and Central America. It arrives in Alabama in late February and is gone by November. It arrives in Vermont in early May and is gone by September. In both spring and fall, adult males begin migrating a couple of weeks before adult females. In fall the young of the year lag a few days behind adult females.

This tiny bird requires a very sensitive close-focus camera that can capture good quality images during daylight. Despite these challenges, near ground–level activity and predictable behavior of this bird make it an easy subject.

Possible targets for capturing hummingbirds include feeders, flowers, sapsucker wells, and hummingbird nests. Obviously the feeder is the easiest option, because you have control over placement and easy access to the camera, but the other targets yield more "wild" images.

The Camera Trap Codger succeeded in photographing hummingbirds at his feeder with a Sony S600 wired to a Pixcontroller Universal circuit board. To get the camera to focus on the bird, he hung a black velvet backdrop behind the feeder. When it was possible to crop out the feeder, the resulting photos are stunning. The bird really pops out from the black background, though it appears to be in outer space.

I was after a more natural look of the bird at the flower, and tried using a homemade camera trap made from a Canon 60D wired to a Snapshot Sniper SSII. Unfortunately, I found that this system does not trigger for such lightweight subjects. So far I have had most success with the Bushnell NatureView Cam HD Live View, which is sensitive enough for the tiny creatures, takes good quality close-up photos in daylight, and has a fast trigger speed for still images. It falls short on videos due to its slow video trigger and recovery speeds, but the photos are surprisingly good. There is a newer motion-activated camera, the Wingscapes BirdCam Pro, which can take sharp photos and videos of small birds as little as 6 inches from the camera. I have not used it, but reviewers say the trigger speed is very slow. It isn't clear if the slow trigger speed is for both stills and videos.

Choosing a flower target is relatively easy. Most hummingbird favorites are red tubular flowers, though they vary by place and time. In early spring northbound birds feed heavily on Japanese honeysuckle along the Gulf Coast. On their breeding grounds they favor red bee balm, cardinal flower, trumpet vine, coral honeysuckle, fly honeysuckle, red buckeye, red morning glory, fire pink, Indian paintbrush, wild columbine, wild bergamot, and a variety of exotic garden flowers. In fall it is thought that southbound birds feed heavily on jewelweed, for southward movement is synchronized with peak blooming of this plant. When they reach the Gulf Coast, they feed heavily at trumpet vine and sultan's turban.

Before deploying the camera, it's best to learn by observation what their favorites are in your particular area. It's not enough to choose a flower just because

Wild bergamot, this specimen growing in Massachusetts, is often included in lists of hummingbird flowers, but it's more attractive to bumblebees and visited only occasionally by hummingbirds if favored red tubular flowers are available. Before targeting any flower, determine if hummingbirds in your area visit that species regularly.

it appears on a list of hummingbird favorites, for the birds may ignore it if an even more appealing species is blooming nearby. On my property, for example, hummingbirds mostly ignore the flowers of trumpet vine and cardinal flower while red bee balm is still in bloom. Each bee balm flower head may be visited every few days, while flowers of the other species are visited only occasionally.

You may also want to consider how flower structure impacts the chances of success. I got all my hummingbird photos at red bee balm, where chances of success are excellent. Each flower head is composed of about 30 tubular flowers, all quite close together. The bird hovers around a flower head for several seconds, sipping from several flowers, one after another, providing multiple opportunities to catch the bird in focus. Further, a single flower head is productive for a long time, because new flowers open as old ones die. I left the camera at the same flower head for a few weeks and got a couple of decent photos per week. A cluster of trumpet vine flowers, on the other hand, is so large that you can really only target one or two flowers at a time.

Flower size is also a consideration for photo quality. The flower heads and clusters of both red bee balm and trumpet vine are so large and showy that they overwhelm the tiny green bird in the photo. The small, subtle flowers of jewelweed give the bird center stage, but only one or two flowers can be targeted at a time.

To capture the ruby-throated hummingbird, learn its preferred nectar sources. This is cardinal flower, one of its favorite native flowers, growing wild at a pond side in Massachusetts. It grows in part shade in wet areas. I often see hummingbirds visiting wild clumps of this plant, but in my garden they visit it infrequently until the even more enticing red bee balm has finished blooming.

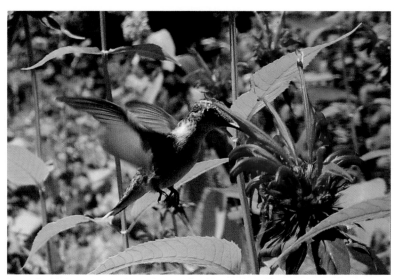

Hummingbirds can't resist large clumps of red bee balm, and I have found that I can get a few nice photos per week at a single flower head. Each one is composed of about 30 tubular flowers and appeals to the birds for a long time, because as older flowers die, new ones open. Red bee balm grows in dense clumps in sunny areas in moist, well-drained soil, often along stream banks. It's easy to grow in the garden. *(Bushnell NatureView)*

Spotted jewelweed likes moist, shady spots along streams and forest edges and in ditches. Hummingbirds are thought to use it heavily during fall migration, but clumps of it in my yard are largely ignored while bee balm, cardinal flower, or trumpet vine is in bloom. The small, subtle flower would allow the bird to shine in a photo, but only one or two flowers can be targeted at once.

While flower nectar is usually a hummingbird staple, sap from sapsucker wells is sometimes important. Spring arrivals on northern breeding grounds find few suitable flowers, so instead they harvest sap from wells created by yellow-bellied sapsuckers until flowers are available. In the far northern part of the breeding range, where suitable flowers are scarce and nectar production may be low, ruby-throated hummingbirds may continue feeding at sap wells throughout summer. In northern Michigan, for example, nesting females feed at sapsucker wells almost exclusively, rarely taking flower nectar. Sap wells also attract insects, which hummingbirds glean from the bark around the holes.

A sapsucker well is a group of holes created by the woodpecker. The holes usually appear in horizontal rows or vertical strips. Early spring wells are created to reach the upward-moving sap in the xylem, and usually consist of deep, small-diameter holes in horizontal rows. Once trees leaf out, wells are made to harvest the downward-moving sap in the phloem, and they initially consist of rows of shallow, lateral slits. Throughout the summer the sapsucker enlarges each slit to form a rectangular hole. Over time the well appears as a group of rectangular holes in vertical strips.

These horizontal rows of small, deep holes comprise an early spring sapsucker well in New York. Late spring wells look like vertical strips of rectangles. Look for early spring wells, for hummingbirds usually switch to nectar when flowers become available.

Yellow-bellied sapsuckers drill wells in over a thousand species of trees and shrubs, but paper birch, yellow birch, hickories, maples, aspens, basswood, apple, and eastern hemlock are among the preferred trees. Wells average 20 to 25 feet above ground, but they are commonly found around eye level. Make note of wells that you find outside of hummingbird season, for sapsuckers often use the same trees year after year, drilling just above holes made the previous year.

An active sapsucker well would make an excellent camera target. The sapsuckers themselves return repeatedly

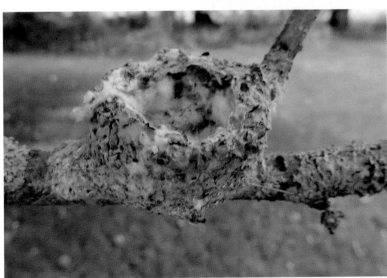

A ruby-throated hummingbird nest after the young have fledged and leaves have fallen. This one is on a horizontal branch, but more often a downward sloping branch is used. *Photo by Tamara Anderson*

Trumpet vine is one of the hummingbird's favorite native flowers. It grows in forest edges and river banks throughout the eastern US.

to feed from the same holes, and other animals, including hummingbirds, many other bird species, chipmunks, bats, porcupines, and martens, also feed at them. Sapsuckers defend their wells from other animals, so interesting conflicts could be observed at this resource.

A most interesting but elusive target would be a hummingbird nest. It is usually located near good sources of nectar (or sap) and often near water. The nest is usually 10 to 20 feet above ground, but sometimes as low as 6 feet, on a twig or small branch that slopes downward from the trunk. Many different species of trees and shrubs are used, but deciduous trees are preferred. The walnut-size nest is made of plant fibers, bud scales, and spider silk, with a lining of plant down and an outer layer of lichen scales. It is usually sheltered above by leaves but open to the ground below, and seen from beneath it looks like a lichen-covered knot. Use online videos to learn the squeaky chips and U-shaped courtship flight display of the male. Watch where the female goes after the male displays, for she may lead you to her nest.

If you find a hummingbird nest, be sure to heed the birding code of ethics and do not disturb breeding birds. Do not remove any vegetation to improve the set, for reduced cover could put the family at high risk of predation. Perhaps the least disruptive way to observe nesting hummingbirds would be to station the camera just after an early brood has fledged, for females sometimes reuse the nest for a second or third brood.

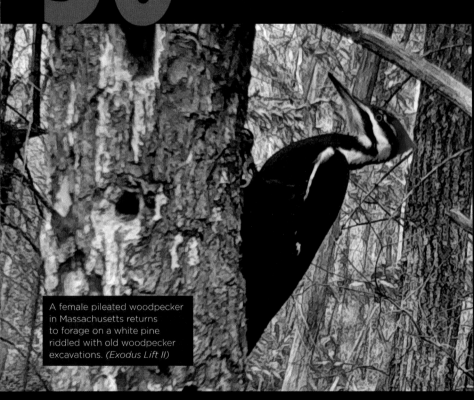

36

PILEATED WOODPECKER

Order Piciformes / Family Picidae

A female pileated woodpecker in Massachusetts returns to forage on a white pine riddled with old woodpecker excavations. *(Exodus Lift II)*

A KEYSTONE SPECIES, THE PILEATED WOODPECKER (*Dryocopus pileatus*) excavates large nest cavities used by at least 38 species of birds and mammals. It also accelerates wood decomposition and may control some beetle populations by consuming the larvae. Once rare due to overhunting and loss of forest to agriculture, it has rebounded well with state and federal protection and reforestation of abandoned farmland.

Physical Characteristics

The largest extant woodpecker in the United States, the pileated woodpecker measures 16 to 19 inches in length. Males are 10 to 15 percent larger than females. It has a long, dark bill and a white chin. When the bird is perched, the back and wings are almost entirely black. It has a white stripe that runs from the bill, across the cheek, and down the neck, and another white

stripe that runs from eye to crest. The male's crest is red to the top of the bill and the female's is red to the forehead. Only the male has a red mustache. When the bird is in flight, a large patch of white bordered by a thin black line along the leading edge of the wing can be seen.

Tracks and Trails

I have never seen pileated woodpecker tracks, but according to Elbroch and Marks (2001) they are 2¼ to 2⅝ long and 1 to 1¾ inches wide. Two toes face forward and 2 backward. The innermost forward-facing toe and the innermost backward-facing toe are much smaller than the other toes. They do occasionally feed and dust bathe on the ground, so track recognition might be helpful, but recognition of this bird's vocalizations, drumming, and feeding sign are most useful in localizing it.

Diet

Ants and grubs are favorites. Carpenter ants are eaten year-round, wood-boring beetle larvae are consumed in spring, a variety of other insects are taken in summer, and fruit and berries are eaten in season. The importance of nuts in the diet is unclear. Hoyt (1957) reported that pileated woodpeckers were observed for many years feeding on pecans in a Georgia plantation, but other than that there seem to be few, if any, reports of pileated woodpeckers eating tree nuts. Suet and, occasionally, peanuts are taken at bird feeders.

Scat and Urine

Droppings are tubular, about ¼ to ⅜ inch wide and 1 to 1½ inches long, and usually whitewashed with uric acid at least at one end. They are often composed of ant exoskeletons, and they are sometimes found on wood chip piles under fresh pileated woodpecker excavations. Birds do not urinate.

Habitat

This nonmigratory species lives year-round in dense, mature hardwood and mixed forest with plenty of large logs, fallen branches, and stumps. Good quality

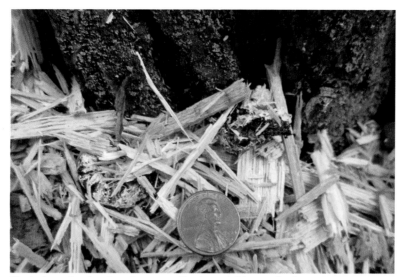

Pileated woodpecker droppings on a pile of wood chips at a fresh excavation in Massachusetts.

habitat has many trees and snags at least 12 inches in diameter at breast height. Bottomlands and riparian areas are preferred. It can inhabit suburbs with large, mature forest patches, and sometimes forages on logs in freshly burned forest, on utility poles, and on abandoned dwellings infested with carpenter ants. Home range size has not been determined in any of the eastern states, but in Arkansas it averages 135 acres. Home range is probably much larger in northern states, where the birds appear to be sparsely distributed.

Breeding

Pairs mate for life. The nest is excavated over a 3- to 6-week period, primarily by males, in a dying or dead tree, in sound or decayed wood. Large trees

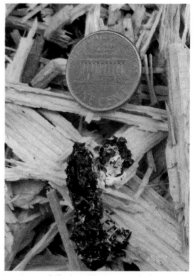

Look carefully for the ant exoskeletons in this pileated woodpecker dropping found in Massachusetts.

are selected, usually with a diameter of 18 to 24 inches at the height of nest cavity. Typically 4 eggs are laid, 1 per day, in March in the far South and in May in the North. Both parents incubate, brood, and provide food. After an incubation period of 15 to 18 days, the naked and helpless hatchlings are then brooded for

10 days. Beginning around 3 weeks of age, young are seen perching at the entry hole, waiting for a parent to feed. At 24 to 31 days, young begin following their parents, learning how to forage. They stay with their parents through summer, leave in fall, and wander until spring, when they acquire a territory and mate. They usually disperse less than 6 miles from the natal area.

Camera-Trapping Tips

The charismatic pileated woodpecker is a great target for several reasons. Its large size means that reasonably good resolution can be achieved with a standard trail camera. It often feeds near ground level and creates unique, easy-to-find foraging sign. It sometimes returns to the same foraging spots, where it may spend minutes per visit. And, if you can't find its feeding sign right off the bat, you can listen for its loud and distinctive vocalizations and drumming to determine its presence.

This bird forages at all levels of the forest from logs, exposed tree roots, and lower trunks to branches high in the canopy. It drills in both decayed and sound wood, usually in search of carpenter ants, which chew at the interior wood to create galleries for their nests. With its enormous bill, the woodpecker chisels off large chips of wood, creating characteristic rectangular to roundish holes. Holes may be several inches deep, and ant galleries are sometimes seen deep inside the holes. Pileated woodpecker feeding sign is unmistakable, for no other woodpecker can create such large, deep holes.

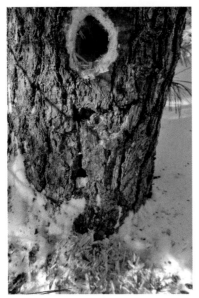

The bright-yellow wood and debris pile on top of the snow indicate very fresh pileated woodpecker activity. This is an excellent site for a camera trap.

Carpenter ant galleries in the hollow of a large pileated woodpecker excavation.

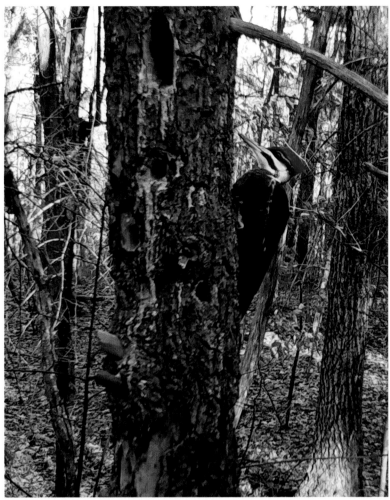

Pileated woodpeckers mate for life and usually stay in contact all winter, roosting and foraging in close proximity. This is the same tree as depicted in the photo on page 251. Here a male visits within two days of the female, likely his mate. *(Exodus Lift II)*

When sound wood is drilled by a pileated woodpecker, the exposed yellow wood is noticeable from afar. When decayed wood is drilled, the sign is more subtle, but in either case, fresh activity is indicated by a pile of wood chips on top of the substrate—snow, fallen leaves, or vegetation—at the base of the tree. There may also be woodpecker scat on or in the pile.

To maximize chances of capturing this bird, target a cluster of very fresh excavations, for the bird is likely to return. Pileated woodpeckers tend to work vertically, creating new holes just above or below an existing hole, so factor that in when positioning the camera.

Pileated woodpeckers probably locate carpenter ants by sound in spring and summer, when the ants are active. In winter, when the ants are in diapause and do not make a sound, the woodpeckers return to foraging spots discovered during the warmer months to harvest dormant ants from their nests. It's probably easier to capture these birds in winter, when their diet is largely limited to carpenter ants and they are revisiting excavations started the previous summer.

If you cannot find the foraging sign, you can try locating this bird by ear. Like other woodpecker species, it drums on hollow trees with its bill, but there are some distinguishing characteristics to the pileated's drum roll. It is given in 3-second bursts and becomes softer at the end. It also has a distinctive call. Its familiar *wuk* call is a several-second series of very loud notes. It may be confused with the northern flicker's call, but the pileated's call is louder and more resonant. You can use online recordings to learn to recognize both the drumming and call.

The species drums and calls at any time of day, but most commonly shortly after sunrise and before sunset. They are noisiest in spring, when breeding pairs are declaring territory ownership, and in fall, when dispersing young are searching for unoccupied territory and adults are announcing occupancy.

Once the family has finished with the nest cavity, it may be used by a pileated woodpecker for roosting, or by another species for either nesting or sleeping. Martens, fishers, squirrels, and certain species of owl and waterfowl are among the possible future occupants. If a relatively low cavity is located—they can be as low as 15 feet off the ground—the adventurous camera trapper could use a climbing stick to deploy a camera in an adjacent tree. The camera should be placed in fall or winter, and not retrieved till the following fall, to avoid disturbing breeding animals.

Southeasterners may find it even more interesting to study pileated woodpeckers, not at their own nest cavities, but at those of the red-cockaded woodpecker, a federally endangered bird. The pileated has an unfortunate habit of enlarging the nest cavities of the red-cockaded, making the cavities unsuitable for the latter. It's a serious problem, because each cavity is a huge investment of time and energy for red-cockaded woodpeckers. They may spend more than a year excavating to a suitable size, and then the cavity may be used for generations. Why pileated woodpeckers enlarge them remains a mystery, but perhaps insight could be gained from observing them through camera-trap footage. Red-cockaded woodpeckers make their cavities in living trees in old-growth, open understory pine forests. Entry holes are 2 to 3 inches wide and may be as low as 18 feet off the ground.

37

AMERICAN ALLIGATOR

Order Crocodilia / Family Alligatoridae

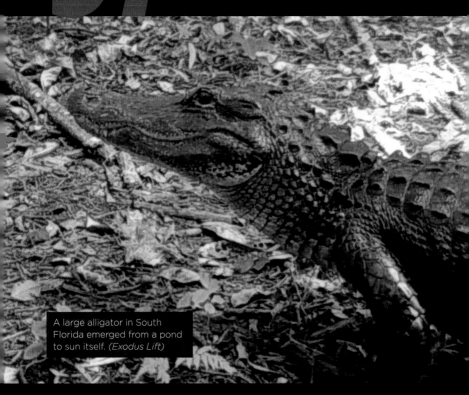

A large alligator in South Florida emerged from a pond to sun itself. *(Exodus Lift)*

ONCE ON THE BRINK OF EXTINCTION due to overexploitation, the American alligator (*Alligator mississippiensis*) is now common within its range in the Southeast, thanks to strict hunting regulations. As a keystone species, it creates habitat critical for many species. When water levels drop, alligators maintain depth by clearing muck from the bottom of the pond. These water holes are vital for a variety of fish, turtles, snakes, birds, and mammals. Also, alligator nests are

Physical Characteristics

Hatchlings are about 9 inches long, adult males may reach 15 feet, and adult females 10 feet, though they continue to grow throughout life and some individuals may reach larger sizes. Young have yellowish crossbands on a black background, while adults are black with cream undersides. Compared to the American crocodile, it is darker and has a broader snout.

Tracks and Trails

The front foot measures up to about 5 inches long and 4 inches wide. It has 4 forward-facing toes, and another toe that faces backward and outward when the animal walks. The 3 innermost, forward-pointing toes have claws. The hind foot may reach 8 inches long and 5⅓ inches wide. It has 4 toes, all of which point forward. The 3 innermost toes have claws.

Alligators usually move in an understep walk, with a stride of 18 to 28-plus inches and a straddle of 11 to 24-plus inches (Tkaczyk, 2015), with the belly raised off the ground and the tail dragging. For a few strides while hauling in and out of water, they often walk with the belly dragging.

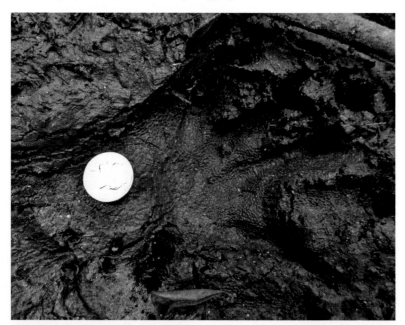

Right front alligator track found in Florida.

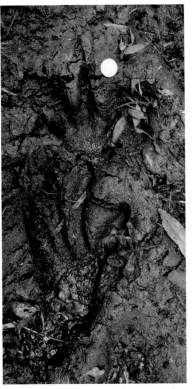

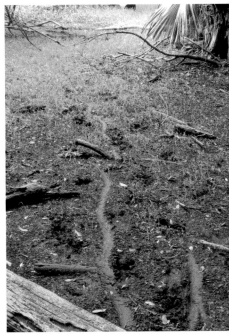

Alligator walking trail with tail drag in Florida.

Right front and right hind alligator tracks found in Florida. The coin placed for scale is a penny.

Diet

Alligators feed on a wide variety of prey. Hatchlings eat insects, larvae, worms, and the like, and they move on to larger prey as they grow. Fish are prominent menu items, and snakes, turtles, amphibians, birds, muskrats, raccoons, and other mammals are taken. Large alligators occasionally take mammals as large as deer. They ambush terrestrial prey from the edge of the water, trails, and roads. On occasion alligators also consume some fruit, berries, seeds, and nuts.

An alligator haul-out area in Florida.

Scat

Both feces and nitrogenous waste are excreted as scat through one opening, the cloaca. Scats have a clay-like consistency. They are brown when fresh and fade to beige, buff, or olive as they dry. When completely dry, scats are white and crumbly. Old white, crumbly scats may be found in abundance at alligator sunbathing areas.

Partially dried scat from a large alligator in Florida.

Habitat

Alligators inhabit freshwater habitat, including swamps, ponds, lakes, streams, and rivers. Females prefer habitats with trees or shrubs for good cover during nesting season. They occasionally visit the brackish water of estuaries, but tolerate it for only brief periods.

Breeding

Courtship usually begins in April, and mating is usually in May. After mating, the female constructs a nest of sticks, mud, leaves, and other debris in a sheltered spot near the water. The nest is 5 to 10 feet in diameter and 2 to 3 feet high. She lays just a few eggs to several dozen eggs, which hatch after about 2 months. They begin to "yelp" while hatching, alerting the mother to come dig them out. She carries them in her mouth to the water and protects them for up to a year.

Camera-Trapping Tips

Because its body temperature approximates the temperature of the surroundings, a reptile is not usually detected by an IR sensor. For an alligator to be detected by an IR sensor, the animal must be moving from an environment of a different temperature. So, for example, an alligator that just emerged from the water can be captured by a trail camera targeting the haul out. However, an alligator lifting its head out of the water will probably not be detected by a camera targeting the water surface.

07:54:52 03/06/17 30·32inHg 62F ▶ EXODUS

This is one of only two alligator photos captured after six weeks by a camera targeting this small pond with known alligator activity. And it might not have been the alligator that triggered the photo. Herons and egrets triggered thousands of photos during this period. Perhaps a bird triggered this one and left the detection zone prior to the photo capture. *(Exodus Lift)*

Where an IR sensor is not likely to detect a reptile, the time-lapse mode of a trail camera can be used. In this mode, the camera is set to take photos at regular intervals, for a period of time during which the animal is expected to be most active. So, for example, if the animal is crepuscular, the camera could be set to take a photo every 15 seconds for an hour at dawn and an hour at dusk. I have not used this method, but I will describe some fascinating alligator behaviors worthy of study, and the interested reader can experiment with camera-trapping methods to capture them.

The breeding period is a time of interesting behaviors. In spring, alligators (males and possibly females) perform a "water dance" in which the animal raises its head and tail out of the water, then lowers itself and bellows at very low frequency, causing the water around it to sprinkle. This is thought to be a way of declaring territorial ownership and attracting mates. It is most common in the early morning and may be more likely captured using the time-lapse mode. However, because part of the animal's body may remain out of the water for minutes, the temperature differential may be enough to trigger an infrared sensor. To maximize chances of capturing this behavior, target a small pond teeming with fish and a large alligator. A small pond limits the area where the dance could occur.

The hole in the center of the photo is the 1-foot-diameter mouth of a tunnel used for shelter by an alligator.

After mating, the female builds a nest. She begins by trampling out a 10- to 20-foot-diameter area, usually near the pond and her burrow, typically a large bank hole she uses for shelter during the cooler months. She gathers vegetation and places it in a pile 5 to 10 feet in diameter. She may construct several nests, eventually choosing one for her eggs. A nest that contains eggs will appear as a conical pile, for she covers the eggs with more plant matter, whilst the unused dummy nests remain flatter. Nest-building behavior is rarely observed in the wild and would make excellent trail-camera footage.

When her eggs hatch 2 months later, she digs out her yelping babies and carries them in her mouth to the water. Once they are in the water, she protects them for up to a year, surprisingly attentive maternal behavior for a reptile.

Alligator hunting and feeding behavior is also worthy of study. Most frequently observed is a single alligator eating a fish. After making a catch, the alligator points its head up out of the water to eat its prey. Group hunting also occurs but is rarely observed. Alligators hunt cooperatively by driving and trapping shoals of fish in shallow water at the shore, or circling them until they are trapped in a tight circle. Observations suggest fairly sophisticated hunting, with different roles for different size individuals, and each waiting its turn to feed in the center of the circle. It would be difficult to use trail cameras to study group hunting in the water, but alligators hunt on land, as well. Do they hunt cooperatively for terrestrial prey? Perhaps trail cameras can help us find out.

An alligator in Florida moving about on land at night. It may be on a hunting mission for terrestrial prey.

The mud around this gator hole in Florida was full of deer tracks. A gator hole is a great target for a trail camera, but be sure to retrieve the camera before spring rains flood the area again.

Even more surprising is tool use for luring nesting birds. The reptile balances a stick on its snout, just barely above water, and lies in wait for a heron or egret gathering sticks for a nest. Then the alligator snaps up the bird. To capture this behavior, get your camera to a heron or egret rookery with known alligator presence during the birds' nest-building period. This is somewhat of a shot in the dark, because you don't know where in the pond this will occur, but at least you don't need to worry about whether the alligator will trigger the camera, because the bird will do so.

Frugivory, or fruit eating, is sometimes seen in captive alligators, but foraging for fruit by a wild alligator is only rarely observed. Try targeting a shrub or tree with low-hanging fruit or berries near a pond with known alligator activity.

Finally, gator holes are magnets for many other species, and therefore they are excellent sites for camera trapping a variety of birds and mammals. Herons and egrets fish at the ponds, sometimes while an alligator lies in wait for a feathered snack. Many mammals hunt in or around the pond, and, during the dry season, they come to drink. And some animals, particularly raccoons and bears, raid alligator nests, which are often near the edge of the pond.

BIBLIOGRAPHY

General Resources

These sources were used for multiple chapters, and I highly recommend them for further reading.

Baicich, P. J. and C. J. O. Harrison. *A Guide to the Nests, Eggs, and Nestlings of North American Birds.* 2nd edition. San Diego, London, Boston, New York, Sydney, Tokyo and Toronto: Natural World Academic Press: 1997.

Brown, D. *The Next Step: Interpreting Animal Tracks, Trails and Sign.* Newark, NJ: The McDonald & Woodward Publishing Company, 2015.

DeGraaf, R. M. and M. Yamasaki. *New England Wildlife: Habitat, Natural History, and Distribution.* Hanover, NH and London: University Press of New England, 2001.

Elbroch, M. *Mammal Tracks & Sign: A Guide to North American Species.* Mechanicsburg, PA: Stackpole Books, 2003.

Elbroch, M. and E. Marks. *Bird Tracks & Sign: A Guide to North American Species.* Mechanicsburg, PA: Stackpole Books, 2001.

Elbroch, M. and K. Rinehart. *Behavior of North American Mammals.* Boston and New York: Houghton Mifflin Harcourt, 2011.

Feldhamer, G. A., B. C. Thompson, and J. A. Chapman, eds. *Wild Mammals of North America: Biology, Management, and Conservation.* 2nd ed. Baltimore and London: The Johns Hopkins University Press, 2003.

Harrison, H. H. *Eastern Birds' Nests.* Boston and New York: Houghton Mifflin Company, 1975.

Lowery, J. C. *The Tracker's Field Guide: A Comprehensive Manual for Animal Tracking.* Guilford, CT and Helena, MT: Falcon Guides, an Imprint of Globe Pequot Press, 2013.

National Geographic Society (US). *Field Guide to Birds of North America.* Washington, DC: National Geographic, 1987.

Reid, F. A. *A Field Guide to Mammals of North America.* New York: Houghton Mifflin Company, 2006.

Rezendes, P. *Tracking & The Art of Seeing: How to Read Animal Tracks and Sign.* New York: HarperCollins Publishing, 1999.

Spielman, L. J. *A Field Guide to Tracking Mammals in the Northeast.* New York: The Countryman Press, 2017.

Stokes, D. and L. Stokes. *A Guide to Animal Tracking and Behavior.* Boston, New York, Toronto, and London: Little Brown and Company: 1986.

Trailcampro.com provides a wealth of information about trail cameras, as well as detailed reviews of many models.

Range Maps

I relied on NatureServe Explorer at http://explorer.natureserve.org/ and IUCN Red List at www.iucnredlist.org/, the field guides listed under General References, and websites of

state wildlife agencies. Please note that exact boundaries of a species' range are not static. Check with your state fish and wildlife department for updated information.

Introduction

Game Camera Battery Information. Retrieved November 28, 2017 from www.trailcampro .com/pages/game-camera-battery-information.

Meek, P. D., G. Ballard, P. J. S. Fleming, M. Shaefer, W. Williams, and G. Falzon. "Camera Traps Can Be Heard and Seen by Animals." *PLOS One.* 9 (2014). Retrieved October 8, 2017 from http://journals.plos.org/plosone/article?id=10.1371/journal. pone.0110832.

Virginia Opossum

Hossler, R., J. B. McAninch, and J. D. Harder. "Maternal Denning Behavior and Survival of Juveniles and Opossums in Southeastern New York." *Journal of Mammalogy.* 75 (1994): 60–70.

Kanda, L. L, T. K. Fuller, and P. R. Sievert. "Landscape Associations of Road-Killed Virginia Opossums (*Didelphis virginiana*) in Central Massachusetts." *American Midland Naturalist.* 156 (2006): 128–134.

Keesing, F., J. Brunner, S. Duerr, M. Killilea, K. LoGiudice, K. Schmidt, H. Vuong, and R. S. Ostfeld. "Hosts as Ecological Traps for the Vector of Lyme Disease." *Proceedings of the Royal Society B.* 276 (2009): 3911–3919.

Kimbal, D. P. "Didelphid Behavior." *Neuroscience and Biobehavioral Reviews.* 21 (1997): 361–369.

Meier, K. E. "Habitat Use by Opossums in an Urban Environment." Master's thesis, Oregon State University, 1983.

Stains, H. J. and R. H. Baker. *Furbearers in Kansas: A Guide to Trapping.* Lawrence: State Biological Survey and Museum of Natural History, University of Kansas, 1958.

Wright, J. D., M. S. Burt, and V. L. Jackson. "Influences of an Urban Environment on Home Range and Body Mass of Virginia Opossum (*Didelphis virginiana*)." *Northeastern Naturalist.* 19 (2012): 77–86.

Eastern Cottontail

Dalke, P. D. and P. R. Sime. "Food Habits of the Eastern and New England Cottontails." *Journal of Wildlife Management.* 5 (1941): 216–228.

Smith, D. F. and J. A. Litvaitis. "Differences in Eye Size and Predator-detection Distances of New England and Eastern Cottontails." *Northeast Wildlife.* 55 (1999): 55–60.

Snowshoe Hare

Aldous, C. M. "Notes on the Life History of the Snowshoe Hare." *Journal of Mammalogy.* 18 (1937): 46–57.

Cox, E. W., R. A. Garrott, and J. R. Cary. "Effects of Supplemental Cover on Survival of Snowshoe Hares and Cottontail Rabbits in Patchy Habitat." *Canadian Journal of Zoology.* 75 (1997): 1357–1363.

O'Donoghue, M. "Seasonal Habitat Selection by Snowshoe Hare in Eastern Maine." *Transactions Northeast Section of the Wildlife Society.* 40 (1983): 100–107.

Pietz, P. J. and J. R. Tester. "Habitat Selection by Snowshoe Hares in North Central Minnesota." *Journal of Wildlife Management.* 47 (1983): 686–696.

Eastern Gray Squirrel

Koprowski, J., K. E. Monroe, and A. Edelman. "Gray Not Grey: The Ecology of *Sciurus carolinensis* in their Native Range in North America." In *The Grey Squirrel: Ecology & Management of an Invasive Species in Europe,* edited by C. Shuttleworth, P. Lurz, and J. Gurnell, 1–18. Woodbridge: European Squirrel Initiative, 2016.

Teaford, J. W. "Eastern Gray Squirrel (*Sciurus carolinensis*)." In *US Army Corps of Engineers Wildlife Resources Management Manual.* Technical Report. Section 4.7.1. Washington, DC: Smithsonian Institution Press, 1986.

Thompson, D. C. "Reproductive Behavior of the Grey Squirrel." *Canadian Journal of Zoology.* 55 (1977): 1176–1184.

Williams, E. "A Comparison of Eastern Gray Squirrel (*Sciurus carolinensis*) Nesting Behavior among Habitats Differing in Anthropogenic Disturbance." Master's thesis, Georgia Southern University, 2000.

Red Squirrel

Layne, J. N. "The Biology of the Red Squirrel, *Tamiasciurus hudsonicus loquax* (Bangs) in Central New York." *Ecological Society of America.* 24 (1954): 227–268.

Woodchuck

Kwiecinski, G. G. "Marmota monax." *American Society of Mammalogists.* 591 (1998): 1–8.

Meier, P. T. "Social Organization of Woodchucks (*Marmota monax*). *Behavioral Ecology and Sociobiology.* 31 (1992): 393–400.

Ouellet, J. and J. Ferron. "Scent-marking Behavior by Woodchucks (*Marmota monax*)." *Journal of Mammalogy.* 69 (1988): 365–368.

Sam, S. and J. Sam. "Videos." Retrieved July 7, 2017 from Woodchuck Wonderland: www.woodchuckwonderland.com/videos/.

Swihart, R. K. "Home-range Attributes and Spatial Structure of Woodchuck Populations." *Journal of Mammalogy.* 73 (1992): 604–618.

Swihart, R. K. and P. M. Picone. "Arboreal Foraging and Palatability of Tree Leaves to Woodchucks." *American Midland Naturalist.* 125 (1991): 372–374.

Eastern Chipmunk

Clarke, M. F., K. Burke da Silva, H. Lair, R. Pocklington, D. L. Kramer, and R. L. McLaughlin. "Site Familiarity Affects Escape Behavior of the Eastern Chipmunk, *Tamias striatus.*" *OIKOS.* 66 (1993): 533–537.

Clarke, M. F. and D. L. Kramer. "Scatter-hoarding by a Larder-hoarding Rodent: Intraspecific Variation in the Hoarding Behavior of the Eastern Chipmunk, *Tamias striatus.*" *Animal Behaviour.* 48 (1994): 299–308.

Elliott, L. "Social Behavior and Foraging Ecology of the Eastern Chipmunk (*Tamias striatus*) in the Adirondack Mountains." *Smithsonian Contributions to Zoology.* 265 (1978): 1–107.

Munro, D., D. W. Thomas, and M. M. Humphries. "Extreme Suppression of Aboveground Activity by a Food-storing Hibernator, the Eastern Chipmunk (*Tamias striatus*)." *Canadian Journal of Zoology.* 86 (2008): 364–370.

Thomas, K. R. "Burrow Systems of the Eastern Chipmunk (*Tamias striatus pipilans* Lowery) in Louisiana." *Journal of Mammalogy.* 55 (1974): 454–459.

Wishner, L. *Eastern Chipmunks: Secrets of Their Solitary Lives*. Washington, DC: Smithsonian Institution Press, 1982.

Flying Squirrels

Holloway, G. L. and J. R. Malcolm. "Nest-tree Use by Northern and Southern Flying Squirrels in Central Ontario." *Journal of Mammalogy*. 88 (2007): 226–233.

Menzel, J. M., W. M. Ford, J. W. Edwards, and M. A. Menzel. "Nest Tree Use by the Endangered Virginia Northern Flying Squirrel in the Central Appalachian Mountains." *American Midland Naturalist*. 151 (2004): 355–368.

Mitchell, D. "Spring and Fall Diet of the Endangered West Virginia Northern Flying Squirrel (*Glaucomys sabrinus fuscus*)." *The American Midland Naturalist*. 146 (2001): 439–443.

Muul, I. *Behavioral and Physiological Influences on the Distribution of the Flying Squirrel, Glaucomys volans*. Miscellaneous publications, No. 134. Museum of Zoology, University of Michigan, 1968.

Natural Heritage and Endangered Species Program. *Northern Flying Squirrel Glaucomys sabrinus*. Mass. Division of Fisheries and Wildlife. Updated 2015. Retrieved July 27, 2017 from www.mass.gov/eea/docs/dfg/nhesp/species-and-conservation/nhfacts/glaucomys-sabrinus.pdf.

Rosentreter, R., G. D. Hayward, and M. Wicklow-Howard. "Northern Flying Squirrel Seasonal Food Habits in the Interior Conifer Forests of Central Idaho, USA." *Northwest Science*. 71 (1997): 97–102.

Taulman, J. F. "Selection of Nest Trees by Southern Flying Squirrels (Sciuridae: *Glaucomys volans*) in Arkansas." *Journal of Zoology, London*. 248 (1999): 369–377.

Van de Poll, R. "Natural and Cultural Resource Inventories: A Guide to Comprehensive ("Level III") Methods for Private Landowners in New England." Doctoral thesis, The Union Institute Graduate School. VI.B.4 (1996): 31–33.

Vernes, K., S. Blois, and F. Barlocher. "Seasonal and Yearly Changes in Consumption of Hypogeus Fungi by Northern Flying Squirrels and Red Squirrels in Old-growth forest, New Brunswick." *Canadian Journal of Zoology*. 82 (2004): 110–117.

Weigl, P. D. "Resource Overlap, Interspecific Interactions and the Distribution of the Flying Squirrels, *Glaucomys volans* and *G. sabrinus*." *The American Midland Naturalist*. 100 (1978): 83–96.

Weigl, P. D. "The Northern Flying Squirrel (*Glaucomys sabrinus*): A Conservation Challenge." *Journal of Mammalogy*. 88 (2007): 897–907.

North American Beaver

Muller-Schwarze, D. and L. Sun. *The Beaver: Natural History of a Wetlands Engineer*. Ithaca, NY: Cornell University Press, 2003.

Walro, J. M. and G. E. Svendson. "Castor Sacs and Anal Glands of the North American Beaver (*Castor canadensis*): Their Histology, Development, and Relationship to Scent Communication." *Journal of Chemical Ecology*. 8 (1982): 809–819.

Common Muskrat

Errington, P. L. *Muskrats and Marsh Management*. Lincoln and London: University of Nebraska Press, 1961.

Meadow Vole

Cockburn, A. and W. Z. Lidicker Jr. "Microhabitat Heterogeneity and Population Ecology of an Herbiverous Rodent, *Microtus californicus.*" *Oecologia.* 59 (1983): 167–177.

Ferkin, H. M. "The Effect of Familiarity on Social Interactions in Meadow Voles, *Microtus pennsylvanicus*: A Laboratory and Field Study." *Animal Behaviour.* 36 (1988): 1816–1822.

Glen, A. S., S. Cockburn, M. Nichols, J. Ekanayake, and B. Warburton. "Optimising Camera Traps for Monitoring Small Mammals." *PloS ONE.* 8 (2013). Retrieved May 17, 2017 from PLOS: http://journals.plos.org/plosone/article?id=10.1371/journal .pone.0067940.

Lindroth, R. L. and G. O. Batzli. "Food Habits of Meadow Voles (*Microtus pennsylvanicus*) in Bluegrass and Prairie Habitats." *Journal of Mammalogy.* 65 (1984): 600–606.

Manson, R. H., R. S. Ostfeld, and C. D. Canham. "Long-term Effects of Rodent Herbivores on Tree Invasion Dynamics Along Forest-Field Edges." *Ecology.* 82 (2001): 3320–3329.

Reich, L. M. "Microtus pennsylvannicus." *Mammalian Species.* 159 (1981): 1–8.

Deermice

King, J. A., ed. *Biology of Peromyscus (Rodentia).* The American Society of Mammalogists, Special Publication 2, 1968.

Timm, R. M. and W. E. Howard. "White-footed and Deer Mice." *Internet Center for Wildlife Damage Management.* Ithaca, NY: Cornell University. Retrieved November 18, 2017 from http://icwdm.org/handbook/rodents/whitefooteddeermouse.asp.

North American Porcupine

Griesemer, S. J., T. K. Fuller, and R. M. DeGraaf. "Denning Patterns of Porcupines, *Erethizon dorsatum.*" *Canadian Field Naturalist.* 110 (1996): 634–637.

Griesemer, S. J., T. K. Fuller, and R. M. DeGraaf. "Habitat Use by Porcupines (*Erethizon dorsatum*) in Central Massachusetts: Effects of Topography and Forest Composition." *The American Midland Naturalist.* 140 (1998): 271–279.

Hale, M. B. "Population Dynamics of Porcupines in Central Massachusetts." Master's thesis, University of Massachusetts, 1994.

Morin, P., D. Berteaux, and I. Klvana. "Hierarchical Habitat Selection by North American Porcupines in Southern Boreal Forest." *Canadian Journal of Zoology.* 83 (2005): 1333–1342.

Roze, U. "Denning and Winter Range of the Porcupine." *Canadian Journal of Zoology.* 65 (1987): 981–986.

Roze, U. *The North American Porcupine.* Washington, DC: Smithsonian Institution Press, 1989.

Roze, U. "Winter Foraging by Individual Porcupines." *Canadian Journal of Zoology.* 62 (2011): 2425–2428.

Struthers, P. H. "Breeding Habits of the Canadian Porcupine (*Erethizon dorsatum*)." *Journal of Mammalogy.* 9 (1928): 300–308.

Eastern Coyote

Adams, J. R., J. A. Leonard, and L. P. Waits. "Widespread Occurrence of a Domestic Dog Mitochondrial DNA Haplotype in Southeastern US Coyotes." *Molecular Ecology.* 12 (2003): 541–546.

Bekoff, M. "Behavioral Development in Coyotes and Eastern Coyotes." *In Coyotes: Biology, Behavior, and Management*, 97–127. New York: Academic Press, 1978.

Berger, K. M. and E. M. Gese. "Does Interference Competition with Wolves Limit the Distribution and Abundance of Coyotes?" *Journal of Animal Ecology.* 76 (2007): 1075–1085.

Harrison, D. J. and J. R. Gilbert. "Denning Ecology and Movements of Coyotes in Maine During Pup Rearing." *Journal of Mammalogy.* 66 (1985): 712–719.

Monzon, J., R. Kays, and D. E. Dykhuizen. "Assessment of Coyote-Wolf-Dog Admixture Using Ancestry-informative Diagnostics SNPs." *Molecular Ecology.* 23 (2014): 182–197.

Way, J. G. *Suburban Howls: Tracking the Eastern Coyote in Urban Massachusetts.* Indianapolis: Dog Ear Publishing, 2007.

Way, J. G., P. J. Auger, I. M. Ortega, and E. G. Strauss. "Eastern Coyote Denning Behavior in an Anthropogenic Environment." *Northeast Wildlife.* 56 (2001): 18–30.

Wolf

Ausband, D. E., M. S. Mitchell, K. Doherty, P. Zager, C. M. Mack, and J. Holyan. "Surveying Predicted Rendezvous Sites to Monitor Gray Wolf Populations." *Journal of Wildlife Management.* 74 (2010): 1043–1049.

Cluff, D. "Wolf Dens 101: Location, Location, Location." *International Wolfe.* (2016): 4–7. http://wolf.org/wp-content/uploads/2016/06/wolfden101.pdf Retrieved 8/26/2016.

Frame, P. F., H. D. Cluff, and D. S. Hik. "Response of Wolves to Experimental Disturbance of Homesites." *Journal of Wildlife Management.* 71 (2007): 316–320.

Fuller, T. K. "Denning Behavior of Wolves in North-Central Minnesota." *American Midland Naturalist.* 121 (1989): 184–188.

Mech, L. D. *The Wolf: The Ecology and Behavior of an Endangered Species.* Minneapolis: University of Minnesota Press, 1970.

Moskowitz, D. and A. Huyett. "Wolf Remote Camera Traps: Scouting Guidelines and Installation Protocol." 2014. www.conservationnw.org/files/wolf-remote-camera -trap-guidelines.pdf. Retrieved August 22, 2016.

Nonaka, Y. "Response of Breeding Wolves to Human Disturbance on Den Sites—An Experiment." Doctoral thesis, Uppsala Universitet, 2011.

Trapp, J. R., P. Beier, C. Mack, D. R. Parsons, and P. C. Paquet. "Wolfe, *Canis lupus*, Den Site Selection in the Rocky Mountains." *The Canadian Field-Naturalist.* 122 (2008): 49–56.

VonHoldt, B. M., J. A. Cahill, F. Zhenxin, I. Gronau, J. Robinson, J. P. Pollinger, B. Shapiro, J. Wall, and R. K. Wayne. "Whole-genome Sequence Analysis Shows that Two Endemic Species of North American Wolf Are Admixtures of the Coyote and Gray Wolf." *Science Advances.* 2 (2016). Retrieved August 26, 2016 from http://advances.sciencemag.org/content/2/7/e1501714.full,

Gray Fox

Cypher, B. L. "Food Item Use by Three Sympatric Canids in Southern Illinois." *Transactions of the Illinois State Academy of Science.* 86 (1993): 139–144.

Farias, V., T. K. Fuller, R. K. Wayne, and R. M. Sauvajot. "Survival and Cause-specific Mortality of Gray Foxes (*Urocyon cinereoargenteus*) in Southern California." *The Zoological Society of London.* 266 (2005): 249–254.

Hockman, J. G. and J. A. Chapman. "Comparative Feeding Habits of Red Foxes (*Vulpes vulpes*) and Gray Foxes (*Urocyon cinereoargenteus*) in Maryland." *The American Midland Naturalist*. 110 (1983): 276–285.

Neale, J. C. C. and B. N. Sacks. "Food Habits and Space Use of Gray Foxes in Relation to Sympatric Coyotes and Bobcats." *Canadian Journal of Zoology*. 79 (2001): 1794–1800.

Nicholson, W. S., E. P. Hill, and D. Briggs. "Denning, Pup-Rearing, and Dispersal in the Gray Fox in East-Central Alabama." *The Journal of Wildlife Management*. 49 (1985): 33–37.

Trapp, G. R. and D. L. Hallberg. "Ecology of the Gray Fox (*Urocyon cinereoargenteus*): A Review." In *The Wild Canids: Their Systematics, Behavioral Ecology and Evolution,* edited by M. W. Fox, 164–178. New York: Van Nostrand Reinhold Company, 1975.

Wood, J. E. "Age Structure and Productivity of a Gray Fox Population." *Journal of Mammalogy*. 39 (1958): 74–86.

Red Fox

Ables, E. D. "Ecology of the Red Fox in North America." In *The Wild Canids: Their Systematics, Behavioral Ecology and Evolution,* edited by M. W. Fox, 216–236. New York: Van Nostrand Reinhold Company, 1975.

Carey, A. B. "The Ecology of Red Foxes, Gray Foxes, and Rabies in the Eastern United States." *Wildlife Society Bulletin*. 10 (1982): 18–26.

Cypher, B. L. "Food Item Use by Three Sympatric Canids in Southern Illinois." *Transactions of the Illinois State Academy of Science*. 86 (1993): 139–144.

Dekker, D. "Denning and Foraging Habits of Red Foxes, *Vulpes vulpes*, and Their Interactions with Coyotes, *Canis latrans*, in Central Alberta." *Canadian Field-Naturalist*. 97 (1983): 303–306.

Fuller, A. K. and D. J. Harrison. "Ecology of Red Foxes and Niche Relationships with Coyotes on Mount Desert Island, Maine." *Resource Management Division Acadia National Park*, 2006.

Gosselink, T. E., T. R. Van Deelen, R. E. Warner, and M. G. Joselyn. "Temporal Habitat Partitioning and Spatial Use of Coyotes and Red Foxes in East-Central Illinois." *Journal of Wildlife Management*. 67 (2003): 90–103.

Henry, J. D. *Red Fox: The Catlike Canine*. Washington, DC: Smithsonian Institution Press, 1986.

Major, J. T. and J. A. Sherburne. "Interspecific Relationships of Coyotes, Bobcats, and Red Foxes in Western Maine." *Journal of Wildlife Management*. 51 (1987): 606–616.

Newsome, T. M. and W. J. Ripple. "A Continental Scale Trophic Cascade from Wolves through Coyotes to Foxes." *Journal of Animal Ecology*. 84 (2015): 49–59.

Scott, T. G. *Comparative Analysis of Red Fox Feeding Trends on Two Central Iowa Areas*. Iowa Agricultural Experiment Research Bulletin 353, 1947.

Statham, M. J., B. N. Sacks, K. B. Aubry, J. D. Perrine, and S. M. Wisely. "The Origin of Recently Established Red Fox Populations in the United States: Translocations or Natural Range Expansion?" *Journal of Mammalogy*. 93 (2012): 52–65.

Theberge, J. B. and C. H. R. Wedeles. "Prey Selection and Habitat Partitioning in Sympatric Coyote and Red Fox Populations, Southwest Yukon." *Canadian Journal of Zoology*. 67 (1989): 1285–1290.

Van Etten, K. W., K. R. Wilson, and R. L. Crabtree. "Habitat Use of Red Foxes in Yellowstone National Park Based on Snow Tracking and Telemetry." *Journal of Mammalogy.* 88 (2007): 1498–1507.

Black Bear

Burst, T. L. "Black Bear Mark Trees in the Smoky Mountains." *International Conference of Bear Research and Management.* 5 (1983): 45–53.

Costello, C. M. and R. W. Sage Jr. "Predicting Black Bear Habitat Selection from Food Abundance Under 3 Forest Management Systems." *International Conference of Bear Research and Management.* 9 (1994): 375–387.

DeBruyn, T. D. *Walking with Bears: One Man's Relationship with Three Generations of Wild Bears.* New York: The Lions Press, 1999.

Kilham, B. *In the Company of Bears: What Black Bears Have Taught Me about Intelligence and Intuition.* White River Junction, VT: Chelsea Green Publishing, 2013.

Rogers, L. L. "Effects of Food Supply and Kinship on Social Behavior, Movements, and Population Growth of Black Bears in Northeastern Minnesota." *Wildlife Monographs.* 97 (1987): 3–72.

Raccoon

Gehrt, S. D., W. F. Gergits, and E. K. Fritzell. "Behavioral and Genetic Aspects of Male Social Groups in Raccoons." *Journal of Mammalogy.* 89 (2008): 1473–1480.

Henner, C. M., M. J. Chamberlin, B. D. Leopold, and L. W. Burger Jr. "A Multi-resolution Assessment of Raccoon Den Selection." *Journal of Wildlife Management.* 68 (2004): 179–187.

Prange, S. S. D. Gehrt, and E. P. Wiggers. "Influences of Anthropogenic Resources on Raccoons (*Procyon lotor*) Movements and Spatial Distribution." *Journal of Mammalogy.* 85 (2004): 483–490.

Schuttler, S. G., M. J. Ruiz-Lopez, R. Monello, M. Wehtje, L. S. Eggert, and M. E. Gompper. "The Interplay Between Clumped Resources, Social Aggregation and Genetic Relatedness in the Raccoon." *Mammal Research.* 60 (2015): 365–373.

Fisher

Gess, S. W, E. H. Ellington, M. R. Dzialak, J. E. Duchamp, M. Lovallo, and J. L. Larkin. "Rest-site Selection by Fishers (*Martes pennanti*) in the Eastern Deciduous Forest. *Wildlife Society Bulletin.* 37 (2013): 805–814.

Gilbert, J. H., J. L. Wright, D. J. Lauten, and J. R. Probst. "Den and Rest-Site Characteristics of American Marten and Fisher in Northern Wisconsin." In *Martes: Taxonomy, Ecology, Techniques, and Management,* edited by G. Proulx, H. N. Bryant, and P. M. Woodard, 135–145. Edmonton: The Provincial Museum of Alberta, 1997.

LaPoint, S. D., J. L. Belant, and R. W. Kays. "Mesopredator Release in Expansion of Fisher." *Animal Conservation.* 18 (2015): 50–61.

Powell, R. A. *The Fisher: Life History, Ecology, and Behavior.* Minneapolis: University of Minnesota Press, 1993.

Powell, S. M., E. C. York, J. J. Scanlon, and T. K. Fuller. "Fisher Maternal Den Sites in Central New England." In *Martes: Taxonomy, Ecology, Techniques, and Management,* edited by G. Proulx, H. N. Bryant, and P. M. Woodard, 265–278. Edmonton: The Provincial Museum of Alberta, 1997.

Powell, S. M., E. C. York, and T. K. Fuller. "Seasonal Food Habits of Fishers in Central New England." In *Martes: Taxonomy, Ecology, Techniques, and Management*, edited by G. Proulx, H. N. Bryant, and P. M. Woodard, 279–305. Edmonton: The Provincial Museum of Alberta, 1997.

American Marten

Buskirk, Steven W. and Leonard F. Ruggiero. "American Marten." In *The Scientific Basis for Conserving Carnivores: American Marten, Fisher, Lynx, and Wolverine*, edited by L. F. Ruggiero, K. B. Aubry, S. W. Buskirk, L. J. Lyon, and W. J. Zielinski. 7–37. Fort Collins, CO: US Department of Agriculture, Forest Service, Rocky Mountain Forest and Range Experiment Station, 1994.

Chapin, T. G, D. J. Harrison, and D. D. Katnik. "Influence of Landscape Pattern on Habitat Use by American Marten in an Industrial Forest." *Conservation Biology*. 12 (1998): 1327–1337.

Gilbert, J. H., J. L. Wright, D. J. Lauten, and J. R. Probst. "Den and Rest-Site Characteristics of American Marten and Fisher in Northern Wisconsin." In *Martes: Taxonomy, Ecology, Techniques, and Management*, edited by G. Proulx, H. N. Bryant, and P. M. Woodard, 135–145. Edmonton: The Provincial Museum of Alberta, 1997.

Krohn, W., C. Hoving, D. Harrison, D. Phillips, and H. Frost. "Martes Foot-loading and Snowfall Patterns in Eastern North America." In *Martens and Fishers (Martes) in Human-altered Environments*, edited by D. J. Harrison, A. K. Fuller, and G. Proulx. 115–131. New York: Springer, 2004.

Payer, D. C. and D. J. Harrison. "Influence of Forest Structure on Habitat Use by American Marten in an Industrial Forest." *Forest Ecology and Management*. 179 (2003): 145–156.

Poole, K. G., A. D. Porter, A. de Vries, C. Maundrell, S. D. Grindal, and C. C. St. Clair. "Suitability of a Young Deciduous-dominated Forest for American Marten and the Effects of Forest Removal." *Canadian Journal of Zoology*. 82 (2004): 423–435.

Porter, A. D., C. C. St. Clair, and A. de Vries. "Fine-scale Selection by Marten During Winter in a Young Deciduous Forest." *Canadian Journal of Forest Research*. 35 (2005): 901–909.

Raphael, M. G. and L. C. Jones. "Characteristics of Resting and Denning Sites of American Martens in Central Oregon and Western Washington." In *Martes: Taxonomy, Ecology, Techniques, and Management*, edited by G. Proulx, H. N. Bryant, and P. M. Woodard, 146–165. Edmonton: The Provincial Museum of Alberta, 1997.

Ruggiero, L. F. "Characteristics of American Marten Den Sites in Wyoming." *Journal of Wildlife Management*. 62 (1998): 663–673.

Wynne, K. M. and J. A. Sherburne. "Summer Home Range Use by Adult Marten in Northwestern Maine." *Canadian Journal of Zoology*. 62 (1984): 941–943.

Weasels

Errington, P. L. "Food Habits of a Weasel Family." *Journal of Mammalogy*. 17 (1936): 406–407.

King, C. M. and R. A. Powell. *The Natural History of Weasels and Stoats: Ecology, Behavior, and Management*. 2nd ed. New York: Oxford University Press, 2007.

Polderboer, E. B., L. W. Kuhn, and G. O. Hendrickson. "Winter and Spring Habits of Weasels in Central Iowa." *The Journal of Wildlife Management*. 5 (1941): 115–119.

Proulx, G. "Long-tailed Weasel, *Mustela frenata*, Movements and Diggings in Alfalfa Fields Inhabited by Northern Pocket Gophers, *Thomomys talpoides*." *Canadian Field-Naturalist*. 119 (2005): 175–180.

Quick, H. F. "Habits and Economics of the New York Weasel in Michigan." *The Journal of Wildlife Management*. 8 (1944): 71–78.

North American River Otter

Kruuk, H. *Otters: Ecology, Behaviour, and Conservation*. Oxford: Oxford University Press, 2006.

Kruuk, H. "Scent Marking by Otters (*Lutra lutra*): Signaling the Use of Resources." *Behavioral Ecology*. 3 (1992): 133–140.

Melquist, W. E. and M. G. Hornocker. "Ecology of River Otters in West Central Idaho." *Wildlife Mongraphs* 83 (1983): 1–60.

Rostain, R. R., M. Ben-David, P. Groves, and J. A. Randall. "Why Do River Otters Scent-Mark? An Experimental Test of Several Hypotheses." *Animal Behaviour*. 68 (2004): 703–711.

Stevens, S. S. and T. L. Serfass. "Visitation Patterns and Behavior of Nearctic River Otters (*Lontra canadensis*) at Latrines." *Northeast Naturalist*. 15, no. 1 (2008): 1–12.

American Mink

Haan, D. M. and R. S. Halbrook. "Resting-Site Selection of American Minks in East-Central New York." *Northeastern Naturalist*. 21 (2014): 357–368.

Harding, A. R. *Mink Trapping: A Book of Instruction Giving Many Methods of Trapping*. Columbus, OH: A. R. Harding Publishing Company, 1906.

Wolff, P. J., C. A. Taylor, E. J. Heske, and R. L. Schooley. "Habitat Selection by American Mink During Summer Is Related to Hotspots of Crayfish Prey." *Wildlife Biology*. 21 (2015): 9–17.

American Badger

Michener, G. R. "Hunting Techniques and Tool Use by North American Badgers Preying on Richardson's Ground Squirrels." *Journal of Mammalogy*. 85 (2004): 1019–1027.

Minta, S. C., K. A. Minta, and D. F. Lott. "Hunting Associations Between Badgers (*Taxidea taxus*) and Coyotes (*Canis latrans*)." *Journal of Mammalogy*. 73 (1992): 814–820.

Sargeant, A. B. and D. W. Warner. "Movements and Denning Habits of a Badger." *Journal of Mammalogy*. 53 (1972): 207–210.

Ver Steeg, B. and R. E. Warner. "The Distribution of Badgers (*Taxidea taxus*) in Illinois." *Transactions of the Illinois State Academy of Science*. 93 (2000): 151–163.

Bobcat

Hansen, K. *Bobcat: Master of Survival*. Oxford: Oxford University Press, 2006.

Massachusetts Division of Fisheries and Wildlife. *Living with Wildlife: Bobcats in Massachusetts*. Retrieved July 27, 2017 from http://www.mass.gov/eea/docs/dfg/dfw/wildlife/wildlife-living/living-with-bobcats.pdf.

McCord, C. M. "Selection of Winter Habitat by Bobcats (*Lynx Rufus*) on the Quabbin Reservation, Massachusetts." *Journal of Mammalogy*. 55 (1974): 428–427.

Canada Lynx

Aubry, K. B., G. M. Koehler, and J. R. Squires. "Ecology of Canada Lynx in Southern Boreal Forests." In *Ecology and Conservation of Lynx in the United States*, edited by L. F. Ruggiero, K. B. Aubry, S. W., Buskirk, G. M. Koehler, C. J. Krebs, K. S. McKelvey, and J. R. Squires, 373–396. Boulder: University Press of Colorado, 2000.

Barash, D. P. "Cooperative Hunting in the Lynx." *Journal of Mammalogy*. 52 (1970): 480.

Fuller, A. K. "Canada Lynx Predation on White-tailed Deer." *Northeastern Naturalist*. 11 (2004): 395–398.

Fuller, A. K., D. J. Harrison, and J. H. Vashon. "Winter Habitat Selection by Canada Lynx in Maine: Prey Abundance or Accessibility?" *Journal of Wildlife Management*. 71 (2007): 1980–1986.

Homyack, J. A., J. H. Vashon, C. Libby, E. L. Lindquist, S. Loch, D. F. McAlpine, K. L. Pilgrim, and M. K. Schwartz. "Canada Lynx-Bobcat (*Lynx canadensis x L. rufus*) Hybrids at the Southern Periphery of Lynx Range in Maine, Minnesota, and New Brunswick." *American Midland Naturalist*. 159 (2008): 504–508.

Organ, J. F., J. H. Vashon, J. E. McDonald Jr., A. D. Vashon, S. M.Crowley, W. J. Jakubas, G. J. Matula Jr., and A. L. Meehan. "Within-Stand Selection of Canada Lynx Natal Dens in Northwest Maine, USA." *Journal of Wildlife Management*. 72 (2008): 1514–1517.

Vashon, J., S, McLellan, S. Crowley, A. Meehan, and K. Lausten. 2012. *Canada Lynx Assessment*. Maine Department of Inland Fisheries and Wildlife Research and Assessment Section. Bangor, ME. Retrieved August 24, 2017 from www.maine.gov/ ifw/pdfs/species_planning/mammals/canadalynx/Lynx%20Assessment%202012_ Final.pdf.

Cougar

Fish and Wildlife Conservation Commission. 2014. *Determining the Size of the Florida Panther Population*. Fish and Wildlife Services. Retrieved May 24, 2016 from www .fws.gov/verobeach/FloridaPantherRIT/20150819%20Statement%20on%20 Estimating%20Panther%20Population%20Size%20-%20revised.pdf.

Maehr, D. S. *The Florida Panther: Life and Death of a Vanishing Carnivore*. Washington, DC: Island Press, 1997.

The Nature Conservancy. 2017. *Florida Panthers: Crossing the Caloosahatchee*. Retrieved July 24, 2017 from www.nature.org/ourinitiatives/regions/northamerica/ unitedstates/florida/explore/florida-panther-kittens-north-of-caloosahatchee.xml.

Wilkins, L. "Practical Cats: Comparing *coryi* to Other Cougars: An Analysis of Variation in the Florida Panther, *Felis conclor coryi*." Florida Panther Conference, 1994. Retrieved August 24, 2017 from www.mountainlion.org/Library/Lion_Research/FL-R- Wilkins-1994-Practical-Cats-Comparing-coryi-to-Other-Cougars-An-Analysis- of-Variation-in-the-Florida-Panther.pdf.

White-tailed Deer

Cheatum, E. L. and G. H. Morton. "Breeding Season of White-tailed Deer in New York." *The Journal of Wildlife Management*. 10 (1946): 249–263.

Herdon, B. *Mapping Trophy Bucks*. Iola, WI: Krause Publications, 2003.

Hirth, David H. "Social Behavior of White-tailed Deer in Relation to Habitat." *Wildlife Monographs*. 53 (1977): 3–55.

Lagory, K. E. "Habitat, Group Size, and the Behaviour of White-tailed Deer." *Behaviour.* 98 (1986): 168–179.

Nixon, C. M., L. P. Hansen, P. A. Brewer, and J. E. Chelsvig. "Ecology of White-tailed Deer in an Intensively Farmed Region of Illinois." *Wildlife Monographs.* 118 (1991): 3–77.

Ozoga, J. J. and L. W. Gysel. "Response of White-tailed Deer to Winter Weather." *Journal of Wildlife Management.* 36 (1972): 892–896.

VerCauteren, K. "The Deer Boom: Discussions on Population Growth and Range Expansion of the White-Tailed Deer." *USDA National Wildlife Research Center—Staff Publications.* 281 (2003): 15–20.

Moose

Bowyer, R. T. and K. R. Rock. "Scent Marking by Alaskan Moose." *Canadian Journal of Zoology.* 72 (1994): 2186–2192.

Coady, J. W. "Influence of Snow on Behavior of Moose." *Le Naturaliste Canadien.* 101 (1974): 417–436.

Geist, V. *Moose: Behavior, Ecology, and Conservation.* Stillwater, MN: Voyageur Press, 1999.

Leptich, D. J. and J. R, Gilbert. "Summer Home Range and Habitat Use by Moose in Northern Maine." *Journal of Wildlife Management.* 53 (1989): 880–885.

Shipley, L. A. "Fifty Years of Food and Foraging in Moose: Lessons in Ecology from a Model Herbivore." *Alces.* 46 (2010): 1–13.

Van Ballenberghe, V. and D. G. Miquelle. "Rutting Behavior of Moose in Central Alaska." *Alces.* 32 (1996): 109–130.

Wattles, D. W. and S. DeStefano. "Moose Habitat in Massachusetts: Assessing Use at the Southern Edge of the Range." *Alces.* 49 (2013): 133–147.

Elk

Furtman, M. *Seasons of the Elk.* Minnetonka, MN: NorthWord Press, 1997.

IUCN Red List. *Cervus canadensis.* Retrieved August 24, 2017 from www.iucnredlist .org/details/55997823/0.

Wild Turkey

Bailey, R. W. "Sex Determination of Adult Wild Turkeys by Means of Dropping Configuration." *The Journal of Wildlife Management.* 20 (1956): 220.

Dickson, J. G. *The Wild Turkey: Biology and Management.* Mechanicsburg, PA: Stackpole Books, 1992.

Giuliano, W. M., L. N. Watine, J. M. Olson, M. Blake, and H. Ober. "Florida Turkey Nest Site Selection and Success." *Natural Resources.* 7 (2016): 644–654.

Wild Turkey *(Meleagris gallopavo).* Natural Resources Conservation Services, US Department of Agriculture, 1999. Retrieved July 27, 2017 from www.nrcs.usda.gov/ Internet/FSE_DOCUMENTS/nrcs143_009939.pdf.

Williams, L. E., Jr. *The Book of the Wild Turkey: Natural History, Range, Management, and Hunting of America's Greatest Game Bird.* Tulsa: Winchester Press, 1981.

Ruffed Grouse

Johnsgard, P. A. *The North American Grouse: Their Biology and Behavior.* Lincoln: University of Nebraska-Lincoln Libraries, 2016.

Jones, B. C, H. E. Miller, and L. Williams. Habitat Management for Pennsylvania Ruffed Grouse. Pennsylvania Game Commission. Retrieved from www.pgc.pa.gov/Wildlife/WildlifeSpecies/Documents/Ruffed%20Grouse%20Habitat%20Management.pdf.

Kubisiak, J. F. "Ruffed Grouse Habitat Relationships in Aspen and Oak Forests of Central Wisconsin." *Wisconsin Department of Natural Resources, Technical Bulletin.* 151 (1985): 1–22.

Great Blue Heron

Butler, R. W. "Great Blue Heron." In *The Birds of North America*, edited by A. Poole. Ithaca, NY: Cornell Laboratory of Ornithology, 2011. Retrieved May 11, 2017 from http://birdsna.org/Species-Account/bna/species/grbher3/.

Kushlan, J. A. "The Terminology of Courtship, Nesting, Feeding and Maintenance in Herons." 2011. Retrieved May 11, 2017 from www.heronconservation.org/wp-content/uploads/2014/12/Heron-Behavior-Terminology.pdf.

Mayer, E. "Is the Great White Heron a Good Subspecies?" *The Auk.* 73 (1956) 71–77.

Ruby-throated Hummingbird

"Aerial Dogfights of Spring." *Camera Trap Codger,* 2007. Retrieved November 27, 2017, from http://cameratrapcodger.blogspot.com/2007/03/aerial-dogfights-of-spring.html.

Bent, A. C. *Life Histories of North American Woodpeckers.* New York: Dover Publications, 1964.

Eberhardt, L. S. "Use and Selection of Sap Trees by Yellow-bellied Sapsuckers." *The Auk.* 117 (2000): 41–51.

Kilham, L. *Woodpeckers of Eastern North America.* New York: Dover Publications, 1983.

Southwick, E. E. and A. K. Southwick. "Energetics of Feeding on Tree Sap by Ruby-throated Hummingbirds in Michigan." *The American Midland Naturalist.* 104 (1980): 328–334.

Walters, E. L., E. H. Miller, and P. E. Lowther. "Yellow-bellied Sapsucker (*Sphyrapicus varius*)," version 2.0. In *The Birds of North America*, edited by P. G. Rodewald. Ithaca, NY: Cornell Laboratory of Ornithology, 2002. Retrieved November 21, 2017 from https://birdsna.org/Species-Account/bna/species/yebsap/foodhabits.

Weidensault, S., T. R. Robinson, R. R. Sargent, and M. B. Sargent. "Ruby-throated Hummingbird (*Archilochus colubris*)," version 2.0. In *The Birds of North America*, edited by P. G. Rodewald. Ithaca, NY: Cornell Laboratory of Ornithology, 2013. Retrieved November 21, 2017 from https://doi.org/10.2173/bna.204.

Pileated Woodpecker

Bull, E. L., and J. A. Jackson. "Pileated Woodpecker (*Dryocopus pileatus*)," version 2. In *The Birds of North America*, edited by P. G. Rodewald. Ithaca, NY: Cornell Laboratory of Ornithology, 2011. Retrieved November 9, 2017 from https://birdsna.org/Species-Account/bna/species/pilwood/.

Hoyt, S. F. "The Ecology of the Pileated Woodpecker." *Ecology.* 38 (1957): 246–256.

Kilham, L. *Woodpeckers of Eastern North America.* New York: Dover Publications, 1983.

Saenz, D., R. N. Conner, C. E. Shackelford, and D. C. Rudolph. "Pileated Woodpecker Damage to Red-cockaded Woodpecker Cavity Trees in Eastern Texas." *Wilson Bulletin.* 110 (1998): 362–367.

American Alligator

Conant, R. and J. T. Collins. *Reptiles and Amphibians: East/Central North America*. 3rd ed. Boston: Houghton Mifflin Company, 1998.

Dinets, V. "Apparent Coordination and Collaboration in Cooperatively Hunting Crocodilians." *Ethology Ecology and Evolution*. 27 (2015): 244–250.

Dinets, V., J. C. Brueggen, and J. D. Brueggen. "Crocodilians Use Tools for Hunting." *Ethology Ecology and Evolution*. 27 (2015): 74–78.

Hunt, H. and J. J. Ogden. "Selected Aspects of the Nesting Ecology of American Alligators in Okefenokee Swamp." *Journal of Herpetology*. 25 (1991): 448–453.

Joanen, T. *Nesting Ecology of Alligators in Louisiana*. Proceedings of the Annual Conference Southeastern Association of Game and Fish Commissioners, 1969. Retrieved August 24, 2017 from www.wlf.la.gov/sites/default/files/pdf/publication/34564-nesting-ecology-alligators-louisiana/joanen_1969_seafwa_nesting_ecology.pdf.

Ouchley, K. *American Alligator: Ancient Predator in the Modern World*. Gainesville: University Press of Florida, 2013.

Platt, S. G., R. M. Elsey, H. Liu, T. R. Rainwater, J. C. Nifong, A. E. Rosenblatt, M. R. Heithaus, and F. J. Mazzotti. "Frugivory and Seed Dispersal by Crocodilians: An Overlooked Form of Saurochory?" *Journal of Zoology*. 291 (2013): 87–99.

Reilly, S. M. and J. A. Elias. "Locomotion in *Alligator mississippiensis*: Kinematic Effects of Speed and Posture and Their Relevance to the Sprawling-to-Erect Paradigm." *Journal of Experimental Biology*. 201 (1998): 2559–2574.

Tkaczyk, F. *Tracks and Sign of Amphibians and Reptiles: A Guide to North American Species* (pp. 23–24, 348–49, 360–61, 413, 428). Mechanicsburg, PA: Stackpole Books, 2015.

INDEX